P]
The -....

"I remember watching televised beauty pageants with my family when I was a kid in the 1970s and Mama saying, 'They're all pretty.' But Jane Little Botkin unveils another view, one that shows how wild, western, chaotic, and sometimes downright ugly things were behind the scenes. *The Pink Dress* isn't a beautiful walk down memory lane. It's a wild ride through the turbulent 1970s, West Texas style. Here she is, Janie Botkin, taking the town by storm."
—Johnny D. Boggs, nine-time Spur Award winner and author of upcoming books *Longhorns East* and *Bloody Newton*

"The great meaning of this story and what makes it a page-turner is how Jane came to peace with difficult parents and extraordinary expectations to eventually become a highly successful writer, but perhaps more importantly, a wife, mother, grandmother, and role model. Her story is one that will linger in my mind and make me want to know her. Bravo, Jane, well done."
—David Crow, best-selling author of *The Pale-Faced Lie*

"It's about time the story of GuyRex (Guyrex) was told, and to have someone like Jane, who was the genesis to the legend of these two incredibly talented men, share it so beautifully is a treat for all. Reading the events of their pageantry has brought back many wonderful memories that truly shaped my adult life as well. If you had the opportunity to be a part of the GuyRex system—that is, if you were a GuyRex Girl—then your life was forever changed for the good."
—Gretchen Polhemus Jensen,
Miss USA 1989, former Miss Texas, and former GuyRex Girl

The
Pink
Dress

Jane Little Both

The

Pink Dress

A
Memoir
of a
Reluctant Beauty
Queen

Jane Little Botkin

SHE WRITES PRESS

Published 2024
Printed in the United States of America
Print ISBN: 978-1-64742-740-5
E-ISBN: 978-1-64742-741-2
Library of Congress Control Number: 2024905794

For information, address:
She Writes Press
1569 Solano Ave #546
Berkeley, CA 94707

Interior design by Stacey Aaronson
Cover photo by Shelley Shroyer Photography, LLC

She Writes Press is a division of SparkPoint Studio, LLC.

Names and identifying characteristics have been changed to protect the privacy of certain individuals.

Permissions

El Paso City
Words and Music by Marty Robbins
Copyright ©1976 Mariposa Music, Inc.
Copyright Renewed
All Rights Administered by BMG Rights Management (US) LLC
All Rights Reserved Used by Permission
Reprinted by Permission of Hal Leonard LLC

One Tin Soldier
From BILLY JACK
Words and Music by Dennis Lambert and Brian Potter
Copyright © 1969, 1974 SONGS OF UNIVERSAL, INC.
Copyright Renewed
All Rights Reserved Used by Permission
Reprinted by Permission of Hal Leonard LLC

Texas Women
Lyrics Excerpt
Words and Music by Hank Williams, Jr.
Copyright ©1981 Howe Sound Music Publishing, LLC
All Rights Reserved

For my THMs

I've got some fond memories of San Angelo,
And I've seen some beauty queens in El Paso,
But the best-lookin' women that I've ever seen,
Have all been in Texas and all wearin' jeans.

From "Texas Women" by Hank Williams, Jr.

Contents

Part Two

Part Three

Preface

I sat inside a hotel bar with four authors I barely knew in San Antonio Riverwalk's Omni La Mansion one late October evening in 2019. Along with a literary agent whom we had invited to our small table, we celebrated our last day attending a western women's writing conference. The evening's weather was highly irregular for South Texas, blustery and wet, not conducive for tourism. But I had visited the historic riverwalk decades before—its low riverboats, outdoor eateries and bars, tropical flowers, and tiny white lights mixed with loud mariachi and rock music.

Like the other storytellers at my table, I began to reminisce my experiences during 1972 when I contested in San Antonio's Miss Texas USA pageant. I shared my story as a tightly handled beauty contestant and soon had the women laughing at my escapades and overly exaggerated rendition of an East Texas accent. When I mentioned my handlers Richard Guy and Rex Holt (Guyrex Associates), nationally known as the "Kings of Beauty Pageants" and who dominated the Miss USA pageant scene for years, the agent's interest piqued. Everyone was surprised to learn that I had been a Guyrex Girl, a term nationally trademarked later. What I didn't tell the women in the bar that night was that I had been forced to move from a dysfunctional middle-class family—from a controlling mother—into a theatrical ménage of high performers who were also intent on managing all aspects of my life for one year.

Fondly called "the boys" by those in their widening circle of distinctive friends in 1971, Richard Guy and Rex Holt were inordinately creative and flamboyant. This aspect caused my father to dig in his heels even as my mother, her life full of drama and deceit, surprisingly relinquished my custodianship to the Miss El Paso-Miss America pageant franchise. One would expect this to be a no-win win for me, though admittedly my year was thrilling and certainly eye-opening for a once overprotected teenager.

The world I had entered was pure allure. It fringed on El Paso's underbelly where a top stratum of moneyed and theatrical artists melded with the city's wilder but popular element. Bank presidents, club auxiliary members, military officers, state politicians, and Hollywood actors, along with drug kingpins, casino high rollers, international detectives, bail bondsmen, and famous defense attorneys, shared a mutual passion for the Las Vegas pizzazz that Guyrex brought to the Sun City. Like the shifting desert sands that squeezed the city between the Rio Grande and the Franklin Mountain, El Paso thirsted for such refreshment, welcoming novel and creative ideas that could help exalt the Wild West city to a cosmopolitan destination. In effect, Guyrex created a fantasy world, not only for the patrons who attended their wild parties and fairy tale balls but also for the girls who were sculpted and refined until a distinctive Guyrex look emerged.

When everyone at our table agreed that I should author this story, I balked. They were not privy to the finer and darker aspects of my experiences, some typical of other beauty queens' accounts. A romance novel author in our group asked the bartender for a clean cocktail napkin and a pen. The women were going to force my promise to write this tale. On the napkin, the writer scribbled, "I am worth so much more than I am willing to admit, and I am going to reach for the stars." Reluctantly, I signed the pledge.

I was a first generation Guyrex Girl—Version 1.0—an experiment as unique and bold as the new queen-makers themselves. And like all first versions in experimentation, I was flawed, as were my creators. Like beauty, my years with Guyrex were just skin-deep in my personal growth, and though pivotal, not the watershed of my life. But if I pick at the years' scabs until they hurt, I finally understand that I never saw myself as a victim and that view was essential to my personal success.

The literary agent warned that the journey likely would be painful. And she hasn't been wrong. But when I make a promise, I always keep it, no matter the impact it might have on me. And that is part of my narrative too.

Prologue

2018

I inserted a key inside a tarnished brass doorknob. The door moaned open, its tattered, spring wreath bouncing gaily on a faded forest-green surface, mocking the purpose of my visit.

Almost a week earlier, I had entered the same door and discovered my mother on the floor, blood seeping on the worn, cream-colored carpet. After the accident, a pink-uniformed lady gently advised that my mother's staying in her own home was no longer an option. But she had no idea that Mother was a fighter, a survivor with a life history of tragedies and disappointments.

The hospice woman looked at me with pity, trying to read my mind. Did she think I felt sorry for my mother? If she had known my thoughts, perhaps she would have been surprised, disappointed. Perhaps, too, I was just tired, worn out from transportation to my mother's doctors' appointments, grocery shopping, and lately, laundry and housekeeping.

But there had been more. During the past months, my mother had begun revealing stories of shame, betrayal, and suffering that, in turn, triggered my recollection of events, albeit in a separate sphere. And that, too, was exhausting. I soon realized that some of my mother's recollections were overridden with alternative truths so she could endure. As for me, I discovered that you can never control what comes back to hit you smack in the face—or pierce your heart.

I recall watching Mother slowly calculating the move behind her bright eyes, battling her suspicion whenever I was involved. She stared at me as if I would dare challenge her decision, then turned her head toward the hospice nurse, and said, "I guess so," adding not-so-confidently, "but only for a short stay."

Relief flooded me. There would be no more arguments. No more spiteful accusations and recriminations. No more worrying.

But that, too, changed three days later after an early morning phone call. My ninety-two-year-old mother had ended her stay with a finality that even she could not control.

Thirty minutes later, a nursing home staff member, dressed in an ornately embroidered turquoise dress for the day's Cinco de Mayo activities, guided me to my mother's room, weaving among occupied breakfast tables adorned with colorful *papel picados*.

A few of the infirm, tilted catawampus in wheelchairs, stared dully at their breakfast bowls, despite the provocative colors and lively Mexican music softly playing in the background. Other residents glanced up curiously, their mouths—some chalked red with "cherries in the snow" lipstick and full of oatmeal—crinkling upward with innocent pleasure.

"Are you here to see Alice?"

"No, silly, she's Susan's daughter."

I hadn't been Susan's daughter. I wasn't even my mother's daughter anymore. I was an orphan who stumbled stupidly behind a nurse, our erratic movements gently floating crepe paper streamers upward and drawing away the women's childlike attention. By the time I saw my mother's thin form lying in bed, her wounds uselessly bandaged, I was almost numb. In the background, strains of a mariachi band's accordion crescendoed.

I peered within the house—reluctantly—trying to avert my eyes from the soiled carpet. After taking a deep breath, I stepped inside, relieved the give-away stains had been removed. I surveyed the rest of the front room for other changes, though every aspect of the house was as intimately familiar as my mother's critical blue-green eyes.

A shabby, square, burgundy recliner, its seat cushion listing sideways like a deflating life raft, sat in the center of the room. Mother had been trying to reach the treacherous chair when she fell. I closed my eyes and envisioned her slumped to one side, perhaps watching *Judge Judy*, *Dr. Phil*, or CNN, or dozing through some nondescript television program—her white noise, Mother had called it, an elixir for sleep.

In my imagination, the chair's new, unfamiliar emptiness appeared to confuse a gathering of young faces surrounding it. Photos of great-grandchildren covered every available flat surface, including the cherrywood end tables, television stand, and fireplace mantel. Six months of magazines were stacked on the white limestone hearth below, and Dollar Store toys filled bookshelves, just in case.

Above the fireplace hung a large portrait of a young woman in chalky pastels, her hair piled high in soft curls, breasts and shoulders faintly covered in pearly roses. The face projected a half smile, and its cyan-colored eyes gazed over my head, almost as if it refused to make eye contact with its semblance. Guilt? I knew the rose-covered gown was pink.

Unlike the front room, my mother's bedroom was left in disarray. A portable toilet needed attention next to the bed, which had its sheets thrown askew. Silhouetted in the filtered morning

light, a stack of winter clothes, ready to be packed away, lay on top of an old ironing board. A memory flitted inside my mind. I had been an eleven-year-old in November 1963, ironing my father's shirts in front of our old RCA, when Dallas nightclub-owner Jack Ruby shot Lee Harvey Oswald, President John F. Kennedy's assassin—live—on television. I had screamed for my mother.

My eyes rested on another fabric heap covering a blond table in the room's corner. I knew underneath the fine quilt pieces was Mother's old Elna, her pride and joy. Despite my parents' financial hardships, my mother triumphed in purchasing the fancy Swiss sewing machine almost sixty years earlier. The last dress she made for me had been a red chiffon gown.

Not long ago, Mother asked if I wanted the ancient Elna, her wrinkled face anxious to please. Looking at it now, instead of polished cotton pieces and a myriad of school clothes and fancy dresses, I only saw jagged rents of sorrow and conflict. No, the sewing machine had never stitched our relationship together the way we both had desired. I did not want it.

Instead, I fled. I hurried through a gauntlet of family faces down a narrow hall leading out of my mother's bedroom. Obligatory photos of grandchildren in their caps and gowns, their expressions serious, appeared to frown across the hall, as if through me, toward youthful studio portraits of their parents, belying any order of family relationships. A young woman flashed by in an emerald-satin gown, and I, wearing the ubiquitous high school black velvet drape. I paused at the last photo. My mother had placed a golden border around an eight-by-ten-inch photograph of a young woman dressed in a gold-beaded scarlet gown.

I held a scepter and wore an official Miss America pageant crown.

Later that evening, I rocked while I wept, sitting in my bathtub with my arms tightly wrapped around my knees, mourning for the understanding that came too late—and the forgiveness that I had begrudgingly withheld.

Part
One

Parents would give us their daughters
because they knew they would get a better
girl back when it was over.
—RICHARD GUY

Chapter One

You Could Be
Miss America

"WANTED! You Could Be Miss America," the words proclaimed in black and white above and below the beaming face of Phyllis George, Miss America 1971. Phyllis was America's girl next door, wholesome and tan, her dark, glossy lips in a dimpled smile revealing perfect white teeth. Even better, she was a Texan, and we Texans believed that our state produced more beauty queens than any other state.

Maddie, one of my Tri Delta sorority sisters, had snatched the poster from the UTEP (University of Texas at El Paso) campus student union and now held it up in the air in the tiled foyer of our sorority house. Her black eyes sparkled with excitement as she spoke rapidly among a circle of girls who had arrived between classes to eat and chat. The main floor of the house was an open design, and the girls standing at the kitchen's island had to pause their lunch-making to hear what caused the excited babble of voices.

In a corner of our main meeting room, to the right of the

wide foyer, plumes of white smoke softly swirling above the daily spades game also seemed to linger. Players placed their fanned cards upside down and tapped long Virginia Slims into ashtrays, already brimming over, while they, too, listened. They didn't dare rise—doing so would require putting their cigarettes down. A Tri Delta never walked with a cigarette in hand.

Somebody turned down the radio on the sound system in the polished, pecan-paneled wall, and Crosby, Stills, Nash, and Young's voices faded with ". . . tin soldiers and Nixon's coming," a lyrical reminder about American discontent on college campuses giving way to Maddie's voice.

Like other university campuses across the country in 1971, our campus, sitting at the foot of Franklin Mountain directly next to an international border, had been a microcosm of American political disruption. Walter Cronkite's evening news, with his nightly body counts, and *Life* magazine's weekly graphic images fragmented our daily lives—adding color to stories about Vietnam War protests and massacres, Weathermen bombings, and Black Power and La Raza Unida rallies. Sit-ins, bomb scares, and streakers, wearing nothing but their ski masks, peppered my collegiate life as I tried to find my own place among scholarly and social organizations while radical groups fomented on campus.

I had not been a rebel, at least not yet, but rather an extraordinarily obedient daughter who feared veering out of her mother's orbit. To make certain that I grew in a healthy environment, my mother became my Girl Scout troop leader, school parent volunteer, cheerleader parent, and primary punisher for all my sins. And because it was understood that college was in my future, Mother pressured me to join myriad organizations in preparation. Later, she complained that I "burned the candle at both ends," but I didn't care since I had been so interested in life—and learning.

To keep up with my activities, Mother had to join them in some fashion as well. Why? To ensure my accomplishments. At first, I didn't question my supermom's role in my life, though rebellion had begun fermenting in my mind. I bravely took a wee step in defiance early on, changing the spelling of my name from *Janey* to *Janie*. Yes, I was gutlessly obedient. Still, my secret pleasure, every time my mother had to read something with my newly spelled name, was *something*.

The sorority was Mother's idea. She had been an ADPi in a Texas Panhandle college, in a Greek system devoid of men during War World II, and, as a result, often reminisced about her friendships with other girls who waited patiently for returning soldiers to repopulate their campus. In college, I would meet a suitable husband, she claimed—someone with purpose and a brain. Still, with the university life she engineered for me, she now had to shoulder new worries about the company I kept.

Possibly my mother dreaded that I would sneak out a window to meet a boyfriend, spending all night out, something she later admitted doing herself. Or possibly she worried that I would run amuck, perhaps to Juárez, Mexico. There, I might sit with my friends in a circle around an ancient table with scarred chairs, cracked upholstery pricking my back, just inside a door near the curve of the Kentucky Club's polished bar. We might play Buzz and drink shots, our brains becoming fuzzy each time someone—their tongues thick like cotton—failed to "buzz" a multiple of seven or eleven or any number with seven in it.

Mother probably feared my walking back down Avenida Juárez, past dark-entranced bars and strip clubs, their neon lights flashing and loud music pumping from speakers, with hawkers inviting us inside: "Hey, girlie, *venga, venga adentro.* Come inside."

She might have worried that I would stop under the sign at Fred's Bar to eat ham and avocado of unknown origin, in a sandwich wrapped in a Mexican *bolillo* and purchased from a ragged street vendor. Inside the doorway, college students and Fort Bliss soldiers would leer and laugh too loudly, while we moved on, stepping over litter that stank of decay and debauchery.

Perhaps Mother feared that two pennies might elude my clumsy fingers in the bottom of my bag, as I frantically tried to find coins to buy my way home through the turnstile gate at the Santa Fe Bridge, even as the person behind me, dodging a splatter of vomit, would ask, "Anyone got change?"

I decided Mother had been afraid of *me* becoming *her*.

There would be no risks with my education. Instead of attending Rice, where academic funding awaited me, I had remained in El Paso, bribed to stay at home with a used canary-yellow GT Mustang convertible. I was *not ready* to live away from home, Mother said. *Not ready* was her excuse for most everything progressive and out of her control in my life. I totaled the car one year later.

Not until spring of my freshman year did I pledge the sorority. Mother had decided that I was also not ready for Greek life when fall classes first started. I couldn't pay the dues anyway, and really neither could my parents. How my mother scraped dollars out of her meager household allowance each month to finance the social side of my developing womanhood I'll never know. Tri Delta was the most expensive sorority on campus, and my childhood friends—my best friends—could not afford to join either. But, if I were taking bets, I would say they were first to cross the border for fun.

WANTED

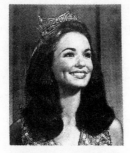

Miss America 1971
PHYLLIS GEORGE
Denton, Texas

You Could Be *Miss America*

Over $4,000 in Scholarships & Prizes

to be given locally

MUST BE

1. Single, never married, or had marriage anulled.
2. High School graduate by Labor Day.
3. Eighteen years old by Labor Day to twenty eight.
4. Must have talent routine which lasts 3 minutes.
5. Must live in, go to school in, or if you attend school elsewhere be a legal resident of El Paso County.

PRELIMINARIES TO BE HELD MARCH 4, 5, 6.

APPLY NOW

Guyrex Associates
1304 MONTANA
533-5279 — 755-2603

AN OFFICIAL *Miss America* PRELIMINARY PAGEANT

Official Miss America pageant poster featuring Phyllis George
and advertising the first Guyrex Miss El Paso-Miss America
pageant (Author's Collection)

I stood on a luxurious cornflower-blue carpet in the sorority house's sunken living room to the left of Maddie and the foyer, as she read out loud, mentally checking off qualifications. I loved this room because of the carpet. My family had squeezed into a post-World War II tract house in Northeast El Paso. I couldn't even

tell you the carpet color in our living room. Perhaps a grayish-taupe, a beaten-down tan, much like some of the city's residents.

$4,000 in Scholarships and Prizes
To be given locally

MUST BE:

1. Single, never married, or had marriage annulled
 [check]

2. High school graduate by Labor Day [check]

3. Eighteen years old by Labor Day to twenty-eight
 [check]

4. Have talent routine

That stopped me. I didn't even hear number five: "Must be a legal resident of El Paso County." Generally suffering from stage fright, my talents were yet to be discovered. In fact, my self-image needed a healthy injection of confidence. I couldn't dance or sing well, but I could play the piano, though I certainly was no Chopin. Phyllis George was a pianist, and I had watched her play last fall.

Like many families during the 1960s and 1970s, we watched the nationally televised Miss America pageant every September, shelving football for at least one evening. We selected our top ten finalists from the parade of states, much like choosing a trifecta from the post-parade of horses at Anapra's Sunland Racetrack.

My father sat in his lounge chair, his Scotch and water in hand, and commented on the long-limbed contestants, openly admitting his predilection for women's legs. "Janey, just look at your mother," he had said more than once. "She has the prettiest legs, doesn't she?"

Mother would beam at the compliment. And she *had* been beautiful, taller than I, with willowy legs, light auburn hair, and a heart-melting smile, especially when she looked at my father. Dad had also been drawn to female vocalists, and more than once, I caught my parents dancing cheek to cheek on our dingy kitchen linoleum to the sultry voices of Lena Horne and Dorothy Dandridge, emanating from the pawnshop hi-fi Dad brought home. My dad loved women, and, like others who encountered him, I was not immune to his charms.

My parents and I knew almost nothing about the contestants parading in a pale rainbow of chiffon gowns in front of the camera—only where they were from and how they looked. We waited for emcee Bert Parks to call out our Miss Texas and hoped that she appeared as exotic and glamorous as Miss New York or as golden-skinned and blonde as Miss California. Usually, we were not disappointed, and having our state in the mix made a family competition that much more fun.

Together, we dissected swimsuit competition, evening gowns, and interviews. But the real entertainment was the talent segment, counting for most of the judges' scoring. Watching Miss America was akin to watching a variety show, much like Andy Williams, Ed Sullivan, or Carol Burnett. It was a time when my parents seemed happy together as they joined in laughing at skits, interview answers, and even mishaps. When we were unified as a family, even watching a silly pageant together, I felt safe and loved—and normal.

By now the girls at the spades table had left their seats and encircled Maddie, along with the rest of us. She continued to read the information underneath Phyllis George's smiling face: "Prelimi-

naries to be held March 4, 5, 6. Apply now at Guyrex Associates, 1304 Montana." That was just two days away!

That night at our weekly Monday meeting, a more serious discussion about the pageant ran high among the girls. An extraordinary competition among sororities was proposed in the hours since the posters first appeared at the student union. Now, entering the Guyrex contest became more like an intramural consideration. Instead of competing in softball or some other athletic contest, where the Chi Omegas usually excelled, the Zetas announced they were entering a handful of girls who had a good chance of winning. While Tri Delta girls were typically stereotyped as rich, blonde, and smart (I fit the latter two characteristics), universal opinion held that Zetas were typically gorgeous brunettes—and fast. It was decided that a Tri Delta could beat a Zeta in the first Guyrex-Miss El Paso pageant, no matter that Phyllis George was famously a Zeta.

"Who's going to enter?" someone asked.

"I will, if I can figure out the talent!" another answered.

"Janie, what about you? I will if you will," my sorority big sister, Gayle, blurted out.

Much later, when asked how I had gotten into the Miss El Paso pageant in the first place, I usually explained that I had entered on a whim. The truth is I had a problem saying no. I was a pleaser who didn't like disappointing anyone. My teachers generally loved me for this very reason while my peers often saw me as weak and malleable. No wonder my mother had guarded me so closely. I handled decision-making dilemmas by disappearing so I wouldn't even have to be asked at all.

With nowhere to hide, I stood mutely while five of my new friends volunteered to parade half naked in front of strangers and organize amateur talent acts. No matter that just two years

earlier, in September 1968, over two hundred women had jour-
neyed to Atlantic City to protest the Miss America pageant as a
sexist "cattle contest," they claimed. "If you want meat, go to a
butcher!" one protester's sign read, disregarding that the women
in the Miss America pageant were scored heavily on their talents.

No bras had been burned at that moment, but the event had
begun a national dialogue about feminism while at the same time
young men were actually burning their draft cards. On this early
March night in 1971, at our sorority house, no girl advocated
tossing her bra in a "Freedom Trash Can" in support of the
women's liberation movement. To many of my sorority sisters,
everyone was getting "liberated" these days.

"Okay," I finally answered, though I would much rather have
played softball. Honestly, I wasn't good at that either. I wondered
how the heck I could manage the talent portion. I had several
homemade evening gowns from high school in my closet. As far
as a swimsuit went, I had suits from working summers as a life-
guard and spending free weekends water skiing at the lake. But
talent? Maddie's talent was decided. With her lithe figure and
dark Puerto Rican looks, she could model the clothes she made
like a pro. Gayle, suddenly grinning, announced she would
dance, but everyone knew she was more comedienne than dancer.
Shirley, her Summer Blonde hair framing an angelic face, could
not only play the piano but could also sing. The girls squealed
over various suggestions and began making up outrageous talent
acts for those who claimed to possess none, as it was decided that
our sorority would be well represented.

I was certain of one thing—I would not tell my parents. This
little contest would join a long list of secrets I had become adept
at keeping.

Chapter Two

The Boys

Some folks claim that El Paso, Texas, should be El Paso, New Mexico. It's true that the city sits in isolation from the rest of the state—635 miles from Dallas, 600 miles from Austin, and 551 miles from San Antonio. These same naysayers maintain that Midland, 306 miles away, is West Texas, and El Paso is not. To other visitors, the city of El Paso, with its sprawl around the southern tip of the Franklin Mountain on the Mexico-United States border, seems more like a foreign country. The Mexican state capitol of Chihuahua is only 239 miles from El Paso.

Fort Bliss Army Base, Biggs Airfield, and nearby White Sands Missile Range routinely transferred military families into the isolated location during the 1960s, when my family moved to the city. Many pondered, "What the hell did I do wrong to get this assignment?" Then the desert, with its vast immenseness and natural beauty, grew on the transferees. Even as they spit the sand out of their mouths, their English became peppered with colloquial Tex-Mex expressions tinged with a slight Spanish accent—*Seguro que* hell yes! (Sure, hell yes!)—as if they had always

been El Pasoans. For me, the love affair began when I first saw the purple-hued mountain, a departure from the flat shelf of the Texas Panhandle—that, and the occasional frilly donkey piñata my father bought for me at the Juárez City Market. Old Mexico, as we called it, had been the real enticement.

In truth, Mexico's character remains everywhere in El Paso. And it is this mosaic of cultures created from centuries of intimate proximity to each other that best defines most of the city's attributes and its residents, past and present. Throw in the geographic isolation from the rest of Texas, almost continuous military occupation, and an outlaw history, and El Paso remains clad with a Wild West reputation. Later I would not only have to swallow the city's historical facts and statistics but also digest its long-lived and complex character in whole so that it would become part of me.

A wild, woolly place up until the late 1800s, the El Paso and San Antonio streets had been lined with saloons and gambling halls and, on Oregon Street, brothels. Infamous outlaws, gamblers, and gunmen such as John Wesley Hardin, Wyatt Earp, John Selman, Bat Masterson, and Pat Garrett frequented these establishments.

While other towns across the country were ending their outlaw eras by the early 1900s, El Paso continued to welcome gamblers, general riffraff, and other fugitives from justice. Also remaining were imported cultural diversions featuring top stars in theater and music—the same arts that dominated when Richard Guy and Rex Holt first appeared together in El Paso society. In the early 1960s, three blocks from the former Acme Saloon on East San Antonio Avenue, and the site where "lawman" John Selman notoriously shot El Paso gunman John Wesley Hardin, was the historic and popular Plaza Theater. Above the ornate theater hall's Spanish-styled first floor, Richard Guy and Rex Holt first worked together as Arthur Murray dance instructors.

The current popularity of ballroom dancing—the samba, cha-cha, foxtrot, and waltz—brought Guy and Rex together, long before their venture into the successful Guyrex business partnership of succeeding years. Guy (as he preferred to be called) had been an army brat, much like the hundreds of other kids who finished their adolescences in El Paso. The son of Puerto Rican parents who retired to El Paso, Guy's real name was Fernando Guiot y Vasquez. Rex, soon to be Guy's partner, was the son of a Southern Pacific Railroad worker who moved with his family from Tucumcari, New Mexico, to El Paso in time to attend and graduate from Stephen F. Austin High School. While Guy worked as an Arthur Murray dance instructor as early as 1958, helping organize dance parties replete with lessons for only $14.50 and free instructional Arthur Murray dance books, Rex excelled in school, where his yearbook pages are filled with academic and extracurricular accomplishments. Even before he began his first semester at Texas Western College (later renamed UTEP), Rex got his start in a collegiate summer musical as a dancer. Perhaps that is how the two met, though they never told me just how they came together.

Guy and Rex soon expanded their craft on evenings at the Plaza Theater. During the day, Rex later told me, he taught art at a local public school. They organized and directed dance-o-ramas for competitive dancing and designed elaborate costumes for themed evenings. Then, in 1963, Guy established Guy's Dance Studio, and the two made their social debut in the El Paso Coliseum representing the new business. In front of a captive audience in a city election rally, they performed a cha-cha exhibition before El Paso politicians gave their stump speeches. Guy's Dance Studio soon became the Guyrex Dance Studio on the first floor of an enormous vintage house at 1304 Montana Avenue, and the men moved in together.

Wives of local executives and other organizations sniffed out Guy and Rex, the pair a novelty to El Paso's socially elite, and the women appeared to clamber over each other to hire "the boys," as they began calling the two men, for private events involving dance, decorations, and design. The women also encouraged their husbands to hire the creative duo to decorate business lobbies at Christmas, and El Paso Natural Gas Company relied first on Rex's eye for artistic originality. He had worked there as an office boy in 1959.

The dance classes had continued, drawing attention to Guy and Rex's newly designed and decorated rooms in their Montana Avenue house. Shortly afterwards, El Paso's Festival Theater hired the men to design and decorate sets and make costumes, advancing the men's reputations even further. But it was the annual Sun Carnival Parade that cinched Guy and Rex's early place in El Paso society. In 1967, El Paso National Bank President Sam Young called upon them to design and build the bank's float, including costuming, for the annual Sun Carnival Parade—and gave them only one month to do it. The float won the coveted Sweepstakes Award.

After myriad more award-winning floats, costumes, and set designs brought accolades to Guy and Rex on El Paso's society pages, the men discovered a new venture in 1970. The franchise to run the local Miss America contest in El Paso, Texas, was for sale—and cheap.

True to El Paso's character, there was another group of men and women who, having benefited from Juárez and El Paso's past violent history, saw business and social opportunities. A half century before Guy and Rex started designing floats, the Mexican Revolution, led by Francisco Madero against dictator Porfirio Díaz and his government, brought war to the cities of Juárez and El Paso.

The rebellion also brought changes to El Paso's ethnic composition, commerce, and attitude. While arms and supplies piped through El Paso to supply the rebel army and the shots from some of these weapons pockmarking Juárez's adobe city walls, a Lebanese and Syrian population sought sanctuary in El Paso after immigrating to Mexico earlier. Well-to-do merchants with cash stashed in their pockets crossed over the border, even as Mexican bullets, losing velocity, softly pinged rooftops of Victorian houses near the College of Mines (another precursor to UTEP) during the first Battle of Juárez. If the new citizens fleeing into the United States possessed only the clothes on their backs, their centuries-old skills at "horse trading" and making money soon helped them establish profitable permanencies in their new home.

Some sought opportunities because of wars raging in their own home countries. As an example, young Joseph Abraham, patriarch of an El Paso Syrian American family, first emigrated to Mexico during the Turkish War for Independence and just as the Mexican Revolution was ending. Peddling door-to-door, selling anything from socks to soap, he survived Juárez for nine years. Then, along with a brother, Abraham found himself in the furniture business after legally immigrating to El Paso.

Guy and Rex partnered with descendants of these opportunists—the Abrahams, Salomes, Maloolys, Rheys, and Chagras, among others. The families' enormous generosity generally overshadowed any potentially ambiguous relationships with law and order, their stories having been interwoven into the Revolution's violent history. For instance, the Abrahams later intermarried with the family that had constructed El Paso's Caples Building. There, Pancho Villa had collaborated with Madero and his new *junto*, which had been established on the building's top two floors.

In Guy and Rex's world during the 1960s, almost fifty years after the Battle of Juárez and after decades in which colorful characters had used El Paso to abscond from sullied pasts, responsibilities, and even arrest, a general indifference to the law still prevailed. If one couldn't hide in El Paso or Juárez proper, an easy walk across the Santa Fe Bridge separating the cities usually guaranteed freedom. If not, the Rio Grande was shallow enough upstream, where adobe, plywood, and cardboard barrio homes looked southwest into the Sierra Madre foothills.

For many, El Paso life was more about skirting the law or the exhilaration of *feeling* like you broke the law. More conscientious citizens paid their maid or yardman Mexican wages—cheap labor—and relished trips to Juárez's downtown market where they could beat down the vendors. Others went further.

Want cheap cigarettes or a bottle of tequila? Cross the border, make your purchase, and at customs, look the agent straight in the eye and claim only one carton or one bottle instead of the five you have tucked away under the backseat of your car. Gasoline too expensive stateside? Add a fake bottom to your truck and smuggle Mexican petrol over a less-traveled border crossing nearby. Marijuana? Polite conversation did not discuss your neighbor's airstrip near El Paso's Upper Valley where all kinds of contraband found its way into the States. Invited to a party in an upscale neighborhood in Mt. Franklin's foothills, where cocaine will be passed around on a silver tray? Politely decline.

Still, to me, it was the character of El Paso's fugitives-turned-citizens that best defined the city—independent, raucous, and undeniably fascinating.

Like many other El Paso residents, my family had a story too. And it would piece itself into the fabric of the city's imperfections, perfectly. We slipped out of the town of my birth because my father

was in debt. Escaping to El Paso was his fresh start, though in
retrospect, he resumed some of the same bad habits there that
caused our family's mess in the first place.

We had lived in Hereford, a small town in the Texas Panhandle.
Nowadays, an uncomfortable odor assaults travelers' senses when
they drive near or through Hereford. But in the 1950s, instead of
stockyards, I remember sweet-scented summers, running in
freshly mown, dew-damp Bermuda grass, the cut blades sticking
to my bare feet. My brother and I played outside every morning
and evening, dodging our weeping willow's slender branches, its
narrow, golden-green leaves cut evenly like my 1950s bangs. No
one dreamed of violence, pedophiles, kidnappers, or even careless
drivers while we crisscrossed the street with other neighborhood
children.

Though he held an accounting degree, my father had taken
over my grandpa's B.F. Goodrich Company store where he sold
farm implements, tires, appliances, and electronics. As a result,
we owned the first television in town. Daddy also built a service
station, the Speed Stop, its fluttering red, yellow, blue, and white
pendants catching the attention of motorists in a new mobile
America, while Mother stayed at home to take care of us kids.
She had been a home economics teacher who quit teaching after
my birth, ostensibly to raise the perfect child, though not neces-
sarily following Dr. Spock's rules of child-rearing. Dad's thin,
brown leather belt, always on hand, hung on his mahogany valet
stand if needed.

My parents' lives had ebbed and flowed with leisure—golf
games, bridge parties, and country club dinners and dances.
They hosted smoke-filled poker parties and all-day, bowl-game
get-togethers, complete with multiple television sets in their
new pink-brick home, which my mother had painstakingly de-

signed. There were boats and airplanes, fishing trips, and vaca-
tions to Mexico, Nevada, Colorado, Minnesota, and Canada along
with their high-rolling friends—bankers, dentists, doctors, and
car dealership owners. Then the money ran out.

After an especially horrific blizzard in 1956 when Panhandle
cattle were smothered in fifteen-foot drifts, the snow sucked up
their noses, a chain of events began to impact my father's store
and ultimately the family's security. Daddy gave credit to clients
who were in dire financial trouble, even as his own debts piled
up and as my parents continued their lavish lifestyle. Reality
eventually smacks the foolish in the face, and, too late, my parents
began to curb their spending. Their trips ended; the custom-
built brick house was traded for a run-down white-clapboard
house on the edge of town. My mother grew humiliated and
frightened.

Not long afterwards, my father began bringing home cash, at
least once a week, hiding it in a drapery valance Mother had
sewn, his mind set on an escape plan to the West, either Tucson
or El Paso. One day, just after I began the fourth grade, we packed
up, leaving the businesses and the shabby house in the dust behind
us. We drove out of Hereford past a familiar sign that read, "If the
color of your skin is black, don't let the sun set on your back!" El
Paso would soon change whatever bigotries were temporarily
embedded into my youthful character.

As for my father, he began making some unusual acquaintances
in El Paso: other runaways much like himself on the up-and-
coming. As he built a successful accounting practice, he really
wasn't that different from those who would soon populate my life
in the world of Guyrex.

Chapter Three

Preliminaries

Two days after the sorority meeting, I stood among thirty other Miss El Paso hopefuls in a foyer inside the UTEP Student Union Building. An eclectic array of public notices surrounded us. On the face of a glass window across the room, a huge poster, tagged with a rainbow-colored peace sign, read, "America, Love It or Leave It!" in letters that appeared to be cut out of an American flag. Near me, a standing bulletin board advertised upcoming theatrical productions while also inviting environmental activism—"Walk for Clean Air" and "Earth Day: A Disease Has Infected Our Community!" UTEP's campus, with its unique Bhutanese architecture, sprawled directly next to the Mexican border and was juxtaposed with several towering gray and red smokestacks belonging to the American Smelting and Refining Company (ASARCO).

Beyond a border fence, Mexico's *colonias* extended onto dusty hills southwest of a corralled Rio Grande, where its residents both bathed and drank in the fouled, muddy waters. Below ASARCO, on the US side, was Smeltertown, a poor Mexican American community consisting of crude plastered adobe houses

and a dingy elementary school. On any given day, UTEP students entered their classrooms with ASARCO's lead emissions stuck to their tongues. One just got used to it—that and the views across the river. Before anyone seriously talked about pollution, El Paso's winter inversion was astounding—and it made for spectacular sunsets.

My stomach lurched when my eyes caught activity through opened double doors leading into a theater. I nervously fidgeted with my contest clothing. My swimsuit was rolled up in a shopping bag, along with a pair of satin shoes matching an evening gown inside a dry cleaner's clear plastic bag and folded over my left arm. My right hand held a manila folder with sheet music.

Earlier that morning, I stealthily escaped my house with the contraband. Mother had been in thought, stirring sugar into her second cup of coffee with the same hand she used to hold her cigarette. Up until this year, she had stopped me almost every morning before I could get to the front door, especially if I wore something new. I would drop to my knees in front of a massive hall mirror, which boys from a vocational class had made for her years earlier, and wait for her approval as she used a yardstick to measure the hem. No more than five inches above the knee and I had permission to leave the house. Now, with no university dress code, she had loosened her scrutiny. My father's activities were of more concern to her.

We were met in front of the theater's doors by an animated, petite Hispanic man, wearing tight black pants, polished, high-heeled black boots, and a long-sleeved purple shirt with an open and exaggerated high collar. Someone whispered that this was Richard Guy, the flamboyant half of Guyrex.

"Gurr-rls," he said, "I want all of you over there." His right hand fluttered aimlessly in space.

Over his head I could see rows of seats and a stage in slight disarray. Folding chairs skewed near a microphone and boxes of materials sat on the floor center stage. A small group of people had already settled into the theater's rear rows and were chatting among themselves in the darkness. Some glanced our way. They looked like businesspeople.

"Never mind," Richard Guy said, rolling his dark eyes dramatically. "Just follow me." His hand, still in the air, appeared to trail him.

Though his walk had been both exaggerated and captivating, I felt my panic rise with each aggrandized gesticulation. In the end, I shadowed the girls in front of me, who were following Guy, as apparently he was called.

On stage, Rex Holt greeted us, smiling broadly. He would become my favorite of the two men, always cheerful and rarely critical. Steady, sandy-haired, and clean-shaven, he appeared to be about thirty years old—middle-aged in my view. He was neither heavy nor lean and, unlike his partner, rather unremarkable in appearance. I discovered later that Rex was comfortably adept at disappearing into a crowd while Guy demanded most of the attention from among their clients and beauty contestants.

Someone passed out lime-green brochures lettered with "Official Guide for Contestants Participating in a Preliminary *Miss America Pageant*." With no time to read, we listened to Guy, who, now standing alongside Rex, had begun explaining the tryout process. Most of us were novice beauty contest contenders. One of the men explained that tomorrow, Friday, we would compete in talent. Evening gown competition would follow on Saturday, culminating with the all-important announcement of ten finalists who would compete next month for Miss El Paso 1971.

I glanced down at the dress and sheet music I evidently

wouldn't be needing now. We had just learned that swimsuit competition would occur shortly. I worried about what to do for the competition. I didn't need to puzzle any longer—Guy suddenly began demonstrating how to walk, pivot, and stand. I couldn't take my eyes off him. When he paused on what he called a "mark," a masking-taped "x" center stage, I quickly looked inside the brochure. "Do not attempt modeling poses before the judges. Carry yourself as the young lady you are and be yourself." One hand on a thrust-out hip, Guy now stood in an exaggerated pose.

I wish I could tell you about my place in the order or how I had felt in the swimsuit competition, wearing my black-and-white one-piece under the bright stage lights, but I can't. In the blur that was to become the first Guyrex Miss El Paso preliminary competition, I can only recall the talent competition and my evening gown. The rest had not mattered.

At home in my bedroom later that evening, I reread the brochure's words several times. The Miss America pageant was the largest scholarship pageant in the world, with over 75,000 girls entering annually and viewed by 100 million people. Talent was the most heavily scored component of the competition.

My talent performance was scheduled for the next day, and quite frankly, I feared it like a blind date. Yet, at least with the date, I could control the outcome, even if it meant escaping an uncomfortable situation. This was different. I had made an agreement, a promise even, to my sorority sisters. Truth is, I never walked away from a challenge or obligation. That simply was not in my nature. Getting myself trapped into a commitment in the first place was another animal. I should have kept my mouth shut.

I found what I wanted in the brochure. "Talent Competition . . . that moment when you and you alone stand on the stage

in complete control. Timing. Not to exceed three minutes. The Miss America pageant in Atlantic City is only two minutes and fifty seconds." The brochure's final admonishment frightened me even more: "Your true personality placed within the framework of your talent act will be your most vital possession in this competition." As always, I felt my inner self withdrawing into my protective turtle-like shell.

I selected "The Green Cathedral" composed by Carl Hahn as my piano piece, the sheet music a gift from my grandmother when I was thirteen years old. She had been a talented, self-sufficient spinster, who earned her first bachelor's degree in 1917, before finally marrying a widower in 1921. The old music piece was a favorite of hers, acquired shortly before my grandfather died of a heart attack after plowing a field on a particularly hot day. Afterwards, my grandmother, with a small child in her care, earned three more undergraduate degrees and finally a master's diploma. One of her degrees was in music, and, as a result, she fostered not only my love of learning but playing the piano for pleasure.

Still, my musical training was sparse. I took only two years of piano, beginning when I was about six. Only one memory stands out. I recall my piano teacher taking my small hand in hers, and closing the fingers into a rounded shape. "Janey," she said, "I want you to hold your fingers just like you would hold a cotton boll."

I had been raised in a farming community, so I understood exactly what she meant. It wasn't that the cotton felt soft—it was all about the husk. If I squeezed a cotton boll, the spiny pod would cut into the delicate undersides of my fingers. I was to hold my fingers so that I played lightly. I can't say I recall much else. The piano lessons ended abruptly because of the family's

finances, though Mother refused to sell her Baldwin Acrosonic spinet piano.

Grandmother used to sing the lyrics to "The Green Cathedral," oblivious to her own labored soprano voice as it strained upward like a turkey vulture, spiraling, and rising in volume with each escalating treble note, before plummeting down the scale in one fell swoop. That hadn't bothered me. Her fingers had played magical chords, freeing my thoughts to the grandeur that must have surrounded this romantic cathedral hidden in a verdant forest of my imagination.

The sheet music was an obvious choice for my talent portion. The trouble was that I practiced it much like I had always played it—imagining whole notes when they were half, pressing the damper pedal too long while pausing to flip each sheet-music page.

The next evening, I walked across the stage toward the upright with deliberate seriousness, pulled out the bench, and settled in to play. I did not give a bedazzling smile toward the audience, exhibiting the required dynamic personality. I dared not look toward the judge. I opened the folder, pulled the sheet music out, and set the folder next to me on the piano bench. I took my time smoothing the pages, already loosened and dog-eared from years of constant use. I certainly had had enough time to memorize the piece, but instead, I held to the habit of playing each melodic line, my near-sighted eyes lingering closely before dropping down to the next measure, much like following a typewriter's carriage return.

Fumbling with some of the keys, I corrected myself at times (I might have sworn silently); otherwise, I plodded ahead with determination. When a page did not turn, I stopped playing completely to flip at it, like swatting away a Texas housefly, the

damper pedal prolonging the last piano chords. No one laughed in the room, though I must have appeared tragically comedic. When the song concluded, I thought I had done just fine.

In the auditorium's shadows, a solitary judge began briskly marking.

Big Girls Do Cry

*E*vening gown competition on the final day of preliminaries was as memorable as the talent competition. I had selected a hot pink velveteen gown, safe by Miss America pageant standards, from my sophomore year in high school. Though wearing the dress brought bitter memories, like unwanted adornments, the dress was wholly mine. I had made it from a McCall's pattern.

Mother had never returned to her home economics classroom after my birth. When, in 1965, I suddenly decided I wanted to learn how to sew, she tried to apply her teaching curriculum. Our fights were epic as I ignored when to baste and where to clip. For every methodical step she demanded I follow, I continued to go by the easy instructions found within the pattern. I finally hauled her Swiss Elna sewing machine into my bedroom, slammed the door behind me, and began making all my school clothes.

Though my mother prided herself on my accomplishments, she had one moment of "I told you so," though she never actually uttered the vindication. One afternoon, upon hearing the telephone ring in the kitchen, I jerked while stitching a seam, catching my finger in the machine's rhythm. The needle ran through my

fingernail, next to the bone, and out the other side. I screamed hysterically as the needle continued to go up and down, transporting my finger with it. My father first burst into my room, took one look, his skin turning a sallow green, and immediately reversed. My mother, however, triumphantly slammed my hand down while turning the sewing machine's wheel clockwise, and my finger released. She hadn't needed to say a word afterwards.

The velveteen dress, made in the privacy of my bedroom, had its own history. My high school teacher asked me to accompany our choir's special performance. Performing the "Battle Hymn of the Republic" did not excite me in the least. My new gown had.

My parents had one sacred rule in our household during the 1960s. I was never to allow a boy in the house when my parents were gone. It goes without saying, a boy was never permitted in my bedroom. I failed on both accounts because of the gown. One Saturday morning, while my brother and I were home alone watching television, a boyfriend came to the front door. I not only asked him inside but proudly took him back to my bedroom closet to show him my dress. Of course, with a little brother, Mother soon found out. By the time my father returned home later that evening, Mother had fueled him into believing that I had committed the worst.

As a younger child, I had endured his spankings, almost always with the thin, leather belt, and predictably after my mother called my father at work to demand I be punished for some daily peccadillo. Two or three strikes on my bare legs usually sufficed, followed by the heart-wrenching, "I don't like to do this, Janey Pooh. I really don't. I love you very much."

As long as I could remember, my father had tucked me into

bed, smelling of cigarettes and Old Spice. Because I begged him to read *Winnie the Pooh* to me nightly, he nicknamed me after Christopher Robin's bear. His hugs and kisses reassured me about my place in the family, while as far back as I can remember, Mother had never even kissed me. I had no idea that she had been competing for my father at that time—even against me. I feared hurting him more than anyone in the world, but I was afraid of Mother.

Together they entered my bedroom, Daddy with the familiar belt in hand. He looked absolutely miserable, but I still expected some sort of fairness, even protection, from him. Mother began her diatribe.

"Until now, you have been like a perfect crystal. But not now! What you have done is make yourself no better than your aunt! Do you want to grow up like her? Do you?"

My dad hung his head even lower as Mother conjured up his sister, and I slowly shook my head no. My divorced aunt lived with a boyfriend.

Mother was a natural bully. Whenever there was a figurative dogpile and she knew she had the upper hand, she piled on with all her might. That was just who she was. If she wasn't winning, she excelled at becoming a martyr, switching to tears over imaginary wrongs. I knew her ploy. In this moment, she was the victor.

"This punishment is to make certain that you never defy our rules again!" Mother nodded to my father, standing alongside her, like a whipped dog himself. Taking cue, Daddy began thrashing me until tiny beads of blood oozed from fiery striations across the backs of my thighs. Mother stood haughtily at my father's side, bitterly glaring at me.

"You will not leave this house until January," she added after the whipping.

"But I promised to play at the military ball!" I blurted out between my sobs.

"Too bad. You should have thought of that." This had been another of Mother's surefire responses.

The following Monday at school, I hid the marks as best as I could by wearing my longest dress since we had not been permitted to wear pants to school. In the end, my dad drove me to the military ball where he waited patiently outside while I solemnly played the "Battle Hymn of the Republic" in my velveteen dress. Then he escorted me home.

On Saturday night, the final day of preliminary competition, I lined up, in between the other contestants, wearing the homemade gown, pleased that it still fit. I weighed about 132 pounds and wore a size 7/8. Not the smallest girl there nor the shortest, I fell somewhere in the middle, which reassured me since I had always been sensitive about my size. Once, after complaining to Mother about how I always had to stand in the back row when we took class pictures, she advised me to get over it.

"Small girls will always be little girls to men," she said. "But not you."

While her comments mollified me, I had been fat-shamed in the eighth grade. I weighed the same then as I weighed this moment, standing in line with the other contestants.

To complete the evening gown portion, emcee Hector Serrano asked each of us the same question to see if we possessed brains to go along with our bodies. A simple question. "Why do you want to be Miss El Paso?"

Of course, I didn't *want* to be Miss El Paso. I entered the contest because I had been asked to participate. Having enough

time to calculate a believable response while other girls answered the question, I delivered some drivel, grinning widely into the blackness of the theater, satisfied with my nonsense, and certain that I had finally shown some personality. Elated with relief, my one-time attempt at a preliminary beauty contest almost concluded. But then we were told to wait.

The judge had already made his selection of the ten girls who would go on to be Miss El Paso finalists. As Guy read the list, I was horror-stricken to hear my name burst through his lips. And even worse, the judging official asked to speak with me.

Billy Don Magness, an experienced judge in local and statewide pageants as well as executive director of the Miss Texas-Miss America pageant, had been the sole preliminary judge. At only thirty-nine years old, B. Don, as he was called, already knew how to run a beauty pageant, how to help a contestant win or place, and how to turn two former dance instructors into beauty pageant godfathers much like himself. Prematurely bald, already slightly rotund, Magness, with a cigar in hand, directed me to sit down at a table across from him. He held up my scoresheet and grinned wickedly at me.

"Let's talk about your talent performance," he began.

I felt an uncertain swell of pride. Though no mathematician, it was obvious to me that I had done well since the talent portion had counted fifty percent of our scoring.

He looked me in the eye—and paused, as if calculating me again—and said, "I want you to know that I counted thirteen mistakes during your piano performance." Again, the grin.

Immediately, my face blushed with embarrassment, and though sitting with my spine straight, I avoided making eye contact. How in the heck had I made finalist?

"And don't *ever* bring your sheet music with you when per-

forming. *Memorize your piece!*" Offering me a charming smile, full of white teeth, he turned to nod his shiny, bald pate at another finalist waiting for her chat, while I exited the table quickly, trying not to cry. I suddenly felt sophomoric in my gown. Even worse, now I had to memorize a piano piece and play it error-free in exactly one month.

It was time to find a pay phone and tell my parents what I had done.

Mom and Dad, their cigarettes' ashes teetering into long, gray snakes over full ashtrays, studied two grainy, black-and-white photos in the *El Paso Times* Sunday morning edition on March 7, 1971. There I stood stiffly with my teeth locked in a frozen smile, my white-gloved arms awkwardly clinching my sides as if I feared being torn away should I loosen any appendage.

Mother said quietly, "Well, I do Suwannee."

Daddy agreed with my mother. "Goddamn," he muttered, a smile pulling at his lips.

Born of a Southern mother, my mother's language was full of hyperbole and idioms. I never could figure out who Sam Hill was or what war Coxey's Army fought. Daddy, on the other hand, had been born and raised motherless in Oklahoma and Texas oil camps, giving him a simpler lexicon. Aside from general cursing, *goddamn* was a primary adjective in almost all his speech.

My parents had no inkling as to the significance of the literature I brought home the night before. They had relegated it to the kitchen table until morning. Later my mother told reporters that she had no idea what the contest had been. Perhaps something at school? Now my parents peered at a glittered banner with bold lettering, pinned from my right shoulder to my left hip, that

read, "Miss Leo's Restaurants." Their daughter was officially a beauty queen finalist.

Crowned Miss Leo's Restaurants in March 1971, I joined nine other finalists representing local El Paso business sponsors. My "raw material" is evident in this photo. Six weeks later, my appearance would be vastly different. (Author's Collection)

Suddenly, Mother's questions assaulted the silence. "When is this pageant?"

"About a month away," I answered warily.

"The brochure says you have to have an evening gown. How much time do we have?" she asked again. I could see Mother's mind calculating, the familiar look of conquest. Clearly, she would make a new evening gown for me, eager for the project.

As for Dad, he saw business opportunities.

Chapter Five

The Business Model

*D*addy perused the photo caption and a news article about the Miss El Paso finalist business sponsorships. As an accountant, he was fully aware of who owned or managed most of these businesses, with some individuals prominent for infamous reasons. The sponsors in 1971 included Amen Wardy's (a high-end department store), Given Paint Company, Harlan O'Leary (a real estate developer), Hilton Inn, Empress Spa, Bowen Company (an industrial engineering firm), Tovar Electric Company, Sheet Metal Products, House of Carpets, and, of course, Leo's Restaurants (Mexican cuisine).

We "girls"—for Guy and Rex never used the term "women"—would promote these businesses for the next five weeks, bringing money to the new pageant franchise—dollars needed to help finance the new Miss El Paso's wardrobe and travel expenses. Already Guyrex Associates advertised over $4,000 in scholarships and prizes. The new Miss El Paso would continue to market local businesses and events as a civic duty to El Paso's commerce and government. The dollar amount in donations would grow to almost double before the second Miss El Paso pageant was even

in its planning stage, as businesses endeavored to become part of the new pageant phenomenon. Years later, when the men used their business model to promote the Miss Texas USA franchise, their winner would earn almost $100,000 in cash and prizes, while the Miss El Paso pageant itself became the country's richest local.

We were also Guy and Rex's trial and errors, ingredients for developing a formula that would promote Guyrex Associates as well. The resulting business model would be cultivated to grandiosity over the next eighteen years, as their final "products" won Miss Texas and finally Miss USA, not once, but multiple times. And safe to say, no local or state pageant in the entire United States would come close to the theatrical productions that the men's showmanship helped create during this same period.

"It's all about the show, glamour, and beauty," Guy said afterward in an interview. "Glamour and beauty will always sell."

Still, beauty pageants were controversial in 1971, especially amid feminism and a push for gender equality. As evidenced by the Miss America pageant brochures—which included prudish rules I was expected to follow—the demise of the beauty pageant appeared imminent in this new age.

So now, each new Miss El Paso finalist represented a business sponsorship, reflecting the current face of El Paso, recently designated an "All-American City." Though the initial list of sponsorships and donors seems innocuous enough, if one looks closer, many of the individuals were Guy and Rex's associates through their involvement with El Paso's Festival Theater, including members of the Lebanese-Syrian American community—the Salomes, Wardys, Abrahams, and Chagras.

Joanne Abraham Chagra, wife of well-known criminal defense attorney Lee Chagra, had been especially involved and planned

to contribute her time to a new Miss El Paso Guild, an organization Guyrex formed to further support income for the Miss El Paso pageant. What is eye-opening, upon further reflection, is that her brother-in-law, Jimmy Chagra, was the registered owner of the House of Carpets, one of the new sponsorships. Yet, Lee and Joanne were the face of the Chagra-Guyrex association, and for good reason.

Jimmy Chagra had garnered an early reputation as a small-time drug dealer, while his brother Lee defended a number of smugglers and associated criminals. At the same time Lee's clientele was growing, Jimmy's exploits also broadened due to El Paso's burgeoning marijuana traffic. Later an FBI most-wanted poster for Jimmy described him as "a carpet salesman, professional gambler, and narcotics trafficker." As a result, the DEA and FBI began scrutinizing all Chagra enterprises and family connections, unjustly suggesting both Lee Chagra and his brother-in-law partner Sib Abraham, Jr. were also drug kingpins through their work as defense attorneys.

At times, a few names on my dad's accounting client register had read like defense lawyers' cases: tax evaders, gamblers, treasure thieves, and even one murderer. Because of these clients' nefarious activities, I had heard not only Lee Chagra's name at home but also the names of other busy criminal defense attorneys, including Abraham and Ray Ramos. For Dad's tax-evasion clients, Wayne Windle was the go-to, the only tax attorney in town. For those clients who killed people, "accidentally" or otherwise, my father could only hope he would not be asked for a financial accounting. But he sometimes was. Such was El Paso. In this Western city, the good guys sometimes tiptoed across a cloudy line demarcating right from wrong with little compunction.

I knew that many of my father's early clients had guarded

pasts. Fortunately, a local banker shared a brief list of other, larger, prospective clients with my father. The banker even helped work out a settlement with a complainant, a former Hereford client, after a constable showed up on our doorstep one evening to serve papers on my father. As a result, my parents' former money problems finally dissipated. Presently Dad's accounting business was thriving, and my mother helped, working some of the monthly books.

"What about piano? I think I'll call Thelma," Mother mused to herself.

Thelma Hurd, the wife of El Paso's Budweiser distributor—and Dad's client—and my mother had become tight friends. She taught piano, a fortuitous association. It suddenly dawned on me that my mother had hijacked my preparation for the beauty pageant. I admit, I put up no defense, relieved to have help with my piano piece and dress.

My father, who had not spoken since his first words of amazement, suddenly exclaimed, "Jay Armes's daughter? This should be goddamn interesting!" The girl in question stood three finalists to the right of me in the newspaper photo.

Evidently the sponsorships were not the only sensational aspects of the pageant—some finalists brought Guy and Rex well-placed publicity. The youngest of the finalists was the daughter of private detective Jay J. Armes, a man well-known for his prosthetic hooks for hands. A year later, Armes would become even more famous after a daring helicopter rescue of American actor Marlon Brando's son out of Mexico. The detective consequently played a small role on *Hawaii Five-O*. Ideal Toy Company would even manufacture an action figure in 1976, modeled after Armes, with detachable prosthetics, various gadgets, and a mobile investigation unit.

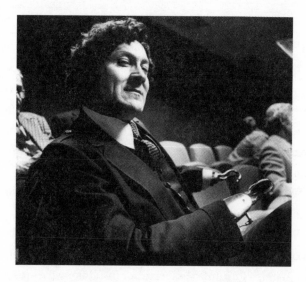

Jay J. Armes, private detective and El Paso celebrity (Courtesy
of *El Paso Times* – USA TODAY NETWORK)

Jay J. Armes, birth name Armas, was well-known in El Paso
for fighting the city to keep an exotic menagerie at his mansion
on North Loop Drive, driving around town in his Rolls Royce,
and of course, deftly using his prosthetic hooks. Guy confided to
me that Armes made him nervous, and clearly, Armes employed
his intimidating appearance when dealing with the public. Still,
both Guy and Armes understood the benefits of good early mar-
keting. Armes's daughter had already been photographed for a
newspaper feature, beaming into her father's face as she handed
her Miss El Paso contest application to Rex Holt.

Now both my parents had something of interest to pull them
together despite their marriage difficulties. Mother had my
makeover to plot, and Dad had an opportunity to broaden his
business associations.

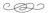

That afternoon, I drove to Guyrex headquarters for a dress fitting, which, unbeknownst to me, would be the first of many fittings during the next decade. The men had not wasted any time. All ten finalists were to be packaged alike—in red, white, and blue—a patriotic parade of pretty young women to highlight the All-American City. With a paper street map to navigate my way, I steered with my left hand, flipping the map in between glances at the Sunday traffic in front of me.

Though the Franklin Mountain swells in the middle of El Paso like a beacon, a compass to all major areas of the city, downtown's streets were a mess to navigate. Like other southwest frontier towns that defined themselves during the 1800s, El Paso had been pieced together much like a log cabin quilt block: a puzzle of narrow streets, some one-way, intersected at right angles with other oppositional streets, until eventually framing a plaza, the heart of the city. Montana Avenue, running east and west, would lead me to the address I sought.

I passed enormous mansions, some quite grand, that gave way to commercial businesses. But the Guyrex office at 1304 Montana Avenue was a surprise, housed in a 1920s foursquare, with two-and-a-half stories of almost 6,000 square feet. The house's top balcony opened above a small, grassy area in front of a glassed first-floor balcony. Standing sentry at the front door to either side were white classical statues. A procession of people flowed in and out through the open door.

I stepped inside the front foyer and paused on a black-and-white checkerboard floor that gave way to burnished wood in a room to my right. The room was full of artsy-looking people. As if to confine them, a ballet barre ran parallel on one wall, bisecting

floor-to-ceiling mirrors—the Guyrex Dance Studio. Black-and-white décor also dominated the main room, with Grecian forms patterned in black-flocked wallpaper hovering over white-wainscoted walls. Aside from the wildly dressed guests, the only other palette color in the room was a live green. Boston ferns and various palms sat on snowy Doric marble stands. Nude statues and other neoclassical art objects dispersed abundantly throughout.

I learned later that the unusual items had been purchased as props for Sun Carnival Parade floats. With only $200 in their pockets, Guy and Rex had recently attended an MGM movie auction in California. There they had won properties used in *Kismet*, *Quo Vadis*, and *Ben-Hur*, though they had intended to bring home Judy Garland's size four-and-a-half ruby-red shoes. Those had sold for $15,000.

Directly ahead I saw my friends Maddie and Gayle talking among other finalists at the foot of a central stairway. Guy stood midway up, a paper in his hand, while a small boy scampered up and down around him. I wondered to whom the child belonged.

After scanning our faces, Guy gave us directions. "Upstairs," Guy explained, "Rex will be taking your fittings for your all-American dresses. You are going to *love* the dresses, girls!" Guy smiled broadly.

This was exciting! We would each have an original Guyrex design. Who cared if nine other people would have the same dress?

I lined up obediently, taking my place behind a girl I did not know. We waited in queue, our arms resting on the white enameled stair railing. Above, Rex called directions to those nearest the second-floor landing. We moved efficiently, each fitting taking only a few minutes. When I got closer to the landing, Rex called out, "When you get up here, go to the room on the right and leave your things. If you're wearing a slip, you can leave it on."

"Wait," I grabbed the girl in front of me. "*Rex* is taking our measurements?"

Nausea swept over me as terror set in. Though I wore a slip, a man was going to measure me in underclothes. My feet would not move. Behind me, the child began jumping down the steps, making a noise that suddenly seemed miles away. I could almost hear my mother's admonishment from long ago.

Chapter Six

Memory Shards

Memories can be beguiling when good. If you have the luxury of time to puzzle the memory pieces back together for the mind's eye, even after all that work is done, the memory may still be faulty with omissions, each rumination colored with emotion. But if the memories are abhorrently jagged—like shards of glass—and you must digest them suddenly, they may force unwelcome pain, repugnant smells, and even gut-wrenching fear to bubble out into your reality. That is what was happening to me.

Alarm overtook my brain as I stood just below the second-floor landing at Guyrex headquarters, waiting for my measurements to be taken. The velvet gown had not been my first fall from perfection. That had happened when I was only seven years old. A neighborhood teenager sexually molested me.

I can remember everything—if I will it so. I was curious about the high schoolers who walked home from school in front of our house every day. They all had bulky, white socks—bobby socks—whether they wore jeans, their cuffs rolled up, or colorful circular skirts. I wanted a pair of the big-girl socks to roll above my tennis shoes.

His jean's cuffs were rolled up. I also remember a madras-plaid shirt and my brother's shouts during a hide-and-go-seek game under the willow tree.

What I remember most is being tossed into the large Mamie-pink bathtub in scalding, hot water in the beautiful, tiled bathroom of our new pink brick house. With a soap bar and washcloth, Mother vigorously scrubbed the imaginary filth out of the rosy pores on my small body. I remember looking up at the recessed lights in the ceiling that I had known from experience could be shattered with a splash of water on the hot glass. If I could just splash some water above her head, high enough to tap a light, the bulb would shatter with a tinkling and end her concentration on washing the stain from my reddened skin. Instead, I sat dumbly, unsure of what I had done. I only knew that I had been bad.

In the background, my dad yelled to my mother that they should call the chief of police, a friend of his, a fellow poker player. "That goddamn boy should be arrested!"

But my mother was cautious. "No, if we do that then everyone in town will know what happened. Janey will be tainted."

In the end, nothing was done. My mother scolded me for obeying a stranger, allowing him to touch me. But I knew something more was wrong, and so had my teachers when they sent me to the principal after I could no longer pay attention in class.

The girl in front of me released my hand from her arm. She grimaced, "What are you doing? You have nothing to worry about, don't you know?" She leaned down and peered in my face with a smirk and said, "They're *queer*!"

I paused to let this revelation sink in. I certainly knew what *queer* meant. The term *gay* hadn't been common in my world

during the 1970s, and in polite conversation one did not discuss one's sexual orientation. I was also tremendously inexperienced, largely because, in all these years, my mother rarely had direct, substantive, personal conversations with me, particularly concerning sexuality. My life's lessons had been given in a series of metaphors when I asked questions. After sixth grade, I just stopped asking. Later, when the appropriate time came, in my mother's purview, an informative pamphlet appeared on my bed. But there had been nothing about this.

Conflicting thoughts about Guy and Rex's sexual orientation swirled in my brain. Was I the only person who hadn't known the boys were homosexual? Was this even true? With a flushed face and ashamed of my naiveté, I tentatively moved up the steps, pondering this newest possibility.

In the end, I stood rigid in my slip while Rex sat back on his haunches with his yellow measuring tape. He moved quickly and expertly, gently wrapping the tape around my small bust, then sliding the tape down to my midriff, and finally tightly around my hips. When he finished jotting down the measurements, he looked up at me and smiled broadly.

"We're done!" he announced and called for the next girl. It was as if he had just taken my temperature, read the results, and written a scrip. Still, my face burned with shame, even as my legs, feeling like thick logs, carried me back to the bedroom used as a dressing room. To be fair to Rex, I had never gotten over the handling of the molestation and subsequent years of fat-shaming. My fears and humiliation had arrived at a new height of angst.

As for Mother, she never mentioned the molestation until I was decades older, and even then, her first inclination was to minimize the event; she finally and quietly admitted, "I didn't think you would remember," the words scarcely escaping her lips.

Other girls had remained in the bedroom, whispering and gawking at themselves in a gilded mirror hung on olive green and orange wallpaper. I pulled my clothes off the matching bed-spread, stepped into a corner to avoid scrutiny just as I had tried to hide in the PE locker room years ago, and put my dress back on. I had no idea that within weeks, I would lose my fears along with my modesty. The other finalists and I would all appreciate the artistic abilities of Guy and Rex. No longer would any aspect of their personal and professional lives be novel.

Even my parents, who had guarded my life so carefully, would completely trust Richard Guy and Rex Holt. Years later, I learned that this was par for the course for most contestants and their parents.

Nine days later, on March 16, 1971, all Miss El Paso finalists were on display for our first public appearance after the Festival The-ater's newest production, *A Streetcar Named Desire*. We arrived in our new Guyrex dresses, designed with sleeveless, high-collared bodices and decorated with red, white, and blue daisies. Circular skirts of white chiffon swirled above satin underskirts, all rolled with fancy French hems. We were uniform with short white gloves, white pumps, and our banners. Guy and Rex intended us to be judged as a group for the next month. The Miss El Paso pageant would winnow the wheat from the chaff later.

I had wondered at the speed in which our dresses were sewn. Only later did I learn about the Mexican seamstresses and seam-sters, many of whom crossed the international Santa Fe Bridge every morning to work on buzzing sewing machines in the Guyrex Associates' warehouse on Texas Avenue. Guy and Rex imagined the designs and selected the fabrics, Rex did the measurements,

and the Mexican men and women made the dresses from scratch patterns.

A post-performance party receiving line had formed, including actors, the director, and set design staff, to welcome theater patrons, many of whom were members of the Festival Theater Guild and new Miss El Paso sponsors. *Southwest Clubwoman Magazine* and local newspapers were on hand to honor the talented cast members and the city's well-heeled, dressed in velvets, organdies, silks, and minks.

It became evident to me that this theater—its actors and patrons—made up Guy and Rex's world, a sphere of imagination and exaggeration that appreciated and employed their artistic geniuses. Just five months earlier, the men had been privileged to decorate a dressing room for actress Julie Adams in advance of her special performance in *The Prime of Miss Jean Brodie*. Local papers covered an opening-night gala and theater party for Adams, also hosted by Guy and Rex. Festival Theater actor and volunteer Barbara Barrington handmade and delivered over two hundred unique, personalized invitations to the event. She had become Guyrex's newest assistant and possibly had been the one to suggest purchasing the Miss El Paso franchise.

A former Miss El Paso herself in 1962, Barbara had a brief career as a classical ballet dancer and model. Now she stood among us, dressed in a hostess gown, her five-feet-nine-inch height accentuated by jet black hair pulled up tightly into a bun. Quite slender and because of her carriage, Barbara seemed six feet tall. Except for a smallish mouth, Barbara's facial features were generous on her ivory skin. Black, arched brows like blackbird wings floated over luminous hazel eyes and a dominant nose. Barbara Barrington stood out in any room.

Barbara would become an early mainstay for Guyrex. When

there were disagreements or misunderstandings among the men and their contestants—and often there were—she bridged the rift between the girls and the pair of overly creative, and often inflexible, men. When Guy or Rex remained entrenched in whatever decision had caused an issue, she provided countenance for anyone who needed to vent. I imagine this worked both ways. Perhaps later, after Guy and Rex became more experienced in pageantry, tensions lessened. But in the present, Barbara had become our lifelines and a welcoming face for Guyrex Associates.

She greeted the patrons, gliding across the floor in small sweeping steps, her floating arms attached to soft hands. Her index fingers extended slightly among her other elongated fingers, tilting upward like an art study. She drew the guests to us, positioned like flowers in an arrangement, placing us in height order, the tallest girls in the middle, with the remaining girls descending in height on either side. I stood in the seven position, not too tall and, blissfully, not too short. Preferably Miss America finalists were at least five-feet-five-inches tall, an inch below my height, though no set standard existed. Phyllis George had been five-feet-eight-inches tall. So, Barbara instructed us how to stand taller, half of us with right feet and toes outward adjoining the other half, who stood in an opposite position.

With the introduction of each patron, it became abundantly clear that one of the Miss El Paso finalists was a favorite daughter of the Festival Theater Guild. Six months earlier, Molly Coyle, a petite, five-feet-one-inch tall blonde, had sung and danced her way to winning the guild's annual Best Actress Award for her roles as Liza Doolittle in *My Fair Lady* and a schoolgirl in *The Prime of Miss Jean Brodie*.

While I may have sensed a thumb placed on the scale for weighing who was selected as Miss El Paso finalists, I knew in my

heart that we were a motley group. Molly stood out with her talent and, of all of us, clearly deserved to be a finalist. At the time, I certainly had no knowledge of her intimate friendship with Guy and Rex, that Guy had been her escort to the Festival Theater's awards gala. With Molly, I wouldn't have to worry about winning a contest that I had no business entering in the first place.

Patrons sidestepped down our receiving line, champagne in their hands, and offered mundane comments. Other chatter around us melded with chamber music emanating from the background, competing with a string of new introductions, including a few socialites who would play a role in my future. Several girls snickered as El Paso's Bozo the Clown walked in the doors with his wife, though television personality Howell Eurich arrived in evening dress and without his schtick, his red nose, and his little dog Puffy. Someone shoved a drink in his hand, and he lined up to meet us. With the arrival of El Paso's local television weatherman and clown, I relaxed, the fitting for the dress I presently wore forgotten.

Truly this was the beginning of Guyrex's ascent to fame. The evening's activities were a prelude for a whirlwind of social engagements, personal appearances, and beauty and poise training that Guy and Rex would use to elevate the new Miss El Paso pageant.

At home, my mother contentedly imagined my new competition gown, oblivious to the new life lessons I was receiving at the expense of my academic education. Her final design would provide the basic pattern for future competition gowns worn not only by Miss El Paso, but Miss Texas and Miss America. Mother, too, thought outside the box.

Chapter Seven

Home Stretch

*O*ur next public appearance was the following Sunday after-
noon at the horse races in Anapra, New Mexico, adjacent to
El Paso proper and Colonia Rancho Anapra, a slum neighborhood
in Juárez. Despite El Paso's acceptable vices, gambling was illegal.
When Sunland Park Racetrack opened in 1959, its small azure
lake uniquely situated within the dirt track, straightaway Juárez's
racetrack had a competitor. Until then, the nearest American
racetrack was located in the Downs, in Ruidoso, New Mexico,
about 140 miles to the northeast. Now thoroughbred and quarter
horse farms and training facilities, following the lazy Rio
Grande, inundated El Paso's Upper Valley.

An "El Paso's Miss America" horse race was programmed
strategically late in the day, the ninth race, just before the derby,
which was the main event. A $9,000 purse awaited the derby's
victor. Heavy gambling and drinking had already been in
progress when we arrived, along with Barbara, Guy, and Rex, on
the windy, spring day. By the time the gates flew open for the
horses to race the derby, $220,570 had been bet, the largest one-
day haul so far that year.

Typically, I would have gone to the paddocks to watch the horses before they saddled for the race, dismissing racing stats and forms. I enjoyed picking winning horses by their appearance and behavior. I had been to Juárez to watch the dogs run, but, unlike horses, they all looked the same to me. It suddenly dawned on me that the grandstand's rowdy crowd of about 3,500 fans, with beers and margaritas in their hands, likely viewed us in the same way—by our looks and walk.

I poked a girl next to me, to tell her my epiphany, but she was concentrating on the conclusion of water acrobatics in the small lake in the center of the racetrack. The wind whipped up waves, and ski boats bounced up and down like fishing bobbers in the choppy water, now turned to muddy brown, while skiers tried to board ski platforms. Then a racetrack attendant signaled for us to proceed in a line toward a white fence at the track's perimeter. Wolf whistles caught in the breeze, followed by more respectable cheers when we stopped next to the track.

The sporting fans saw a disparate group of women. The tallest finalist was five feet, nine inches tall and the shortest five feet, one inch. Normally, we were four brunettes, five blondes, and one brownette, but on this day, two of the girls wore wigs to overcome the wind, changing their hair color.

I secretly wondered if Guy or Rex had whispered in B. Don Magness's ear concerning our selections. "Pick her," they might have mouthed, or "Not that girl, we can't fix her," adding, "We can't hide the figure in a swimsuit, and we can't create talent!" Or "Don't judge them on how much their clothes cost or their makeup or how their hair is done. All these things can be given to them later."

"Judges shouldn't support someone who's a trained seal," Guy would declare later. "I say to the judges, 'Say this three

times: The product is beauty, the product is beauty, the product is beauty!'"

By 1975, when Guy and Rex were more experienced and confident pageant and business managers, their opinions became more succinct. Once, after Guyrex managed only Miss Universe pageant contestants with no talent expectations, critics caustically observed the pageants were no more than "meat" contests. Guy would indignantly claim that "My beauty queen is a salesperson; *that's* her talent."

Presently, the Miss America *competition* (it's no longer called *pageant*) continues to have talent competition. Yet it has eliminated competition in physical appearance (swimsuit), instead focusing on each *candidate's* (they are no longer called *contestants*) voice and social advocacy. Candidates' sashes contain only the names of the states they are representing, the "Miss" having been dropped.

But, in 1971, the Miss El Paso finalists, wearing their gender identifiable sashes, were singers, dancers, drummers, piano and guitar players, comediennes, and models, and we were all applying for the job of Miss El Paso, part of the Miss America pageant scholarship program.

Spectators in the stands might have recognized a prominent district judge's daughter, a policeman's daughter, and an El Paso Natural Gas Company inspector's daughter, an experienced beauty contestant. Of course, there was also Molly Coyle, "Best Actress" during last year's Festival Theater season, and Marlene Armes, private detective Jay J. Armes's daughter. The others, like Maddie, Gayle, Shirley, and me, were less experienced with no political or social connections. We contrasted well for the audience, just like the parade of horses now entering their gates for the ninth race.

"And they're off!" The horses had sprung quickly at the buzzer's sound. The race was long—one mile—and a spine-tingler. We stood by the fence, the setting sun's rays glaring on the sides of our faces, as we tried to follow the blur of colors on the back stretch. By the time the horses had breached the home turn, the announcer's voice rose a pitch with excitement.

"And down the stretch they come! It's Rustle Up, now ahead by a length. Now two lengths!"

The horse called Rustle Up had opened a two-and-a-half length lead ahead of the 2-to-1 heavy favorite, a horse named Cheju. Rustle Up was a long shot at 12-to-1 odds.

"Dawn's Dandy in third, Sizzlin' Round in fourth, and . . ." The voice trailed off in a gust of wind. "Wait! Lewis has just put Cheju into drive. It's still Rustle Up, with 100 yards to go. And here comes Cheju!"

In the end, the favorite, whipped up to speed, won, and the long shot Rustle Up took second place. I wondered if this was how the Miss El Paso pageant would end, a community favorite winning over the rest of the long shots.

With the race concluded, we lined up on the track in our all-American dresses, just as Barbara Barrington instructed us. Sand dervishes danced at our feet and wisps of hair caught in our fake eyelashes while we tried to hold our white skirts in place. Somehow, we had been able to freeze for a split-second photo with Lewis, the winning jockey, who, remarkably, was shorter than Molly. Behind us, the American flag blew hard, the wind drowning out cheers from the grandstand.

Our appearances continued with just three weeks to go before the Miss El Paso pageant. Several days later, we were guests at a buffet lunch and wedding gown fashion show at Hilda Harrell's home. Hilda, a wedding planner, also reported for the *El Paso*

Herald Post's society page and would record notable events in my life later. She was also Barbara Barrington's experienced stage mother.

My mother had been able to attend her first function as a finalist's parent, and Hilda rewarded her with a newspaper description the following day. She reported that Mother, in a pink frock, looked like a beauty contestant herself. I'm certain my mother, upon reading the description, was secretly pleased that her neighbors saw the article as well. I know the event to be significant because she placed both our orchid corsages in the refrigerator when we returned home. Life at home presently appeared to be on an even keel, and I dismissed any worries concerning my parents' increasingly unsettled relationship. Looking back now, I realize that these short months were but a Band-Aid to a marriage festering with distrust and jealousy.

The El Paso Chamber of Commerce and the mayor's office also invited the Miss El Paso finalists for special presentations. After we were noted for our civic support at a chamber meeting, a photographer grouped us around a music set. He placed me at an ebony grand piano. I gently touched the keys, marveling at an instrument much finer than the one I had at home.

Miss El Paso finalists present uniformly at an El Paso Chamber
of Commerce meeting. (Author's Collection)

Later, the same photographer also took a photo of Mayor
Bert Williams in his office handing me a new marketing resolu-
tion for the city. Another finalist, the judge's daughter, stood
strategically on the mayor's other side.

The last time I had been in that office was in October 1965,
the fifty-year anniversary of the Girl Scouts. A different Mayor
Williams (Judson), in honoring Scouts, invited my troop to his
office, the same room we stood in now. I promptly threw up in
front of him. Too much excitement, my mother had explained,
after the alphabet soup came up.

No squeamish stomach this time, the photo caught me grin-
ning, my white-gloved hands sharing the proclamation with the
mayor. "El Paso—You're Looking Good!" it read.

If it weren't for the piano lessons, being a Miss El Paso final-
ist had not been so bad after all, I decided.

Chapter Eight

Trip Wires

Two nights before the Miss El Paso pageant, I awakened to the sounds of missiles exploding to the northeast of our house. The Army's White Sands Missile Range, and McGregor Range especially, announced scheduled missile testing regularly to the public. If we drove out Highway 54 on the floor of New Mexico's Tularosa Basin toward McGregor during the daytime, we could see white contrails go up, and sometimes curve down, before ending in small white puffs upon impact. Night was different, with most tests scheduled around two o'clock in the morning. I waited for more booms. Though they never worried me, sometimes the house rattled softly.

My brother and I had grown up with the knowledge that unexploded ordnances were a danger in the desert where we played near our Milagro Hills neighborhood in Northeast El Paso. Even a mock Vietnam village, where soldiers trained, was situated not too far away. But, I had been more afraid of my mother with a pistol, who also woke me up in the middle of the night during one of my parents' blowouts. My mother was sobbing loudly, and when I climbed out of bed, rubbing the sleep out of my eyes, I surprised

both my parents in their bedroom. Mother was pointing a pearl-handled .22-caliber pistol at my father. I froze—and tears began running down my face. Mother immediately put her arm down, and Daddy held me in his arms. They both assured me nothing was going to happen. Later, when I snooped in their bureau, I avoided the drawer where the pistol lay.

Now fully awake, I reflected about a different explosion that had occurred days earlier and how it related to my future.

Kabooooooom! The tinkling sounds of glass shards hitting the pavement had awakened me from another drowsy stupor. I had barely left my 8:00 a.m. class in the Liberal Arts Building on the UTEP campus, sleepwalking in the direction of my US history class in Magoffin Auditorium. All the front windows in the auditorium and those in Old Main had just shattered. The jolt temporarily froze students around me, but no one ran. A guy beside me muttered with slight admiration, "It's those crazy bastards again." We glanced southward toward Globe Mills's silos.

Despite a recent Weathermen's protest bombing at the nation's capital, we weren't especially worried about our campus's bomb threats, now a common occurrence. If someone had an exceptionally horrifying exam, for example in Spanish, and I am not saying who that person might have been, all he—or she—had to do was tell a particular UTEP athlete, and he would call in a bomb threat. Problem solved. In my adult hindsight, I realize calling in a bomb threat on a college campus during the unstable atmosphere that permeated America in 1971 was obviously insane. But we had no fear.

Earlier that morning in full view of UTEP's early risers on campus and in honor of the university's roots in mining and the

patron saint of engineering, some boys had ascended the lofty, historic silos, situated next to the Rio Grande and El Paso and Southwestern Railroad tracks. There they painted a green cloverleaf and "TCM" on the silos' summits. It was March 17, Saint Patrick's Day, also known as Texas College of Mines (TCM) Day.

Everyone knew the engineering students were responsible. Engineers *were* crazy, and I didn't know anyone who dated one. Obviously, they had underestimated the charge they set. Now, the tagged silos, along with another ragged TCM, in large kelly-green letters on a field of white, and running up a flagpole in the campus commons area, no longer seemed ominous. But, my class had been canceled.

There was yet another reason I had not slept well. Final exams were around the corner, and I wanted to continue to make the dean's list. I took a heavy load for a freshman, seventeen hours, and enjoyed studying for my history and English classes—that is, until the Miss El Paso business. In my ignorance, I had not weighed any disadvantages and obligations if I competed in the Miss El Paso pageant. Even if I had, Guyrex Associates was not your average beauty pageant business.

Now Guy and Rex's demands were sabotaging my coursework. The irony that the Miss El Paso-Miss America competition was a scholarship pageant had not been lost on me. Still, with a photographic memory, I could avoid tripping up on my other course exams, even if only reviewing my notes or textbook one time. Unbeknownst to me, fall semester 1971 would be the last time I would excel in school. I was about to settle into an unfamiliar realm, a fourth dimension of academic mediocrity, earning the first C's in my life.

Preparation for the upcoming Miss El Paso pageant *had* been good for my mother, and we had been getting along well too. As a

stay-at-home wife, her day typically began with a cup of coffee and then some gardening. When she wasn't working on my father's accounts, she did a few household chores, though typically these were mine or a Mexican maid's. Mother cooked terribly, but she possessed an extraordinary green thumb and creativity that transferred to all sorts of artistic endeavors. Ironically, to earn extra household income, she had just finished teaching a sewing class at the Northeast YMCA, on evenings alternating with Richard Guy and his ballroom dancing classes in the same building. The two artistic geniuses never crossed paths.

When not sewing or gardening, Mother spent leisure time in a coffee klatch with neighboring women and then repeated the social affair with them again at the end of the day, only with a Scotch and water—or two—before my father got home and wanted his round of cocktails with her. Through eavesdropping, I learned what she thought of me by the third-person accounts she gave to her friends and later to my father. I called them the Bastille Street Ladies' Club. To say that they were gossips is an understatement. Unfortunately, a couple of the women were familiar with my father's affairs, knowledge that, when coupled with other catty gossip, would cause problems later. Mother had recently updated them with my travails and shared her design for my competition gown.

My new dress would be red, not just Crayola red, but flame red. Few women in the Miss America pageant had worn bright colors up to this point. The contestants' bland gowns, when grouped on stage, were typically a washed-out sea of indistinguishable pastels. Mother determined that my dress should be bold, so different that I would stand out like a firecracker despite my poor piano playing. She designed a low-necked and sleeveless bodice gathered in soft chiffon, a wide, ready-made, ruby and

golden beaded band crisscrossing between my breasts and wrapping around my waist to my back. The gathered skirt was one layer of chiffon over a red satin underskirt. The design appeared simple but elegant. A local shoe shop had satin pumps that could be dyed to match the dress.

Dad, also busy, called his clients to see if they wanted to purchase tickets to the Miss El Paso pageant and help fill my parents' table there. Astoundingly, tickets were $50 a couple, over $350 in 2022 dollars, with a Las Vegas-style dinner show guaranteed. His entourage began to expand quickly since the novel pageant attracted lots of attention in the newspapers. Already, posters with all of us posing in our red, white, and blue dresses, wearing our banners, were strategically placed around town. They read:

El Paso's

MISS AMERICA BALL & PAGEANT

APRIL 10

7:12 p.m.

HILTON INN

FEATURING

RCA'S INTERNATIONALLY FAMOUS

CONCERT & RECORDING ARTIST

ROUVAUN

Star of CASINO de PARIS

DUNES HOTEL and COUNTRY CLUB

LAS VEGAS, NEVADA

Tickets Available at

Guyrex Associates

1304 Montana

533-5279 / 755-2603

AN OFFICIAL *Miss America* PRELIMINARY PAGEANT

Guy and Rex had booked the finalists for as many public
appearances as they could cram in before the Miss El Paso
pageant. Local papers and their society page editors then duti-
fully publicized the events to the public, supporting Guyrex's
attempts to marry the beauty pageant to El Paso's All-American
City theme.

"We expose the girls to this type of activity," Rex wryly noted
later, "[because] when you are a little college girl, you don't ex-
perience this kind of thing." The men wanted public appearances
to compensate their sponsors and to sharpen all-important social
skills we might be lacking. I am certain now that his new wisdom
transpired because of me and our upcoming explosive relation-
ship.

After all, I was only eighteen years old.

I had my frustrations too. In trying to meet Guyrex's expec-
tations and please my parents both, I was losing the race that
truly mattered to me—my academic studies in pursuit of a degree.
Obviously, I couldn't run with the hare and hunt with the
hounds.

Now, lying in bed, besides the usual nightly noises, the muffled
rumbles in an unusually peaceful household comforted me. Was I
ready for the competition? My new gown hung in the closet, and
my last piano lesson with Thelma Hurd, on a Steinway baby
grand in her home music studio, had occurred earlier that day.
Thelma had selected a classical piece by Enrique Granados titled
"Playera" or "Spanish Dance No. 5," a fitting choice honoring the
city's history. Still, with my limited formal lessons, the piece
challenged me. Thelma had not been deterred.

Tall and willowy, Thelma possessed an acerbic tongue, which

she consistently applied to her husband Charles, owner of El Paso's Budweiser distributorship, when we accompanied them on fishing trips to Arizona and New Mexico. Besides the ever-present reminders of anything Anheuser-Busch in our household, my favorite recollection of Thelma is with a glass of white wine in one hand, her long, pale legs extending out of Bermuda shorts, cat-eye sunglasses posed on her turned-up nose, and sarcasm flowing out of her lips. Because of her directness, I worked with her nervously at first, but in the end, it turned out my mother had made another wise decision. Thelma was a perfectionist, a professional at converting a passable piano player into a near-perfect performer. Never derisive, she patiently pulled the best out of my fingers.

Yes, I was finally ready for the Miss El Paso pageant. After its conclusion, I would be able to return to my studies and normal life. Content, I rolled back to sleep.

Chapter Nine

The Pink Dress

The contestant posed dramatically in a slave girl costume, just as if she were in Technicolor like actress Yvonne De-Carlo in the old movie classic *Slave Girl*, with a leashed cheetah stretched beyond her bare feet. She had been singing "Born Free," and the large cat, apparently too tame—or too drugged—to care that its leash, taut as a hangman's noose, yanked upward. There had been quiet tittering, of course, but not too much. The performance was original, and certainly no other Miss El Paso finalist could later claim to have given her human audience a brief moment of primal fear. Besides, her father sat conspicuously near the dais.

Dressed handsomely in a black tuxedo and grinning proudly at his cheetah-tamer daughter, Jay J. Armes sat with his wife at a round table near the stage, she in a bedazzled white evening gown that accentuated her Asian beauty. His empty plate still sat before him. Moments earlier curious onlookers, glancing surreptitiously in between bites of their own meal, had observed the detective's own performance as he finished off his steak dinner using his specialized hooks for hands.

Armes had years of practice using the prosthetics. He was a small boy when he and a friend broke into a Texas and Pacific Railroad Company section house and stole some railway torpe- does. When Armes rubbed two of the torpedo sticks together out of curiosity, they detonated, resulting in both his mangled hands being amputated. And now, Armes, comfortable with his celebrity curiosity, clearly enjoyed the public's attention, though most locals afforded him cautious leeway, if not a certain degree of respect.

My parents, too, sat proudly near the Armes table, awaiting my talent performance. With them were the Stanley Marcuses, owners of pawn shops in town; the John Yerbys, owners of El Paso's Standard Oil Distributorship; and of course, the Charles Hurds, with Thelma on pins and needles. We were partners in my talent competition after a month of piano lessons in her studio. My sponsors, Mr. and Mrs. Willie Terrazas, completed the group who would be rooting for Miss Leo's Restaurants. All were my father's clients, except for the Terrazases. My father would likely change that.

Sitting next to my father, Mother, in a pale blue gown, beamed victoriously. This was just as good as being in Las Vegas with their old Hereford friends. Even better, her methods of child-rearing were validated. She looked toward my father. A handsome man in his own right, he wore a dark suit, his knees uncomfortably bent just below the table's edge. Scandinavian blue eyes, framed by long eyelashes, were generally what people first noticed about my father's tanned face. That, and his smile. He had wavy brown hair, thinning on top, which thickened slightly just above his ears. There, trimmed sideburns accentu- ated long smile lines from the outside corners of his eyes to his chin. When someone said how much I looked like my mother, I

quickly pointed out the error of his or her judgment. I clearly took after my father. We had the same wide smile.

On the other side of Armes's table sat Lee and Joanne Chagra at the House of Carpets table. A consummate high roller when not representing El Paso's hard-core criminals in court, Lee was clad head to toe in black, his dark hair and eyes adding to the allure of his gambler persona, known in Las Vegas as the "Black Striker." To complete his Wild West look, it had been rumored that Joanne had given him an ebony cane with a golden satyr's-head handle. I don't recall the cane, modeled after the one that Bat Masterson carried on the television series, or Lee's customary black cowboy hat at the ball. Instead, I clearly remember Lee's handsome appearance, his broad smile, and large personality. I liked him—and Joanne, too, a petite, vibrant go-getter who helped produce the pageant, also dressed in black.

Joining the Chagras were Tati and Sue Santiesteban. One of Lee's best friends and a former defense lawyer, Tati was presently a Texas state senator and another charismatic personality. Among others rounding out the table were El Paso bail bondsman, Vic Apodaca, and his wife Kris. Like Sib Abraham, the FBI would taint Vic unfairly later, primarily because of his business associations with the Chagras. Kris, a former model, sat at his side, exquisite, blonde, and stylish, while Vic Apodaca, with his large bulk, beard, and heavy head of thick black hair, intimidated me. Though he had not bought a sponsorship, Apodaca had purchased a full-page ad in the forty-two-page Miss El Paso program, advertising "professional surety" in five Texas cities.

The Crystal Ballroom at El Paso's Airport Hilton Inn had been transformed into a cabaret. A runway coursed down the center of the ballroom, among the glittering, red-and-white round tables, crowded with spring flowers adorned in blue satin ribbons, lit

white tapers, and champagne and wine glasses. Cigarette smoke wafted toward the ceiling from most tables, conspicuously hazing the stage lights lining the dais and runway. Darkness extended beyond the lights, toward the back of the ballroom near side meeting rooms, now repurposed as dressing rooms, where we contestants prepared and waited for our turns to compete.

Below the runway to one side, Lou Barton's musicians sat relaxed in their chairs, instruments ready to accompany contestants when cued. In front of the orchestra, stairsteps led to the top of the runway where an emcee and his microphone stood. Rex, also outfitted in a black tuxedo, stood at the foot of the steps, inhaling deeply from a cigarette. A chain-smoker, the habit salved his anxiety. Guy, on the other hand, was a wreck, his small face pinched with a pained, worried expression. He took anxious drags on his own cigarette in between pacing to the dressing rooms, stage, orchestra, kitchen, around the tables, and back. His behavior caused apprehension among some of the contestants. We feared making mistakes and ruining his show. Fortunately for us, Rex smiled words of encouragement as each of us waited our turns to compete.

So special was this evening that, in exchange for each $25-a-plate contribution, six hundred guests received hand-delivered, gold-leafed ceramic invitations to commemorate the inaugural event.

The "boys," new owners of the Miss El Paso franchise, were in the process of executing a stunning extravaganza. Announcement of the winning Miss El Paso would be the climax of the special night. More significantly, this one production, by itself, would help propel the men into the path of the Miss Texas-Miss America pageant's movers and shakers. The new Miss El Paso would cement the deal.

I had arrived earlier in the evening, along with my parents, wearing my red, white, and blue finalist dress, in anticipation of the first act in the pageant's program. The opening production number would be a choreographed parade of Miss El Paso finalists, under the guise of "El Paso, You're Looking Good!"—the city's new motto. My dress had not been cleaned in a month, and I imagined it looked just as spent as I felt. We had been to eleven functions in four weeks. I dreaded wearing the dress this last time in the choreographed number. I also dreaded the upcoming swimsuit and evening gown competitions, interview, and especially my talent performance. I dreaded being me—here—in the Hilton Hotel grand ballroom with my parents, who believed their wayward daughter was back in line, as they comfortably ordered their drinks, smoked their Salems, and chatted proudly with all who stopped at their table.

In the dressing room later, after the production number, I fumed again, this time in front of a mirror that disgustedly revealed my fine hair wilting with each passing pageant minute. I hadn't dared to put it up. The last time I did that, I paid three dollars for my hair to be pulled up and crowned with curls at a Juárez beauty shop, like Audrey Hepburn wore in the movie *Breakfast at Tiffany's*, but—the Mexican way—lacquered stiffly. When a desert sandstorm hit the city afterward, just as I called my mother to come pick me up at an outdoor pay phone, my new do turned to a curlicued sand sculpture. Lesson learned.

While listening to the small talk around me, I tucked a good luck charm into my bra between my breasts. My grandmother, upon hearing that I had made finalist after playing "The Green Cathedral," sent me a fairy stone, a piece of staurolite crystal,

formed naturally underground into a perfect cross. Thought to bring good luck to the wearer, I prayed for its protection—no tripping, missed stairsteps, errant musical notes, cuss words, or unladylike bodily functions. Already my stomach had begun gurgling with hunger. None of us had eaten dinner.

We began changing for the talent competition while former Miss El Paso titleholders were introduced, including Guyrex assistant Barbara Harrell Barrington. She had been a nineteen-year-old when she made finalist at the 1962 Miss Texas pageant, quite a feat. And, she was also the last Miss El Paso. I wondered if the former beauty queens had tummy tucks and facelifts in preparation of their introductions, as opposed to the augmentations they withstood in their younger years—false eyelashes, fake hair, and their small breasts squeezed into cleavage, taped into place, and padded with falsies under the corsets they wore. *Nothing worse than a faded old beauty queen*, I decided, grimly smiling to myself. I went back to adjusting my hair at the mirror when Barbara floated into our dressing room, silencing the girls' chatter. Of course, she excepted my rule about old beauty queens.

"Hello girls. Anyone need help?" Barbara smiled through pink lips, her face porcelain below her black hair, piled in ringlets on the top of her head—*like Audrey*, I thought. No one answered. All of us, our mouths agape, stared at our handler.

Barbara wore the most beautiful dress I had ever seen. Layers of pale pink chiffon swirled into a soft cloud that flowed from an empire waist. Pink silk roses—so tangible as if to exude fragrance—adorned the low scooped neckline and covered the entire bodice. Adding contrast, tiny rosebuds with green velvety leaves peeked out among the larger flowers. The brief sleeves, too, were even round mounds of roses, pulled down over Barbara's soft, white shoulders. A Disney princess's dress, a Cinderella or Snow White

creation, so magical was its appearance—only without the little bluebirds flying around the wearer. This was no Guyrex gown, but a fairy tale reverie, wholly individual in design and materials.

Later, when Barbara walked among the tables where El Paso's finest sat, wearing costly Guyrex gowns, trademarked by an abundance of sparkly jewels and beads, the socialites queried her about her dress. Barbara smiled and explained, "No, this is *my* design. I designed it, and I created it." She had made the dress just for this pageant and her Miss El Paso alumnae introduction.

As for me, I had never seen a dress so romantically lovely, and like others in the Hilton Inn Crystal Ballroom on April 10, 1971, I envisioned how I would look in the pink dress.

Chapter Ten

Presenting Miss El Paso, 1971

The Miss El Paso pageant talent competition was in full swing. I stood in the darkness watching my sorority sister Maddie, Miss Given Paint, on stage. She was concluding a modeling skit that she wrote. Not a singer, dancer, pianist, nor any other typical performance artist, she cleverly illustrated her talent as a seamstress and clothing designer. Wearing a patriotic-colored prairie dress with a red dirndl waistline, Maddie narrated a solo fashion show, talking all the while as she transferred her ensemble—stripping down into a midi, then a gaucho with vest, next a mini, revealing tall white go-go boots, and finally, a pair of flowered hot pants. The audience, especially the men, roared their approval.

Before Maddie and Marlene Armes had been Marty, Miss House of Carpets, wearing a folksy white blouse and azure checkered skirt. Marty sat on a stool with her guitar, and in popular music style, sang Peter, Paul, and Mary's "Leaving on a Jet Plane." The tallest of all of us, a striking brunette, her résumé also included piano, dancing, and modeling. The crowd at the Chagra table burst into whistles, cheers, and applause when Marty concluded, canceling the plaintive song's lingering mood.

Then there had been Shirley, Miss Hilton Inn, another of my sorority sisters who triumphed over most Zetas' earlier preliminary pageant entries. This had been no surprise since Shirley studied voice on a music scholarship. Like Marty's, Shirley's music selection had been gloomy. Wearing a jeweled pink crepe gown, Shirley sang "One Tin Soldier," a Vietnam War protest song.

There won't be any trumpets blowing
Come the Judgment Day
On the bloody morning after
One tin soldier rides away.

If not for emcee Serrano's comical interjections between talent acts, the hotel staff would have had to hand out tissues to the audience, now mellow with wine, full stomachs, and depressing entertainment themes.

Well-known around El Paso as a seasoned actor, choreographer, and dancer, Serrano was a close friend of Guy and Rex's. Tall and reed thin with thick black hair, he wore even thicker black glasses, giving him a serious, studious look. But, when Serrano opened his mouth, to joke with the audience or tease the contestants, he brought levity to the pageant's production. He also choreographed the Miss El Paso finalists' opening production number, so we had gotten to know him earlier, another familiar face besides Rex, at the point of no return—that is, the head of the runway. Serrano was the last person we saw after our ascent to the platform before we competed.

Glancing quickly at his information card, Serrano introduced the talent act just before mine, though he knew the performer intimately. Molly did not walk out to the stage, but waltzed her way, arms stretched out, drawing the audience to her as she sang

"I Could Have Danced All Night" from *My Fair Lady*. The act was the same one she had performed at the Festival Theater the previous year, the one for which she had received a Best Actress Award. Though Molly stood petite, her performance was huge. I shouldn't have watched. Molly had revved up the audience, many of whom were Festival Theater patrons. I was next.

Rex patted me on the back as I slowly climbed the steps to the runway. I nodded at Hector Serrano, and then carefully navigated my way in dim lights to a grand piano that had been rolled onto the center of the stage. I sat down at the piano's bench, touching the cross hidden in my bra as the spotlights brightened, when Serrano announced, "And now we have Miss Leo's Restaurants, Miss Janie Little, performing Enrique Granados's 'Spanish Dance, Opus 5, No. 5,' also known as 'Playera.'"

I gave my best smile in the direction of my parents' table, though they, like the rest of the audience, sat somewhere in darkness beyond the stage lights and my vision. I stared at the piano keys with no sheet music in front of me. If I could just begin my piece, I knew the song's spell would capture me. I tentatively began the first few "grace" notes with my left hand, rolling the bass keys. Instantly my fingers went to work, setting a quick rhythm required to transport a dramatic theme my right hand would bring to life. The music began swelling, carrying me along with its wistful echoes of a Spanish love dance—a melody that made people close their eyes, allowing the piano chords to swathe a romantic ambience around them. Trancelike, I played on, forgetting who I was, where I was. Then it was over.

The audience clapped loudly and enthusiastically when I stood and bowed. The elephant that had been sitting on my chest had finally stood as well, and my body relaxed, freeing a deep breath to sough through my lips. Or maybe it was B. Don Magness's

smirking face dissolving before my eyes. I had made a couple of minor mistakes, but Magness did not sit at the judges' table this time and I doubted he would have caught the small errors anyway.

Swimsuit competition passed like a whirlwind, our individual poses and group judging taking little time. I stood in line with the girls and obeyed Serrano's instructions—"turn left," *pause*, "turn back," *pause*, "turn right," *pause*, "turn forward." We endured each suspension while the judges assessed and compared our figures, making notes. A former boyfriend nicknamed me B. H. Pinky when I worked as a swim instructor at the YMCA, the moniker becoming a sensitive issue. I had worn a pink bikini and tended to be bottom heavy (BH). Now, we posed with our backsides to the audience in the glare of spotlights.

Worse, the fairy cross let me down when I turned left instead of right, abruptly facing the girl next to me. Unfortunately, it was Marty, and the audience laughed when I looked first at her throat directly across from my nose, and then slowly up into her surprised eyes. I felt my chest and face flush, knowing there would be a trail of red splotches afterward.

On stage, Rouvaun, the entertainer flown in from Las Vegas especially for this event, took over, beginning his rendition of "Granada," while we prepared for the final portion of the Miss El Paso pageant, the evening gown and interview competition. We changed into our gowns with enough time to take deep breaths before parading down the runway for the last time. We pivoted on marks taped to its floor, while smiling into hot, white lights. Soon, everything would be over—the preparation, stress, and my parents' mutual enjoyment of my activities. This pageant had drawn them together—again—and their annual accusations of infidelities, too much Jim Beam, and their children's imperfections seemed abandoned for the moment.

At last, I joined the line of the other chiffoned women mid-stage, all of us wearing our sponsor banners, but only I stood in a brilliant red dress. The interview round commenced, consisting of a variety of questions, some serious and others superficially shallow. It really didn't matter. Unless a contestant totally muffed her answer, most judges already knew the order on their scorecards. Our judges were Miss Texas pageant dignitaries who took their charge seriously.

Every other aspect required by the official Miss America Scholarship Organization had been met—a talent competition worth 50 percent of the scoring; a swimsuit competition, worth 25 percent; and now the evening gown competition, coupled with the interview, rounding out the final hundred points. The new Miss El Paso would go on to the Miss Texas-Miss America pageant in Fort Worth in two short months, and Guy and Rex would prepare her uniquely. We waited, wondering who that girl would be.

Then Hector Serrano called out Miss Congeniality, and my sorority big sister left the line to receive red roses and a trophy. Gayle, her face painted and dressed in a red-and-white polka-dotted clown costume earlier, had performed a lively modern dance but was rewarded for her natural affability. Now we awaited the naming of the top four finalists.

Immediately, a drum roll undulated, crescendoed, and faded. Serrano played the audience—and us—heightening the suspense. We stood, white-gloved arms tense, left feet back and right toes forward, waiting. It's a wonder none of us fainted. A motley group of inexperienced girls a month earlier, we were packaged like Tiffany gift boxes, readied for the big reveal. The illusionists, Richard Guy and Rex Holt, I'm quite certain, held their breaths, too, no doubt hoping the judges had selected a winner that could

transform easily into their first Guyrex Girl. After what seemed an hour, Serrano, judging that he had sufficiently whet the appetite of the audience, opened an envelope and began reading its contents.

"When I call your name, please step forward," he commanded. "These names are not in any particular order," he added, smiling at the audience. The drum roll continued, softly, *pianissimo*. I scanned for my parents. *I wonder what they think now.*

"Miss Laura Katherine Fant." The audience clapped. I had expected Kathy to place. Tall and brunette, she had performed a two-part rendition to "A Patch of Blue." Another pregnant pause.

"Miss Molly Coyle." More applause. *Of course.*

"Miss Anita Waller-Ney." Anita had performed "Sunday Morning," a drum solo. She took her place next to Molly. I had been fascinated with Anita's hyphenated name.

One more name to be called out. About this moment, hope surprisingly swelled within me—hope that I might be named one of the runners-up. The past month with Guy and Rex had been an amusing novelty, but maybe this wasn't just a lark with my sorority sisters after all. I really was a competitor at heart. I had just gotten a slow start. My stomach began churning.

"Miss Jane Louise Little." I froze momentarily before stepping forward toward the lights. One scarlet dress illuminated in a field of pastels. *Is this really happening?* Everything could have ended at that moment, and I would have been perfectly happy. But there had been more.

"Okay, girls. It's time to name the new Miss El Paso!" Yes, the four of us had held hands just like all those other sappy beauty contestants on television. I always figured that they probably hadn't really liked each other by this point in their competition, even hoping that the girl standing on either side of them would suddenly faint, or better yet, throw up. I suddenly feared I would

be the one vomiting, as my stomach lurched. It had happened before.

"Third runner-up, Miss Anita Waller-Ney!" The audience clapped hard as Anita received her flowers, obviously disappointed. Another Serrano pause.

"And second runner-up, would the lovely Miss Kathy Fant step forward?"

Like a punch in the gut—my wind sucked in, and I couldn't breathe. Afraid to look at the contestant who just slipped away from our newest lineup, the familiar flush began spreading once again from my chest to my face like fire. The audience applauded hard, not for the second runner-up, but for me and the other girl left standing on the runway. She brushed up against me, and I turned to look, my knees locked. It was Molly—our heights noticeably disparate, like the cartoon characters Mutt and Jeff. Quite frankly, I had never considered the rewards of winning. But, in a space of minutes, all that changed, and with it, my life's path. Now I desperately wanted to win, though in March, one month earlier, I certainly couldn't have cared less.

Hector Serrano revved his voice up a notch as he once again signaled the ubiquitous drumroll. It seemed to last forever. Then he found his words.

"First runner-up, Miss Jane Little—and the new MISS EL PASO 1971 . . . Miss Molly Coyle!"

My knees weakened, and I hardly remember being whisked away from Molly with a bouquet of yellow roses and a first runner-up trophy thrust in my hands. I felt numb. It was over.

Molly's tears streamed down her face. She had danced and sung her heart out. Richard Guy, beaming proudly, and a laughing Rex Holt immediately hugged their winner, even as an official Miss America crown was pinned to her head and red roses placed

in her arms. Guyrex Associates would have no trouble with this winner. If they could just stretch her some.

Rouvaun began singing "Somewhere My Love," and dancers took the floor. I had already danced once with Lee Chagra when Tati Santiesteban asked for his turn, both men congratulating me on my night. Afterward, Rouvaun switched to a Frank Sinatra song, still accompanied by Lou Barton's orchestra, the music exciting and upbeat for once tonight. From the corner of my eye, I saw Jay J. Armes rise and begin to approach me.

Suddenly I felt an arm around my shoulder.

"Janey Pooh, would you like to dance?"

Daddy smiled broadly down at me, revealing the small gap between his front teeth that I loved. We walked out on the dance floor while Mother watched from the darkness.

Chapter Eleven

Bastille Street Ladies' Club

I woke up Sunday morning after the Miss El Paso pageant feeling relaxed—free from sorority obligations and my parents' most recent invasion of my life. It was just three weeks until finals, and I had to ace my tests to ensure making the dean's list again.

After exams, my family would caravan to Elephant Butte Lake for the Memorial Day weekend, an annual ritual at the desert lake signaling the beginning of our summer season of water skiing, tanning, and fishing. Though my parents struggled with each other in their tumultuous partnership, they somehow managed to create cocoons of recreation, woven with outdoor activities with our friends whose parents shared like-minded distractions but who also appeared indifferent to my parents' marital problems. My parents' troubles had just been part of life—calm mixed with an occasional tempest, nothing to worry about. Weren't other families similar with small day-to-day dramas?

The morning paper had run an obligatory photo of Molly Coyle, not in her Miss El Paso-Miss America crown but in street

dress. The newspaper's society writer reported that Molly had said that she had been "overwhelmed," and that when she and I were the last two contestants standing, she became numb. Otherwise, the runners-up had been endnotes in the short article, including that I had done a "professional job playing the piano."

Mother wasted no time sharing all details of the evening with her girlfriends in the Bastille Street Ladies' Club. And at least one of them was getting sick of hearing about *Janey this* and *Janey that*. Mother couldn't see it yet, but her adult women friends were beginning to behave like thirteen-year-olds. A catalyst was about to propel the entire family in a direction no one foresaw.

It was finals week at the University of Texas at El Paso. I drove from the Porfirio Díaz exit north onto I-10 near campus in my canary yellow GT Mustang convertible. The car's top was down, errant Charcoaler's hamburger wrappers and various other paper items fluttered loosely in the floorboard, and, I am ashamed to admit, a few even swirled up and out.

On KELP, an AM radio station, Derek and the Dominos were singing "Layla," and I joined them, my voice fading into the warm, afternoon breeze that whipped my hair around my sunglasses and into my eyes. Fortunately, on this lovely Tuesday, May 4, 1971, Steve Crosno, El Paso's most famous disk jockey, chose the extended version of the song.

When I arrived in front of our house about thirty minutes later, Dad's gold Cadillac was already sitting in its customary place in the small driveway. Like most of the pawnshop's used electronics and jewelry Daddy presented us, he brought home a "new" car every two years. The Cadillac, though several years old, was his most recent acquisition, and safe to say, there was no

similar car on Bastille Street. Since my father only came home early before lake trips on Fridays, curiosity, more than panic, immediately propelled me into the house.

"Here!" Mother called, sounding gleeful in her one word. She was sitting tilted in a homemade redwood Adirondack chair on the back patio while trying to balance a drink and a cigarette in her hand. Hot house palms and red hibiscus framed her chair, and beyond, a lush Eden hid our stone property wall.

My mother was made up, something she normally didn't do on any day when she puttered in her flower garden. She had even combed and sprayed her short bouffant hair. A fuchsia-lipstick smile was stuck on her face. I immediately became suspicious, my newly liberated spirit dissipating. She looked like the proverbial cat that had just eaten a canary.

Though it was still early in the day, Dad had already changed into Bermuda shorts and was sitting in a matching Adirondack chair near a side table he had also built, his bony knees extending above crew socks and white tennis shoes. Cautiously, I sat down, facing my parents, on the perimeter in one of our old metal yard chairs, its pale-yellow paint flakes sticking to the undersides of my knees. Now I was in a nauseous sweat.

"Molly Coyle *resigned. You're* Miss El Paso now!"

"I'm *WHAT?*"

Mother continued, almost breathless. "She's getting married or something like that. *Everyone moved up one place!* We have to go to Guyrex—*now*," she said breathlessly, standing. "*They're waiting.* Go find your evening gown. Wait, wait, we have to do something about your hair," she added, after noticing my windblown locks. Dad remained quiet and didn't rise. I couldn't discern what he was thinking, and that bothered me.

Molly Coyle had been Miss El Paso for only three weeks. In

that brief time, she collected her $500 college scholarship, a
wardrobe of red, white, and blue clothes, and a hairpiece from
the House of Wigs. She had flown to Fort Worth to meet Miss
Texas officials and other city contestants and walked the stage
and runway where she would compete for Miss Texas in July.

She traveled to Austin as well, as an El Paso emissary to
support "El Paso Day" and a "Taste of Texas" celebration at the
Governor's Mansion. She sat in session at the state capitol,
watched legislation pass, and stuffed her mouth with Central
Texas barbecue. She presented Texas Governor Preston Smith
with a cowboy hat and to other state officials, sombreros and
red-and-white ashtrays that said, "El Paso, You're Looking
Good!" And now, Molly had quit.

Forty-five minutes later we joined Guy and Rex at their
house on Montana Avenue. Guy looked absolutely miserable. His
mouth smiled, but his expressive dark eyes betrayed his hurt
feelings. I felt sorry for his disappointment, believing he had bet
everything on Molly. Rex, ever the pacifier, reassured my parents
that I would get a scholarship too. Molly had returned most of
her prizes. Still, I would not be able to wear her clothes, and the
men would be out money as a result.

I changed into the scarlet evening gown that Mother had
made while Rex fussed with getting the official Miss America
crown clipped in my thin hair. Guy positioned me at a jaunty
angle with an official scepter in my hands in front of the house's
black-and-white flocked wallpaper. I forced a timid smile for a
newspaper photographer while white statuaries teased my fake
coronation.

I don't know why Molly withdrew to get married. Perhaps
she had no choice. Perhaps the contest had been a gambit, her
only goal to prove she could win. Perhaps the ambitious role Guy

and Rex set upon her was not what she anticipated. It didn't really matter what the reason was. I accepted a crown too late to enjoy the initial accolades. I felt sorry for myself, even angry, at being shorted. I had no way of knowing that the title would leave an indelible mark on my life and Guy and Rex's careers as well.

The next day's newspaper story mocked my situation even as it provided more fodder for Mother's bragging rights. She had given a detailed interview to a reporter and basked in every word captured for her friends to read. According to the paper, I was a "new breed" of beauty contestant—"beauty AND brains," espoused the article. I was carrying eighteen hours at UTEP (actually only seventeen) and had been on the dean's list, doing my studying at night. A string of academic achievements followed, which Mother had certainly provided. Not only that, but the paper reported that I had been the arm-wrestling champion of our neighborhood. I was aghast. Worse, because of becoming Miss El Paso during finals week, the story was now a lie. My grades were about to plummet.

Fragrant red-and-yellow rose bouquets began arriving, covering Mother's hard rock maple dining room table, along with congratulatory cards from sundry Texas state politicians and local businessmen. Newspapers also showed an immediate interest, reporting my stats in advance of the upcoming Miss Texas pageant. Typical of evaluating women in the twentieth century, my appraisal consisted of my body's measurements: height, 5'7"; weight, 116 pounds; bust, 36"; waist, 22"; and hips, 36". And like my GPA, these attributes were largely untruths, if not deliberate exaggerations. The El Paso Times also reported that I had been a student of piano for ten years (only two years); I had graduated at the top of my class in high school (I ranked fifth); and because I was an arm wrestler and water skier, athletic (definitely untrue!).

Lest neighbors should forget other tidbits about me, a few members of the Bastille Street Ladies' Club made certain that a history of my juvenile delinquency leaked through a stealthy rumor mill. This was partly my parents' fault. Mother had confidently shared rearing her flawless daughter, righteous in her parenting skills. Not surprisingly, it was natural that someone should look for cracks in my perfection, just as the city of El Paso oppositely began endorsing my new activities publicly and proudly while my mother gloated.

My sophomore year in high school had begun with the whipping over the pink velvet gown but ended in a six-month restriction. In between, my mother was bold in controlling all my activities. When she was not getting enough daily intel through personal direction of my extracurriculars, she drove to my high school campus, parked on a side street, and used binoculars to watch me between classes. On one occasion, when one of my friends pointed her out, Mother ducked down to hide on her station wagon's vinyl front seat, her elevated bottom compromising her position. Afterwards, my friends formed human buffers to block her view.

When Mother's daily reconnoiter failed, she resorted to invading my privacy while I was away from the house. No doubt a calculated gift, she presented me with a Christmas diary where I felt immediately obliged to bare my deepest feelings. Then Mother secretly read every word.

To make certain I never talked to a particular friend, the one I had invited into our house to see my velvet gown, she explained to a classmate that she needed her assistance in reporting my activities. Mother emphasized it was for my well-being. Amaz-

ingly, the classmate complied. And this is what led to my last childhood downfall and the most recent Bastille Street Ladies' Club gossip.

I, along with four friends, had become founding members and officers of a local Tri-Hi-Y, a girls' service organization affiliated with the YMCA. The move would look good on our college résumés, one parent had advised. At an annual membership party, we were to kidnap new inductees to join our club and deliver them to a slumber party afterward. Instead, we had a side stop distraction. After piling into a large white Oldsmobile belonging to the only one of us who had a driver's license, we passed a house where an upper-classman beer party progressed. The boys were playing drinking games and never saw us enter the yard.

Unnoticed, we loaded an entire case of hot beer, one opportunely sitting in an open garage, into the trunk of our car. We proceeded to drive down desert streets, boldly tossing almost full cans of beer out the windows. Imagining we were getting inebriated, we giggled at our cleverness. Later, the classmate, whom my mother enlisted to spy on me, ratted.

And while my parents called each parent about their daughters, certain that others were to blame for my transgression, I was the only one grounded for six months. Stripped of our Tri-Hi-Y memberships, we apologized publicly. Teenage sinners in a Christian organization—I had even been the chaplain.

The women in the Bastille Street Ladies' Club had known the juicy details of this event—because Mother proudly bragged about how she had dealt with me. They gossiped behind her back to mutual friends, neighbors, and other residents. This gossip, coupled with rumors regarding my father's extramarital flings, was designed to hurt my mother and not me.

Mother told me years later that the first time my father

cheated she had been six months pregnant with my brother. An-
other neighbor, in another small neighborhood, rushed to her
door to give Mother the devastating news—that instead of playing
golf on Wednesday afternoons, my father was having an affair.
Mother indignantly ordered the woman out, denying that my
father would ever stray. To admit her husband cheated would
devalue my parents' social standing in the small town. Instead,
she beat Daddy's favorite putter against our house's pink bricks
until it was crooked as a dog's hind leg, providing what she called
a "small measure of satisfaction."

A litany of infidelities continued after the family's move to El
Paso, several too appalling to share. Other events, looking back
now, seem less deplorable. One evening, my father took the family
to dinner at a new client's Italian restaurant. The owner, a beau-
tiful woman who looked much like Sophia Loren, came to the
table to meet the family. I recall how she looked at my father, and
my mother's polite unconcern, when Daddy excused himself to
discuss a business item in the client's office at the lady's request.
We had finished eating by the time Daddy finally returned to the
table. I was barely a teenager, but I knew—and so did my mother.
The night Mother pointed the pistol at my father, and subsequently
burned their old love letters to each other, was the result of yet
another betrayal. Yet, Mother stayed with my father, once telling
me in a rage that if she had to choose between us kids and Daddy,
she would choose my father. He was her weakness, and no number
of cocktails could drown the desperation she lived with daily
while she struggled to keep him.

Now my father finally had an excuse to isolate my mother from
the neighborhood where gossips knew too much about his activi-
ties. As for my mother, she could wave goodbye to the duplicitous
neighbors with satisfaction, even as El Paso newspapers became

enamored with Janie Little, Miss El Paso 1971. A family move was imminent after living in our small Bastille Street house for over eight years.

Even more astonishing, while my parents searched for a property, Mother uncharacteristically turned me over to a new set of custodians, a total abstention of parental responsibility. To be clear, my mother was never a stage mother, and now Guyrex Associates would conduct every aspect of my life.

Chapter Twelve

The Art of Illusion

ichard Guy, Rex Holt, and Barbara Barrington studied my reflection in the floor-to-ceiling mirror in the Guyrex Dance Studio. I felt like a tiny bud under intense magnification by people who hoped that with close examination, they might discover unique qualities proclaiming me a newly discovered flora that only needed a bit of nurturing to bloom. The Guyrex team, however, was about to be disappointed with this first inspection—I was still plain Jane Little. As a result, they were about to experiment with a challenging flesh-and-blood composite that would eventually become recognizable as a Guyrex Girl.

After a decade of manipulating future contestants' natural attributes into the Guyrex vision of what a beauty queen should look like, the men would recognize that individuality is truly the best attribute a girl can possess. And then, Guy would finally say, "If you're doing *Playboy*, let's have *Playboy*. But if you're supposedly doing a beauty pageant, why pad? Why glue?"

For me, there would be padding and gluing. Only later would Guy and Rex realize that they should have been enhancing what a girl already possessed, and that symmetry of form trumped the

sum of a woman's measurements. Unfortunately, those epiphanies would take years to appear. The three now analyzed their raw material.

Rex brought a scale and measuring tape downstairs. Despite what newspapers reported, my actual weight was 132 pounds and my measurements 34-24-35. Guy bluntly declared, "Oh my God, she's fat!" Any semblance of courtesy and respect for my feelings disappeared with my parents' abdication of my best interests. But Guy was smiling. Was he teasing? I looked in the mirror at Barbara's face, and she was laughing along with Rex.

Barbara was rail thin, her long body perfect for a New York runway, while I, on the other hand, was short-waisted and hippy. After discussion, it was decided that I would move in with Barbara, who would prepare my diet. Coupled with daily exercising that she would also provide, Barbara vowed she could get inches off.

"How many inches?" Guy asked. The men planned to design two evening gowns for multiple night processions at the Miss Texas pageant, another for the evening gown competition, and a dress for the talent portion. Apart from the suburbs in the Fort Worth-Dallas area, where most Miss Texases were bred, often small-town chambers of commerce awarded their beauty queens a paltry sum, usually $50, to purchase an evening gown and swimsuit and sent the girls on their way. Clearly, Miss El Paso would be vastly different from all of Texas. Her wardrobe would be extensive and micromanaged by a pair of imaginative men intent on the art of illusion. Fort Worth was in for a surprise!

"Three inches?" Barbara offered. I realized that Barbara was a pleaser, too, a kindred spirit. Guy and Rex considered the new goal while I decided an inch all the way down was possible. But that is not what the fellows had in their heads. Guy was still not sold.

"Can we get her waist any smaller?" Guy asked.

"Well, she can wear a Merry Widow under her regular dresses, but not the gowns," Barbara said.

The year I was born, Maidenform began producing the Merry Widow, a misnomer for a tortuous corset that, unlike the old Mae West look, was intended to squeeze wasp-waists while separating breasts. My mother still wore a girdle, but I had never seen her in a corset, which in my mind was something my grandmother wore along with her stout, black shoes. Just two years earlier at an anti-Miss America pageant demonstration, protesters called all bras, corsets, and girdles "instruments of female torture," arguing the articles were "enforced femininity."

Yet, in Hollywood's pop culture during the 1960s, despite the women's liberation movement, femininity still reigned, and anyone could identify actresses who wore corsets, many wearing their cone-shaped breasts pointed directly outward like armored missile tips. Since Guy and Rex loved everything about Hollywood costuming, Barbara's suggestion was immediately accepted. But the popular corset didn't address my evening gown measurements.

"Let's see where we are in a few weeks, and then I'll sew the waists smaller than Janie's actual measurement. We can zipper her into the gowns to get the effect we want," Rex said. I was aghast with the plan, but I remained characteristically silent.

Barbara also explained that wearing two-inch heels would improve my height since I was only five-feet-six-inches tall. Under Barbara's supervision, I could practice walking, modeling turns, and posing every day in the dance studio wearing the shoes. Doing specific ballet exercises would also strengthen my calves so there would be no wobbling or tripping.

The trio moved on to my hair, Guy noting that it was too blonde. "*Everyone* is a blonde now—*boring*! We *have* to make Janie different."

It was the era of the Summer Blonde, and even though my hair was naturally light, I, too, had streaked the popular product in my hair, activating the bleach in the sun's heat while I tanned. The team decided that darkening my hair to an ash color, using a "reverse frost" or what today we would call "low lights," would make me stand out among the blondes and brunettes on stage. Afterward, Diane Salome's House of Wigs could match my new hair color with hair pieces to augment my fine hair. The men did want me to continue tanning for a healthy, girl-next-door look.

"What about Janie's talent?" they mused.

Rex noted that Phyllis George had won the Miss America pageant playing, "Raindrops Keep Falling on My Head," from the recent *Butch Cassidy and the Sundance Kid* movie.

"What's most popular in the movie theaters now?" Guy asked.

The idea that I would not play a classical piece but a pop selection suddenly piqued my interest. I eagerly spoke up, "I can play 'Love Story.'"

The movie of the same name, with Ali MacGraw and Ryan O'Neal, had been a blockbuster release the past year. Barbara clapped her hands while the others looked at me, evaluating what I said. Suddenly we had a four-person conversation.

As it turned out, Guy had a friend who could pull movements, ranging from the *Love Story* theme itself to Mozart and a waltz from the movie's entire soundtrack, and compose new orchestrations to bridge them together. I was set except for having to wait for the new composition, and only then would I be able to practice and memorize our designed medley. There wasn't much time.

The next day, I moved into the Barrington household in East El Paso. Barbara's husband John was a dour-faced man who appeared to be at Barbara's beck and call. He was a good sport about sharing the house with a total stranger, as far as I knew, and

managed the couple's two small children when Barbara worked with me. Still, I was acutely aware that I was an intruder. After my first diet dinner in their house, John leaned over to me and said, "I'm sorry about your meal. Barbara's used to this. She's like sleeping with a bag of bones at night." I flushed, embarrassed that he revealed the intimacy.

Barbara did know all the tricks of the modeling trade, it was true—how to lose weight, stay thin, and maintain energy that a former professional ballet dancer such as herself would have had to employ. The next morning, I looked at my plate—one egg, fruit, a piece of dry toast, and a vitamin. I was starving, and the meal did nothing to fill me up. I depended on the caffeine that one cup of coffee provided.

By lunchtime, I was famished, and my energy waned. After dinner, all I wanted to do was go to bed. I was grateful for the preparation of my meals, but realistically, maintaining my strength and thought processes on what I soon discovered was a 900-calorie daily diet was hardly sufficient. Soon, a diet pill was added to my regimen to alleviate my failing energy level.

I don't recall whose idea it was to give me amphetamines, but I was naturally drug sensitive, and the pills began to play havoc on my emotions. I began to clash with Guy and Rex.

Chapter Thirteen

Rebel with a Cause

The days that followed were tedious. Barbara had my breakfast ready early so that we could go to the Guyrex Dance Studio for the morning's exercise class. There I stretched on the ballet barre, and together we did demi-pliés, strengthening thighs and calves. Afterward, I practiced walking in high heels with Barbara stopping me every so often to drag her finger up my spine to the top of my head.

"Janie, imagine you are a puppet," she said with her finger pushing on my crown. "A string is attached to the top of your head, pulling you up. Your carriage is important. No slumping. Stand straight!" I had become a good slumper in seventh grade when I towered over the boys in my class. Breaking the old habit was difficult.

The sensation of Barbara's touch jolted me upward, but pleasantly. *Take a deep breath*, I told myself. *Tuck in my belly*. The tightness worked to control my balance as I walked in circles, made turns, and pivoted on the balls of my feet like a professional model. We also practiced sitting, that is, how to sit like a lady. Barbara demonstrated how I should cross my ankles and not my knees.

Barbara Barrington, a former *Vogue* model and professional
ballerina, worked tirelessly to help train new El Paso and Texas
Guyrex beauty queens. Here, she illustrates how to sit "like a
lady." Later she co-founded the Barbizon School of Modeling.
(Author's Collection)

Walking and posing for swimsuit competition was another
Barrington minicourse, though I wasn't really supposed to model
per the Miss Texas pageant handbook. The footwork was difficult
for me since I was as pigeon-toed as a polar bear. Walking in
high heels was an accident waiting to happen. We practiced how
to stand for swimsuit competition—how to position arms to con-

ceal body flaws. In my case, the job was to minimize my hips while enhancing my small waist. I stood tall with the imaginary puppet master pulling the crown of my head upward, stretched my neck taut, sucked in my stomach, tucked my buttocks, and pushed out my chest. If that wasn't enough to remember, I also placed my right foot in front of my left foot in a modified ballet third position and turned my right shoulder back just slightly so that my right arm rested along the side of my hip, concealing any unwanted inches. My left shoulder, on the other hand, was positioned behind me, and my left arm placed behind my left hip to reveal my waist.

"Good job!" Barbara called out. "Just remember to look natural and smile!"

"Look natural, for real?" I protested. In time, however, I was able to do the swimsuit poses in a blink of an eye, moving naturally. Barbara was a great teacher of poise and beauty as it turned out.

After a light lunch, we addressed other tasks related to preparation for the Miss Texas pageant. We went shopping for accessories, had dress fittings, and had hair and makeup sessions. Diane Salome showed me how to hide a human-hair fall, now dyed to match my new hair color. A former Miss Venezuela plucked my eyebrows for the first time, illustrating how to measure a triangle for each brow, using an eyebrow pencil. Barbara taught me how to apply false eyelashes, using eyeliner to extend the outside corner of my cat-shaped eyes.

I studied, too, preparing to be El Paso's official ambassador to the rest of the state. I reviewed El Paso history, the city's relationship with Juárez, and its geological and meteorological facts. I memorized current economic trends and statistics. I learned everything about long staple cotton, alfalfa, and chilies. And all the while, I was hungry and restless.

I began looking forward to the afternoons when I could get in my Mustang and drive to Thelma Hurd's piano studio. The music lessons didn't matter—it was what I did on the way. I stopped at a Circle K corner grocery store to satisfy my cravings, which were increasing daily. Sometimes, I bought chunks of American cheese. Other times, I inhaled gooey honey buns, hiding the wrappers under my car seat, exhilarated that I was cheating on Guy and Rex.

In fact, I had become increasingly more defiant, to Richard Guy particularly. Rex may have been a soft touch, and Barbara, an understanding confidante, but Guy demanded too much. His habit of gesticulating his moody criticisms was wearing me down. Lately, his hair had begun falling out, and like a mangy terrier, patches of white skin dotted his brunette head as his own anxiety began affecting his health. I didn't care since I blamed him for my starvation. The men may have known how to design and sew costumes and gowns, market themselves, and create sensational floats, but they had no idea how to transform a girl into a beauty queen, as far as I was concerned. I was certainly more than a float ornament. For the first time in my life, I was about to rebel, despite my parents' desires. I looked for a fight, and Memorial Day weekend provided the catalyst.

Weekly, I checked in with my parents, relating all my activities while whining about the Guyrex starvation plan. Mother typically minimized my experiences. "Oh, Janey, you're exaggerating! Just do what they tell you."

Dismissing my mother, I begged Daddy to let me join them for the holiday weekend, our first boating trip of the summer. At the lake, I could get my first sunburn and build it into a golden tan in a matter of weeks. I could water-ski, eat Frito pies, and drink Tabs. Later, beside a campfire, smelling of salt cedar and

greasewood, I could lie on a cot under a clear, starlit sky, and listen to KOMA on a transistor radio. I insisted that I needed this break after three weeks of intense training and the debilitating diet. Ultimately, the decision was left to Guyrex. When I told everyone my plans, Guy threw a fit.

"No way are you going home," Guy lectured. "Besides, camp food will ruin your figure."

I doubted he even knew what campers typically ate. I bet he had never even slept in a tent or eaten a s'more.

"And we don't want you waterskiing. You'll get bruises. You might even get hurt! Then where would we be?" he added dramatically.

So, I did something I had never done in my life to this point—I quit. I quit being Miss El Paso. They could call up the next runner-up. Barbara had looked at me with large, disappointed eyes, and I felt terrible for her after all our work together. Though part of me felt like a traitor, my spirit, much like a piece of elastic stretched beyond its endurance, had snapped. They had whittled me down too much, too quickly, though they, in their newest endeavor, had no clear idea what the final product should be. I remained firm.

After I arrived back home with my luggage, Mother was beside herself and clearly unhappy. She goaded me for "giving up," though she certainly could see the physical changes in my body. Honestly, quitting did not feel as good as I thought it would, but I never admitted this to her. That same evening, Guy began calling Daddy, the phone conversations spirited and emotional. Guy was fully aware that my father was the only person who could sway me. Dad, unlike my mother, defended a break from beauty pageant insanity. Then Barbara took over as a mediator, and not surprisingly, the two worked out a plan. A

day or two later, I received a letter from Barbara, a spiritual note, one she surely intended to be uplifting.

> We falter in our weariness and sink beside the way, but God leans down and whispers, "Child, there'll be another day. And the road will grow much smoother and much easier to face, so do not be disheartened," Janie, "this is just a resting place." Just listen to your father, *he's the greatest man I've ever met.*

I wondered if Barbara knew that the well-known quote was used often as a memorial after a death. The words were apropos. I had been dying inside. Worse, I recognized that, like most women, Barbara had succumbed to my father's spell.

In the end, Barbara succeeded in convincing Guyrex to surrender to Daddy's negotiations. I would remain a contestant if I could go on the Memorial Day camping trip. In return, I promised not to water-ski. Mother would make certain that I had food choices other than Frito pies. I could bury my guilt.

Everyone chilled for the brief hiatus, especially my mother. Unbeknownst to me, she had begun taking her own mood-shaping pills—Valium, popularly known as "mother's little helper"—creating an entirely different dynamic at home.

Before we left for the lake, she blithely telephoned Meston Travel Center in the White House department store in El Paso's Bassett Center, to arrange accommodations for Fort Worth. She wasn't about to let this trip to the Miss Texas pageant slip away. As for me, when I returned to Guyrex after our camping trip, I decided I would be the one in control.

Chapter Fourteen

Transformations

Barbara stepped back and surveyed my new figure after six weeks of the intense diet and ballroom exercise. I certainly felt thinner, and when I looked at my reflection earlier that morning, I imagined my ribs were beginning to protrude in my back. The new measurements confirmed my own assessment— 31-21-32! Barbara's rigorous regime over my personal habits had worked. I lost nine inches total in six weeks, three inches in every measurement. Relief that stealth bingeing on honey buns and cheese hadn't even mattered poured over me.

We both peered at my diminished bosom, but I was the only one suddenly dismayed. The yellow measuring tape had not lied, and the moment was a déjà vu. I now possessed the chest of a twelve-year-old. The last time I had been this mortified, I was with Mother.

It was seventh grade, and several of my classmates' chests had begun to bud. One girl already carried a spectacular set of breasts on her slim athletic build. She certainly wasn't aware of the social significance of wearing a bra while the rest of my

friends and I were. We were desperately envious and soon began begging our mothers for bras.

An ensuing underwear race established our pecking order on the school playground as new bra wearers emerged. Every time a girl triumphantly wore her first bra to school, she also donned a sheer, white, cotton blouse so that all could witness her new transformation into womanhood. Girls would pull and "pop" the back strap through the blouse's fabric as part of the ritual initiation into the sorority of brassieres. I so wanted to join them.

I had studied my own chest and determined that my swollen and tender nipples needed protection. My whining to Mother lasted only a few days when she suddenly surrendered and took me to a new shopping center in Northeast El Paso. In one store, Mother escorted me to a back wall where drab gray curtains hid sizing booths. An assortment of bra boxes holding all shapes and colors were stacked along a counter nearby. A kind saleslady approached us, immediately understanding our mission. She smiled brightly at me.

"My daughter insists that she *absolutely has to* have a bra," my mother said. "I know she's not ready yet. It's just baby fat," Mother spit out.

There it was. I wasn't ready. I immediately felt my face redden with shame, and I could feel the saleslady looking at me with pity.

"Let's see," she said, pulling a measuring tape from under the counter. Together we went behind a curtain, leaving my mother behind to wait. I took off my blouse and endured her scrutiny as the measuring tape wrapped around my bare chest.

Moments later, the saleslady whispered to me, "I know a bra just perfect for you."

I came home with a Teenform Pretty Please Gro-Cup training bra, size 30A, my mother's words still stinging. Eventually, my

pleasure in the special purchase would conquer the mortification that she had thoughtlessly flung my way, but the memory remained. I suspected that I was close to that same size now, as I stood in front of the mirrors at Guyrex headquarters.

Rex saw my face. Like the saleslady years ago, he sensed my humiliation. He smiled, "Don't worry. I can fix that."

I had heard stories about using tape to create cleavage on flat-chested pageant contestants. Small breasts were squeezed and pushed upward, held in place with wide, sticky tape. Falsies then filled the vacuums in bras, creating the illusion of bounteous bosoms. It was hell getting the tape off later.

"I'll sew padded bras into all your gowns. You'll see. It will work," Rex insisted. No torture tape for me.

I trusted Rex's words implicitly. The only caveat was that all my gowns would have waists sewn two inches narrower; this was Guy's decision. The boys would squeeze me into the dresses—just like Mammy had pulled the corset strings tightly on Scarlett O'Hara, the famous, petulant Southern belle of author Margaret Mitchell's *Gone with the Wind*. And just like Scarlett, I would still have to watch what I ate. Just a half-inch extra and the dresses wouldn't zip.

After six weeks of rigorous diet and exercise, I was sculpted into
a first generation Guyrex Girl. Here, I am squeezed into a
Southwestern outfit made of upholstery fabric. My natural waist
was 21 inches wide while most of my gowns were sewn with 19
1/2 inch waists. (Photo by Joe Casarez, Author's Collection)

Without the added stress of having to lose any more weight
and my mother's new nonchalant attitude toward my Guyrex
makeover, I began to relax and enjoy my new status. The city of El
Paso had embraced me wholly. I wasn't exactly liberated, but
seeds of self-empowerment began to sprout. I was learning how
to disagree amicably and not with petty indignance. I was no

longer fighting against a current that was dragging me out to a sea of pageantry competition but, rather, swimming with it to a new terra firma of my choice.

To celebrate the success of my new physical and mental transformation a week later, the boys invited me to go to Juárez and afterwards to their warehouse for fittings. In Juárez, they planned to pick up decorative items for their float-building business. I accepted, curious about the new float themes they were imagining. We drove in their cherry-red van over the Santa Fe Bridge and on to Avenida Juárez, navigating past a slew of dental offices and liquor stores before slicing through the avenue's neighborhood of adult entertainments and small eateries.

I was well acquainted with the northern portion of Juárez's Strip. Two blocks from the bridge, we passed the Kentucky Club, its walls lined with black-and-white glossies of famous guests who no doubt sipped its famous margaritas. I had been to other nearby college hangouts as well, including Alcazar's, where waiters expertly poured red wine down guests' faces and into their lips, and Fred's, famous for its beer and ham sandwiches. This was a safe zone unless an out-of-towner walked out of a bar with an open liquor container. Juárez police were always ready to arrest naïve teenagers, unfamiliar with local ordinances, holding them in an open jail yard until parents paid hefty ransoms to bail them out.

We finally stopped at a warehouse well beyond the bars and clubs, and while Guy and Rex loaded their purchases from the building into the van, I waited outside, delighted to be part of the foray. I had never ventured this far into Juárez, day or night. Other stucco-fronted warehouse buildings were nearby, while beyond, I could see private homes hidden behind walls that were capped with colorful glass shards, glistening in the afternoon sunlight like a maharaja's jeweled turban.

Then the excursion took a different twist when, on the return trip back toward the bridge, Guy suddenly parked the vehicle. We were near the far south end of Juárez's fabled Strip, where a laundry line of neon-bathed storefronts linked seedier 24-hour bars, nightclubs, cabarets, and restaurants.

"Come on! Let's go for a walk. Who knows what we might see!" Guy teased while Rex giggled.

In a blink of an eye, Guy's uncharacteristic spontaneity stripped me of my solid footing. El Paso lore was full of stories about sleazy businesses where no girl should go—places like the infamous Cave, where so-called donkey shows (use your imagination) delighted the perverted, and raunchy strip clubs, where college boys blushed with salacious interest in dark, corner spaces. Surely, the men knew we were in an unsavory part of Juárez.

I was familiar with several establishments outside the Strip's fringes. I knew that City Market was somewhere to the east, though I never paid attention to location when my family traveled there to shop, where we were greeted by desert landscapes and Elvis Presley and John F. Kennedy portraits painted on black velvet. While my brother evaluated Mexican jumping beans, my attention, instead, had been on acquiring another piñata from rows of sundry, paper-frilled shapes hanging on rusty wires across the ceiling.

I recalled that also somewhere to my right was the Plaza de Toros, but I had been there only one time. We left the bullring when I became sickened—whether from drinking a sugary Mexican Coca-Cola or from viewing a mounted picador goad a blood-soaked bull by sticking red *banderillas* (long barbed darts) into the animal's thick, black hide. When I think about it, it was more likely the bull's revenge that had made me ill. The enraged animal had disemboweled the rider's mount, like

a fisherman gutting a Texas crappie, despite the horse's padded protection.

The Guadalupe Mission was also just blocks away to the east. There, ancient wooden stairsteps, cupped with centuries of use, had transported my father and me to the top of the seventeenth-century tower. Local legend proclaimed that the mission's shadow pointed to the location of Franklin Mountain's Lost Padre Mine at noon on a specific day of the year. I personally believed that the mine already had been discovered. A gold ingot had shown up inside my father's office safe for temporary safekeeping, its owner another of Dad's seedy clients. Now, in my new predicament, the proximity of the popular tourist attraction was reassuring.

So, I permitted Guy and Rex to lead me to a new attraction. We passed squatting, stone-faced Tarahumara Indian women, wearing colorless cotton blouses and circlets of bright beads adorning their wrists. Small children peeked from within the faded folds of their mothers' long skirts, their small, brown hands held out for passersby's coins. We stepped over and around rank-smelling drunks sitting on the stained sidewalk with legs stretched out, while others listed sidewise with afternoon inebriation, their eyes closed.

Then Guy abruptly stopped at a red-painted door. Above its header, a neon-yellow-lit sign proclaimed, "Featuring Miss El Paso and Miss Texas!" The boys grinned. I wondered then if this had been the true purpose of our excursion into Juárez. Had picking up supplies been a ruse? A fresh mix of emotions momentarily engulfed me—curiosity tempered with intense incredulity. I admit, I had to see this other Miss El Paso. I timidly followed Guy inside where loud music and tobacco smoke assaulted my senses. Rex snickered behind me.

Pale legs of a Mexican woman wrapped around a lit pole in the center of the dark room while her body arched back in feigned pleasure. Her peroxide-blonde hair was full and long, swinging downward from a garish face, caked with makeup now cracking into sweat rivulets. Black eyeliner emboldened her empty, dark eyes, and liberally applied ruby-red lipstick smeared her lips, frozen in smile. The woman wore nothing but a glittered G-string.

Customers sat at small tables in the darkness of the periphery, while a bartender took drink orders from a bar that served dually as a barrier between client and attraction. Our eyes adjusted, and we approached him. He glanced at me with surprise.

Pointing to the woman now dangling upside down like an opossum, Guy asked, "Is that Miss El Paso? We saw your sign outside." The bartender seemed perplexed.

"¿*Me comprendes?*" Guy asked.

"*Si, señor. No, ella es Meez Tejas! Meeez El Paso está arriba, tra-bajando.*" (That's Miss Texas! Miss El Paso is upstairs, working).

We all understood what "working" meant, and Rex suddenly burst out laughing.

"No, no, *this* is Miss El Paso with us!" he said in English, pointing at me.

The barkeep, realizing we weren't paying customers, glared at Guy and Rex, and then at me, confused. I smiled sweetly at him.

The joke over, we left as suddenly as we had entered. And I discovered that I had enjoyed the spur-of-the-moment diversion immensely, even though Richard Guy's obsessive-compulsive personality likely planned the risky strip club visit down to the last detail.

What would Mother have thought? It didn't really matter, and I realized that I didn't need her approval. I was wearing my

"big girl" panties now, believing I could manage anything the
boys threw in my path

Later, inside the Guyrex warehouse on Texas Avenue, welders
were busy rebuilding the frameworks from previous year's floats,
based on original designs for the upcoming Sun Carnival Parade.
Last year's storybook heroes were gone. No semblance remained
of *My Fair Lady* gliding down a suspended staircase on shimmer-
ing, silver foil; Cleopatra, her float in the shape of an Egyptian
boat; and Dr. Zeus, with his feathers plumed in green, yellow,
and turquoise. Even last year's sweepstakes winner Hail Caesar!
had met its fate in the warehouse, its two tiers demolished, the
horses and Roman soldiers sent home. After the basic ironwork
was complete, wood and other materials would be used to recon-
struct each new float. By summer's end, final decorating could
begin and would not end until the morning of the parade itself,
January 1, 1972. I had no idea that buried behind the traps of the
boys' float building, a new Miss El Paso float was being conceived,
iron rod by iron rod.

The warehouse was situated north of two international border
crossings, the Santa Fe and Stanton Street bridges, facilitating
the stitchers who came to work daily from Juárez. These Mexicans
attended sewing machines, now whirring among racks of velvets
and satins, near the dismantled story scenes. Though Guyrex's
emphasis typically had been sewing float costumes, the boys
were now in the business of designing and making evening
gowns as well. This was Rex's realm, and his artistic talent dis-
played everywhere.

As if to make up for the early afternoon stunt, the boys led
me to where women sat at a table covered with various beads and

rhinestones, hand sewing jeweled patterns on layers of fabric. When Rex introduced me to the ladies, they looked up at me and shyly smiled. Then Guy rolled a garment rack near the table. These were my pageant gowns, finally finished. Rex began to present each dress to me. The women, whose fingers had carefully stitched the dresses, watched my face.

First was a sleeveless, turquoise chiffon. Rex had copied much of my mother's original red dress design, though the gown's ornamentation was unique. Its heavily beaded waist crisscrossed upward on a deeply cut bodice. Silver tubular beads surrounded large crystal rhinestones in flower shapes while other cat-eyed rhinestones, some a half-inch long, were set in a Native American pattern. Unlike Mother's design, this dress had three skirts, two chiffon and one satin. A matching beaded, turquoise throat choker accentuated the gown. Just as Rex had promised, stitched inside the dress was a dyed turquoise bra with pockets for falsies.

"When do I wear this?" I asked, smiling.

"You will have two evenings of processions before the final competition. This is one of your procession gowns."

I instantly fell in love with the dress even as I warily studied its tiny nineteen-inch waist.

Another procession gown, the second dress was a unique chocolate-colored halter with a flowing scarf trailing from its choker. Amber tubular beads on gold ricrac covered the entire halter bodice and wound around the throat. Though I discovered later that the dress was uncomfortably heavy and snagged the undersides of my arms, I would not have to worry about my waist measurement because of the halter design. Four chiffon skirts, three chocolate and one a lighter brown, and a brown satin skirt flowed from the halter.

The Miss America brochure cautioned, "Your only possible expense will involve wardrobe requirements for the three competitions (swimsuit, talent, and evening gown). [The] evening gown need not be expensive, for it will not be judged. It should complement your particular beauty and allow you to walk with natural grace and poise, which will be judged, together with your personality (interview)." Obviously, this Guyrex Girl would be showcasing far more than what a typical Miss Texas pageant contestant brought to Fort Worth. Rex pulled another chiffon evening gown from the dress rack—my competition gown.

Again, the boys borrowed Mother's original pattern as well as her decisive choice of scarlet. Made like the turquoise gown, the dress had the same ornately beaded waist but with golden rhinestones and beads handsewn over silver and gold ricrac. Three red skirts, two chiffon and one satin, fell from the waist, and each skirt, like the other dresses, had a hand-rolled, French hem. Unlike the turquoise dress, this gown had long sleeves, slit from the shoulders to wide, matching beaded cuffs. The gown was dazzling. I turned to smile my appreciation to the seamstresses. Their faces crinkled with pleasure.

We checked the fitting of each of the three gowns. They zipped easily on me despite the slimmer waists. *Have I lost more weight?* I looked into a narrow wall mirror, pleased with each look.

"Which one of these will I wear for talent?" I asked the boys.

Guy and Rex smirked at each other; their faces suddenly devious as if they were about to execute another prank. Rex left to pull something from a garment rack across the room. When he returned, I immediately recognized the voluminous folds bundled in his arms. It was the pink dress.

"Barbara's going to let me wear her dress? But how?" I asked

in disbelief, knowing the disparities between our heights. I could hardly contain myself.

"No, this is *your* gown. We added more skirts and roses."

In fact, the dress had *six* skirts, the upper five made of drapery-sheer fabric instead of chiffon.

"It won't wrinkle. Don't you think it fits the *Love Story* theme perfectly?" Guy asked, with a wide smile.

Indeed, it did. My new pink dress *was* perfect. Guy and Rex had seen to recreating the beautiful gown for me, almost identical to Barbara Barrington's design, yet more practical.

The boys studied me while I sniffled and tried to hold back tears. I realized that we all were profoundly happy with each other for the first time.

I navigated through nylon and silk layers as Rex slid the gown over my head and zipped me. Then Guy fussed with the silk roses, opening the pink petals to cover the back zipper, and Rex made certain he adjusted the velvety-green leaves as well. Then he pulled the rose-covered shoulders down over my arms to be even with my collarbone, puffing the soft rosy mounds on my shoulders. He lifted the skirts and let each one cascade slowly with a soft *swoosh*, satisfied with the final effect.

When I looked into the warehouse mirror, I saw a Cinderella princess looking back at me. Richard Guy and Rex Holt had transformed an ordinary girl into a distinctively stunning pageant contestant. It wasn't magic at all but the emergence of Guyrex's unique vision, despite their trial and errors.

It was time to go to Fort Worth for the Miss Texas-Miss America pageant. I had no idea that my unusual preparation and these very gowns would cause intense scrutiny and conflict among other contestants and judges.

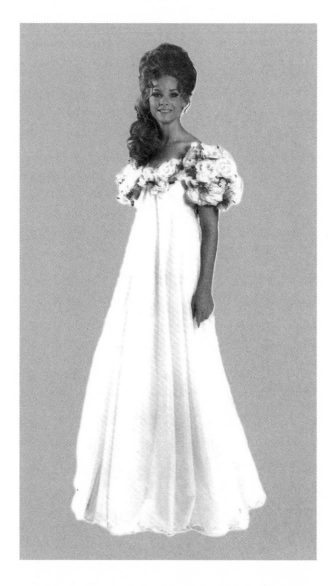

A Guyrex gown, this pink rose dress became a symbol of my
fairy tale year with "the boys." Richard Guy and Rex Holt
worked tirelessly to create a world of fantasy for their beauty
queens, clients, and friends. They called it "Oz."
(Photo by Joe Casarez, Author's Collection)

Part
Two

The first time I went to the Miss Texas
pageant, I walked out. I couldn't believe it.
There they were arguing over a $250 dress, and
I told them I was thinking of giving my
contestant $12,000 worth of gifts!

— RICHARD GUY

Chapter Fifteen

Bon Voyage

"I'm starving!" I complained. A fresh pimple erupting on my chin certainly didn't assuage my distress when I glanced into a visor's mirror to see if Mother was listening.

"Chew some gum," she mumbled.

My mother was sitting at a small stationary table in our family RV across from Hilda Harrell, newspaper correspondent and Barbara Barrington's mother, and Dorothy Holt, Rex's mother. Above the smoky table, blurred images of a West Texas plain flashed by a wide framed window. The women had newspapers and magazines spread out in front of them, along with scissors, an ashtray, and my mother's pack of cigarettes. Still not looking at me—that is, my physical manifestation—Mother held a copy of our local chamber of commerce magazine. It was open to my photo. Then she reached for the scissors. The ladies had decided to chronicle my journey.

I frowned, sitting up front in the passenger captain's chair with my thin, bare legs stretched from the bottom of my hot pants across the dash. My father, seemingly deaf, was piloting. I plopped a piece of Juicy Fruit in my mouth.

Behind our motor home, two minivans followed, one driven by Guy and Rex, the other by the Barringtons. Both vehicles were filled to the brim with my evening gowns, hostess gowns, daytime dresses, rehearsal costumes, and swimsuit. Another two thousand dollars worth of shoes, gloves, underwear, jewelry, hair products, and pieces—donated by local businesses—were also crammed into the vans. Both vehicles were covered in white shoe polish proclaiming *Janie Little in Ft. Worth! Miss El Paso 1971!* And *El Paso, You're Looking Good!*

We were on our way to the Miss Texas-Miss America pageant on July 3, 1971, and our grand entrance would be memorable.

June's earlier events had been productive and pleasant for all of us. The effects of Valium had indeed washed over my mother, and her anxiety over my father's activities and my misdeeds dissipated. And with a new evenness to her mood, we rallied together for my final preparation. All the time, I was ridiculously hungry.

Mother provided newspapers with snippets of information, including that I had been born in "the town without a toothache," where naturally fluoridated water came out of Hereford's wells. To prove her assertion that I possessed flawless teeth, she whisked me to a dentist to have my teeth examined and get a professional opinion. I did have perfect teeth—straight with no cavities—and my mother paid for the dentist's endorsement to prove her assertion in case someone wanted to look this gift horse in the mouth. Guyrex would be required to produce a media packet for Miss Texas pageant officials, one that would proclaim the famous aforementioned teeth.

A professional photographer also snapped shots of me garbed in various Guyrex-designed gowns and daywear. Barbara

Barrington expertly affixed two sets of false eyelashes on each eye, one set glued on top of the other with black eyeliner filling the gaps. I felt like a wide-eyed Dr. Seuss Cindy Lou Who while I became used to the heavy lashes and stickiness at the corners of my eyes. Barbara also wove two hairpieces into my own mane to create a Hollywood look. That I would be able to replicate her cosmetic work by myself would come in handy later when contestants, acting like high school mean girls, complained about my personal makeup artist.

A full photo spread appeared on June 12 in the *El Paso Times*. There I stood smiling my perfect teeth in a swimsuit pose; in a tailored miniskirt, vest, and white go-go boots, holding textbooks; and in a red, white, and blue hostess gown with a measuring tape, pair of scissors, and spool of thread adorning my neck, pockets, and hands. Evidently, Guyrex was trying to create a narrative about me as well.

The photo that captured most readers' attention was centered among the others, a four-by-six-inch photo of my headshot in the pink dress. Above the mounds of roses and below a head of hair piled high, dramatic eyes gazed directly into the camera lens. Over the next year, countless photos of Miss El Paso would appear in Texas newspapers, many with the pink dress, as Guy and Rex honed their marketing skills.

Shortly afterwards, Joanne Chagra invited me for brunch at the couple's current home, not the fortress they would later build to protect themselves from tenacious DEA agents, ex-clients, and thugs. She had become a key figure in the new Miss El Paso Scholarship Guild, collaborating tirelessly with other women to raise money for the Miss El Paso pageant.

My mother had been coerced into joining the circle of society women who conveyed their talents from the Festival Theater

Guild to the new scholarship guild. So far, Mother had only attended a couple of meetings as an honorary member. There would be fashion shows, decorating, ticket sales, and sundry other events and tasks where members could contribute. But I doubted Mother's membership would last beyond my pageants.

When Barbara Barrington and I walked into the Chagra home, an inviting scent of fresh bread immediately assailed our senses. Joanne had prepared traditional Middle Eastern pastries and bread, placing me in an awkward position. Did I dare eat the honeyed, cinnamon, and sugared sweets? How could I deny my hostess's gifts? She sat us down in her kitchen, at a table where I could look out into the backyard through a window nearby.

There was no formality or stiffness, and spiced aromas wafted from the oven. Joanne's coffee-creamed complexion appeared unruffled while other family members, who happened to live on the same street, dropped by to meet me and wish me good luck. Ignoring Barbara's reluctance at my sampling the pastries, my hostess placed a plate before me. I avoided Barbara's eyes and permitted myself a few heavenly bites.

Through the window, I could see children racing each other in the backyard when one little girl ran into the kitchen crying to her mother. Life has a way of intertwining unrelated persons and events into a common rope, and ten years later, I would teach this youngest Chagra daughter and hold her in my arms as she wept again, this time over the upcoming anniversary of her father's death. Lee Chagra was murdered in his office on December 23, 1978.

Also, in June, I received a formal invitation from Commanding General and Mrs. Lloyd L. Leech, Jr. and Major General and Mrs. Raymond L. Shoemaker to attend a formal reception and dance in honor of the "Proud and True, Class of '72" United

States Military Academy. The academy had begun sending cadets to Fort Bliss Army Base for new defense missile training. Because of the Vietnam War, the 1972 graduating West Point cadet class was large. Cadets were sent in groups, each for a three-day stay highlighted with a "cadet hop."

I had forsaken my social life since my ascension to Miss El Paso, Guy later remarking to future contestants, "We will not tolerate negatives like boyfriends or parents." I had a boyfriend prior to the pageant, and the new title had given me a gutless excuse to break up with him, much to my parents' pleasure. Yet, the promise of a date was a welcome respite from pageant preparation.

My uniformed escort at the dance was unfailingly polite but managed to step on the skirt of my turquoise Guyrex gown and tear it. He was utterly humiliated and apologetic, no matter my assurances that the dress could be repaired. Later I received a formal apology from the United States Army with an offer to pay for the designer gown. The mishap hadn't bothered me in the least. I had just received another invitation, this time to be a guest of Miss Texas pageant officials and Phyllis George, Miss America 1971.

Marty Robbins's voice crooned "El Paso" over the loudspeakers at El Paso International Airport as I walked toward my departure gate. This would be a quick turnaround trip to Fort Worth two weeks before the Miss Texas pageant. The song's timing seemed a good omen—for my ears only—and suddenly I felt significant, beautiful even. From "out in the West Texas town of El Paso," I was going to personify my hometown's Wild West I-can-do-anything attitude against the eastern, polished naysayers.

Just as Molly Coyle had done days after she was first

crowned Miss El Paso, I was finally getting my trip. Only, I was to be a guest of Phyllis George, the same Miss America whose face highlighted the poster that had gotten me into the pageant in the first place. Other select Miss Texas contestants and I were scheduled to attend a local pageant and receive last-minute pageant preparation tips.

In Fort Worth, B. Don Magness met me at the airport along with another contestant, Miss Haltom Area, a gorgeous, statuesque blonde whom he already seemed to know from past pageants. I had heard that no girl won Miss Texas first time out. Often it took two to three times contesting in the preliminary state pageant before advancing to the Miss America pageant in New Jersey. Texas girls moved from local franchise to local franchise until finally hitting the Miss Texas crowning jackpot. In short, these contestants were professional contenders. Magness had assigned an experienced local pageant winner to teach me the ropes as a courtesy to Guy and Rex, and I shyly accepted her guidance. Besides, Magness was charming and funny, not frightening as he had appeared at the Miss El Paso preliminaries. In fact, the other girls seemed to adore him, including Phyllis George, who had also competed in the Miss Texas pageant, the largest state pageant, two times before winning the title.

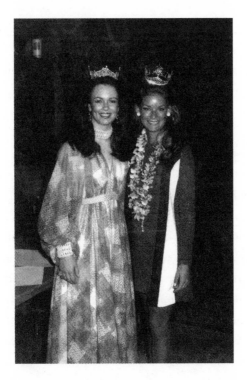

To further my training, I traveled to Fort Worth, Texas, to meet
with Miss Texas Executive Director B. Don Magness and
current Miss America, Phyllis George. Magness later became
the subject of controversy within both the Miss Texas and Miss
America pageants. (Author's Collection)

When I finally met America's reigning girl next door, I was
immediately smitten with her charm. Phyllis exuded a personal
warmth that immediately bypassed all barriers of formality and
unfamiliarity. In this moment, and in years to come, she made
me feel as if I was important to her. Phyllis draped an orchid lei
around my neck, and, with her arms wrapped around me, we
posed in our crowns for a photo that was immediately picked up

in El Paso newspapers. Her complexion was pale to my tan, but our crowns were identical.

We shared another commonality: hovering around Phyllis had been her mother.

Two media events marked the twelve hours before my send-off to the 1971 Miss Texas pageant. The night before, supporters, friends, and family gathered on the black-and-white checkered floor of Guy and Rex's Montana Avenue home for a bon voyage party. I stood at the foot of the stairs, greeting visitors in the Southwestern upholstery concoction—a full-length Native-American-themed skirt and bolo vest in black, turquoise, and purple geometrics. Completing the Guyrex design was a sash of purple drapery material wrapped around my thin waist and terminating with a bold tassel. Again, I thought of Scarlett O'Hara, this time when she made her regal appearance wearing a gown made of her home's antebellum drapery. Or, maybe it was Carol Burnett's parody of the famous scene, dressed in emerald drapery and tassels, that nagged me. I would be digging up yams in Texas dirt if my journey didn't diverge from Scarlett's path soon.

Reporters and photographers had been on hand to capture the send-off nearby. They simultaneously launched questions to Mother while Daddy stood next to her in front of the familiar, black-flocked wallpaper. The reporters might as well have been a firing squad from the look on my father's face.

"Mrs. Little, did you ever think your daughter would become Miss El Paso?" one asked.

An innocuous question, and Mother need not have answered with more than a yes or no. Instead, she gave the reporter a mouthful. "No, definitely not. She was a tomboy."

I sighed when I realized the arm-wrestling story was about to emerge again.

"She loved horses. She was the *champion* arm wrestler on our block," Mother said, emphasizing "champion" as if my wrestling prepubescent boys was a notable accomplishment.

Then Mother dramatically paused, a look of pseudoconcern flooding her face. "We were worried that her personality might change. Of course, with a little brother, she couldn't get a big head."

Mother smiled, calculating what she could add next while I glared at her. I was certain that my father never shared this belief. Only Mother relished sharing flaws she imagined in my character. As the reporters gave my mother free rein to continue her long responses to the one question, Dad began shuffling his feet. A secret was about to become exposed. It wasn't the Scotch or Valium helping divulge my hidden weakness—just my mother, unhampered.

"One of the main problems has been Janey's music. She hasn't had that much formal training," Mother revealed. "She does have a natural ear and rhythm. And all of us love music, so that probably helps her."

Later Guy and Rex had to refute these last remarks, and future news stories would report that I had ten years of professional musical training, a gross exaggeration. And like a drunken man trying to show how sober he is, I would need to fool an audience and judges at the pageant. In truth, I was ill-prepared to participate in the talent competition. I knew it, my music teacher Thelma Hurd knew it, and so did my parents. I had yet to play the *Love Story* medley without fumbling over the piano keys. In true Guyrex form, I would need to portray an illusion of musical ability.

Immediately before our departure the second media event took place, this time on the front lawn of Guyrex headquarters.

Television reporters and newspaper photographers milled around the house's front windows painted with "El Paso is with YOU! Good luck, Janie Little, Miss El Paso 1971!" The motor home backed into a narrow front driveway, also tagged with braggadocio. Local newspapers later reported an entourage would be trailing us, including several of Dad's clients, representatives of El Paso's prominent family-owned businesses, various politicians/lawyers, and other Miss El Paso Guild members.

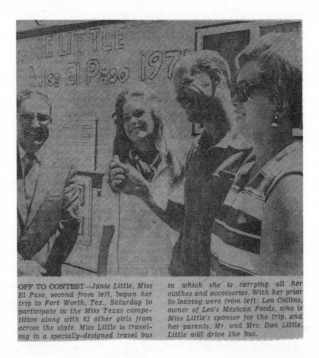

OFF TO CONTEST—*Janie Little, Miss El Paso, second from left, began her trip to Fort Worth, Tex., Saturday to participate in the Miss Texas competition along with 63 other girls from across the state. Miss Little is traveling in a specially-designed travel bus* in *which she is carrying all her clothes and accessories. With her prior to leaving were from left: Leo Collins, owner of Leo's Mexican Foods, who is Miss Little's sponsor for the trip, and her parents, Mr. and Mrs. Don Little. Little will drive the bus.*

"Off to contest" July 3, 1971, my parents and I interviewed with reporters before the Guyrex phenomenon hit Fort Worth two days later. The pageant temporarily halted their marriage difficulties.

(*El Paso Times,* July 4, 1971, page 5A, Author's Collection)

I hurt for my grandmother, who had made a long drive to El Paso to babysit while my parents were gone. She stood to one side with a wistful smile on her face while my sponsor Leo Collins, owner of Leo's Restaurants, and my parents were interviewed for local television news. This time, my father wore a wide grin on his face. When it was my turn to speak, I made certain to mention my grandmother's good luck charm.

As our trek continued to Fort Worth, the women chatted among themselves while cutting and pasting newspaper articles into a scrapbook. Someone had a copy of a recent *Fort Worth Star-Telegram* featuring Miss Texas contestants. On one page, I appeared wearing the pink dress. Mother cut out the photo reverently.

At the same time, Hilda Harrell used a black ink pen to write a caption on a pastel illustration that defined our six-hundred-mile-plus journey together. When she finished her inscription, she passed the cartoon to me. A full-page General Foods ad portrayed a blonde girl with a Buster Brown haircut, her black eyes and mouth wide open like Edvard Munch's Expressionist painting *The Scream*. Hilda had taped two words inside the cartoon character's gaping mouth.

"I'm hungry!" the caption squealed.

When we finally pulled under the portico of Fort Worth's Downtowner Motor Inn, a marquee above the entrance read, "Welcome, Janie Little, Miss El Paso." I knew it wasn't because Miss El Paso had arrived. It was Guyrex who had descended on Fort Worth, and fireworks were about to start popping.

Chapter Sixteen

Fort Worth Meets El Paso

*A*t seven-thirty the next morning, sixty-three local pageant winners, their sideways glances analyzing the competition like gladiators entering the Colosseum, paraded into Sherley Hall's downstairs lobby at Texas Christian University (TCU). It was time to officially register for participation in the 1971 Miss Texas-Miss America pageant. The lobby was packed with contestants, parents, the media, and other onlookers. Photographers took random shots of girls hamming it up for reporters, who would capture the first of many human-interest stories to inundate state newspapers throughout the week.

Miss South Plains shared that she had forgotten her clothes. Miss Denton announced that she almost flew her own plane to Fort Worth but changed her mind last minute. Another contestant walked around handing out Texas buckeyes to the girls for good luck, while still another passed out red roses, courtesy of Tyler, Texas. I didn't have a feel-good story to share unless I wanted to talk about my teeth, and that wasn't about to happen. Nor had I arrived in Fort Worth to compete for Miss Congeniality. So, I

waited patiently in line for my registration packet while Guy stood at my side, fidgeting.

When it was my turn at the registration table, I received my suite assignment with three other girls. I was informed that an official hostess had been assigned to me and Miss Gladewater, one of my roommates. Besides being responsible for getting us up and ready for each day's activities, my hostess would be responsible for enforcing the rules in the Contestant's Handbook. She would also report any infractions of these same rules. In essence, the hostess, not Guy and Rex, would be my lifeline during the next week.

Guy grabbed the registration envelope and, pulling my arm, led me to a table where he could empty out the contents of the packet. Unbeknownst to both of us, he had just broken Rule #8.

Falling out of the large envelope first was a white rosette with my name and title displayed in the center with two short streamers that read "1971 Miss Texas" and "Contestant" in gold. I was to wear the rosette at all-day functions. My official banner, to be worn only during the four nights of competitions, was folded gently into the packet as well, with instructions to wear it from the right shoulder to the left hip. Last was the Contestant's Handbook, a half-inch book with Miss Texas officials' and judges' bios, cheat sheets with stats on each contestant, daily schedules, and *the rules*. The Miss Texas pageant evidently operated like a well-oiled machine—that is, until we arrived. Guy bent over the booklet and began reading the rules that all contestants were expected to follow. Most notable were the following:

Rule #1 – The Miss Texas Pageant hostesses have complete charge of all activities, interviews, pictures, recordings, and any other activities of the Contestants during the Pageant.

Rule #2 – Contestants will be accompanied by her Hostess at all times.

Rule #4 – A Hostess must be present for all approved interviews and pictures. No telephone interviews without the permission of the Hostess.

Rule #7 – Accredited publicity men and photographers covering Contestants from their hometowns have automatic approval for interviews and pictures of their particular contestants, provided they are registered. See #4.

Rule #8 – Contestants are not permitted to speak to any man unless in the company of the Hostess. Contestants will not allow men in their rooms. The Contestant's own family is <u>not</u> excepted.

Rule #10 – Official Pageant automobiles are assigned for the exclusive use of the Contestants, Hostesses, Judges, and Pageant Executive Director.

VIOLATION OF ANY RULE WILL BRING AUTOMATIC ELIMINATION FROM FURTHER JUDGING, <u>ALTHOUGH THE CONTESTANT WILL NOT BE ADVISED OF THE ACTION.</u>

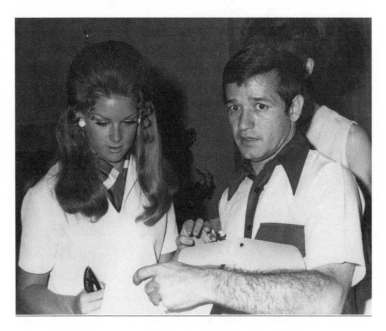

July 5, 1971, a worried Richard Guy reads the rule book
governing Miss Texas-Miss America pageant contestants. He
and Rex Holt would not be able to have in-person contact with
me the remainder of the week. I was thrilled!
(Author's Collection)

Hallelujah! The boys would not be permitted to invade the
sanctity of my room, or even talk to me privately, for one entire
week. I couldn't believe my luck! The buckeye that I had slipped
into my pocket was working.

While Guy and I had been completing the registration
process, my parents paid a professional photographer $100 to
follow me throughout the week, taking photos for a memory album
for my birthday. One week later, I would turn nineteen years old
if I didn't die from abject failure on stage during my talent com-

petition. The photographer's first photo was of Guy, looking per-
plexed, while he reviewed the rules with me.

The fact that he would have no access to me had sunk in. A
second photo, taken moments later, captured me, thin-faced and
dressed in red, white, and blue, a color scheme that my daily
wardrobe would patriotically repeat throughout the week. Without
testing the keys, I posed at a well-used upright piano in a commons
area on the second floor where officials said I could practice during
the week. The photographer caught Rex's and my smiling faces
coming back downstairs afterwards. I was set.

Rex and the Barringtons conspicuously parked the Guyrex
minivans in front of Sherley Hall and then pulled the doors wide
open for all to see. An onlooker might have thought they were a
catering service except for the vans' white shoe-polished graffiti
and Barbara's dramatic appearance. The three began extracting
Miss El Paso-labeled suitcases, gowns, dresses, bags, and a four-
foot dressing room mirror, complete with a frame of round
lightbulbs. Then the men carried the items through the crowded
lobby and up to the second-floor suite.

By the time they made their second trip from the vehicles,
the professional contenders and the media knew that an inter-
loper had arrived. Curious girls followed Rex, John, and Barbara
upstairs to my dorm room and stood in the hall whispering
among themselves.

While a third trip was in progress, the girls entered the
suite and began rummaging through the Miss El Paso para-
phernalia, which barely fit in the dorm room closet. They were
in the process of pulling out my pink dress when Barbara
caught them, advising them politely but firmly to exit my room.
I had not even seen the suite yet, but now I was marked. I would
have to be vigilant among envious girls. Barbara alerted me that

cutthroat contestants had been known to sabotage other con-
testants' competitions.

"Janie, you're going to have to be really careful," Barbara
said, grimacing. "I heard of a contestant deliberately stepping
on a girl's evening gown in order to rip the skirt just before
competing onstage."

I let her words sink in. I would not only have to watch out
for Guy and Rex's furtiveness regarding my eating habits, but
now I had to beware of other girls who might sabotage my
chances at winning. The Miss America pageant and all local
pageants leading up to it were scholarship competitions. Win-
ning was not just about fame but future endorsements, profes-
sional employment, and money. Most Miss Texas contestants
had spent months preparing for this week; many had prepared
for years.

By the time I gathered with the other girls to meet our
hostesses, Guy and Rex had disappeared, no doubt to find B.
Don Magness and complain. My parents left to party with their
friends, the rules not bothering them one whit. The entourage
from El Paso had arrived, including its movers and shakers.
Mother had also contacted some former Hereford Country Club
friends—people who, like my parents, moved away but to Dallas.
They, too, appeared, as did my aunt, uncle, and cousins from
Oklahoma. An enthusiastic crowd would be cheering me on,
starting with my first competition on Wednesday night, July 7.

When I returned to my room, a list of what I was to wear for
the rest of the day was taped to the wall next to my closet. My
new roommate, Miss Gladewater, stood in front of it. Though a
pianist like me, Gladewater would be dancing for her talent
competition. Her brunette head tilted as she read the list.

"You have to wear all this? *Today?*" she asked, with awe, as

she studied the detailed wardrobe itinerary. Shoes, gloves, jewelry, type of undergarment, and outerwear were assigned to each activity for the rest of the day. I don't know if she was incredulous at the extensive list or because I brought so much with me, but I could have sworn Gladewater's look at me changed from awe to pity. She had arrived in Fort Worth with minimum necessities required, and she did not have anyone dictating her choice of dress or monitoring her activities.

Guy intended to spy on me when I arrived downstairs each morning before breakfast, and Barbara would bring directives back upstairs to amend and correct my dress or behaviors throughout the day. It didn't take long for the rest of the girls to figure out that I had handlers. And one of them was my personal makeup and hair artist.

An 11:00 a.m. luncheon had been scheduled at El Chico Restaurant—Mexican food, my favorite! I bravely ate only the lettuce and tomatoes while inhaling the aroma of cheese enchiladas, floating in the middle of my plate. They beckoned like an island paradise in an open expanse of red sauce. My stomach growled, but Guy had warned me more than once that I would have to watch what I ate or my gowns would not zip up. Afterwards, official drivers with official buses took us to the brand-new, $2 million Tarrant County Convention Center for our first rehearsal.

We would be dancing a number for Wednesday's opening night, a hillbilly hoedown that featured the current Miss Texas and singer, Bellinda Myrick. Someone had the brilliant notion that all of Texas identified with square dancing, something I hadn't done since fourth grade PE. A producer shouted orders while the production crew set up backdrops and arranged lights. We scrambled everywhere, trying to understand our positions and what we were supposed to do. For four and a half hours, we

practiced the production number's choreography over and over and rehearsed the parade of cities.

Within an hour I was operating on empty calories. One girl muttered, "If you can endure this week, you should at least get *something*." Getting faint, I leaned down with my elbow on one knee as if I were about to swing into a do-si-do with a piece of straw in my mouth. The photographer captured the pose.

Back at Sherley Hall, I had my third change of clothes for the day, this time for our 5:00 p.m. dinner at Four Winds Restaurant. Barbara had arrived to do my hair and makeup and check that my wardrobe followed the list next to my closet. Her presence on the floor was like a siren. Heads peeked out of doorways to scrutinize the statuesque woman carrying a makeup kit and whose own made-up face and black hair resembled Morticia from *The Addams Family*.

Later at the restaurant, I intended to nibble on low-calorie side dishes and avoid the main course put in front of me. But I was a hopeless backslider and sneaked one itty-bitty bite of steak. I involuntarily looked around to see if Guy or Rex was watching. But they weren't. They weren't at the restaurant at all.

What I didn't know was that while we were eating, other well-known Fort Worth-area pageant directors had begun complaining to Miss Texas pageant officials that I brought an unfair advantage with Barbara and my wardrobe. At that moment, B. Don Magness, Miss Texas pageant director, Miss Texas pageant committee members, and Guyrex, were in a contentious meeting discussing the complaints.

After dinner, contestants were transported to the KTVT television studio to view the previous year's Miss Texas pageant. Some were drowsy from the meal and exhausted from day one's demanding schedule. It was difficult to pay attention, and I nodded

off. Those of us new to the pageant had no idea that the next days would be infinitely more difficult.

But the Miss Texas pageant committee had foreseen our needs. When we walked back inside Sherley Hall at 9:00 p.m., a feast of carbs—fruit and vegetable trays, cheeses, assorted bags of chips, chocolate candy bars, pastries, cookies, and soda pop—met our eyes. The girls shrieked and rushed the tables to grab snacks to take upstairs. I would have joined the pack, but Guy and Rex stood next to a wall, their piercing eyes warning me not to indulge. My hostess also kept an eye on me to make certain the men didn't talk to me. It hadn't taken her long to notice my dilemma.

Once I was able to tear my eyes away from the food, I saw other tables laden with rainbow bouquets and fruit baskets extending around walls of the hall. Every contestant had been designated a spot where gifts and other good luck offerings could be collected throughout each day. Western Union had been on strike since May, but the tables were covered with handwritten notes and cards.

I followed an alphabet of contestants' titles until I came to my retrieval spot. Next to me, Miss Farmersville squealed. In front of her was a good luck gift from her parents, a cage with a live rabbit—four rabbit's feet! I looked at my empty spot. No lucky rabbit for me. But then I saw a small vase of flowers. I was awash with guilt when I read the accompanying card my ex-boyfriend had sent.

Later in our suite, my roommates sat on their beds devouring their booty. Miss Corpus Christi nudged Miss Greenville, both brunette dancers like Gladewater, pointing to me. I was not eating anything, nor had I brought food up for later, though I had placed the flowers next to my bed.

"Why aren't you eating?" Corpus Christi asked.

"Because she has spies downstairs," Gladewater answered for me.

I already determined that they thought I was stuck-up with my piles of gowns, dresses, shoes, and specially made makeup mirror. I sat on my bed and began explaining to the other girls what it meant to be a Guyrex contestant, though I had no idea that the term *GuyRex Girl* would later be trademarked. Immediately I had their empathy.

"Well, we'll take care of that. Besides, we burned enough calories today to last the rest of the week!" Gladewater announced, as she marched out the door on her way downstairs to grab a candy bar for me. She was back with a handful of snacks within minutes.

Did I feel guilty? Absolutely. But I ate the chocolate anyway. Suddenly, the week was looking better. I now had three partners in crime every evening when we returned to Sherley Hall. Yes, they were my enablers.

The next morning, Tuesday, July 6, I waited for Barbara to come to my room to help with my hair and makeup after an early breakfast in the TCU cafeteria. I was looking forward to a pool press party sponsored by Coca-Cola at Green Oaks Inn, pageant headquarters. Preapproved reporters and photographers would be on hand to interview contestants. Afterward there would be a change of clothes for a luncheon sponsored by the Downtown Lions Club at the Sheraton Fort Worth Hotel. Another outfit change would follow for rehearsal where dinner would be catered. Later, we would travel back to Sherley Hall where the girls could sneak food for me, and we could visit until lights out at midnight. But something was wrong. Barbara was late, and when she finally arrived, her face was dour.

The protesting contestants had been successful in their objections to Barbara the previous evening. Though the Miss Texas pageant committee had thirty-three enlisted assistants—one for every two girls—to help with hair, makeup, and ironing, I would have to share Barbara's expertise with the complainers. She would have to do their hair and makeup before even coming to my room. Apparently, my extravagant wardrobe also provoked a hot discussion.

Guy later remarked, "The first time I went to the Miss Texas pageant, I walked out. I couldn't believe it. There they were arguing over a $250 dress (a Guyrex gown), and I told them I was thinking of giving my contestant $12,000 worth of gifts!"

In the end, Guy and Rex were awarded a concession since B. Don Magness must have recognized potential profit from his association with Guyrex Associates. The boys and John Barrington became designated Miss Texas pageant drivers. Now they had full access at all my events, even if they were not permitted to speak to me privately. There would no longer be itty-bitty stealth bites, and I was on my own for my makeup and hair.

Chapter Seventeen

Collusions

They wouldn't play. The treble keys only made muffled sounds when I pressed them. Several keys made no sound at all. No way could I practice the complicated *Love Story* medley with its fine treble trills on the ancient upright piano. Of the sixty-three contestants, only eight were pianists. The rest of the girls' talents split between dancing and singing. Was I the only one who had discovered the piano to be inoperable? Worse, was I the only one who needed to practice?

As in the Miss El Paso pageant preliminaries and the Miss El Paso pageant, the issue of my talent loomed heavily over me, not unlike a comic strip's small, gray cloud with rain bursts following me overhead. Yet, my cloud seemed more a purplish-green tempest, tinged with orange winds swirling to the ground and picking up dirt like a Texas Panhandle tornado. I had yet to play the competition piece without errors, and calamities followed me like the storm's debris.

Lately I had begun praying at odd moments during the day, not just at night after a particularly momentous day or after an

unusually stressful one, and that's if I even remembered. Now, it seemed, after every moment worrying about my talent (and that was often), I offered God a short plea. "Please, dear Lord, please don't let me mess up!" Then I would feel guilty for asking for something so trivial. Obviously, I was picking up religion while praying for a miracle.

Earlier that morning the press pool party had been a success. The sun's rays ignited a bright kaleidoscope of swimsuit colors, the barefoot girls braving the heat. A statistician had provided a summation of the handbook's cheat sheets for the press pool. Compared to contestants in the past, our average height had in-creased one inch, and we had gained an average of one pound, but our measurements were about the same. The shortest contes-tant was five feet tall, and the tallest was six feet. The oldest was twenty-four and the youngest, eighteen. Brown and blue-eyed girls were evenly split, accompanied by nineteen green-eyed girls. Only one contestant was African American, Miss Prairie View A&M.

As if understanding the geography of the city that I represented, photographers posed me in my royal blue swimsuit standing in a water feature with Miss West Texas State University and Miss West Texas. I'm certain that only I knew true West Texas was El Paso. We smiled for the photographers, trying not to sway as our toes painfully gripped small river rocks. Afterward, I gave a television interview, amid a slew of photographers whose camera snaps sounded like a child's bucket of click beetles. Tony Slaughter, a *Fort Worth Star-Telegram* journalist and a local celebrity, reported the hubbub around me. It must have been the Guyrex effect.

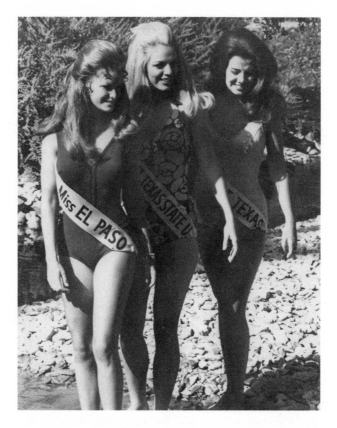

I posed in swimsuit (left) alongside Miss West Texas State
University and Miss West Texas. I'm certain that only I knew
true West Texas was El Paso. (Author's Collection)

Fortunately, John Barrington, and not Guy, had driven our
official bus back to Sherley Hall, and I felt somewhat pacified as I
rushed inside to my table in the foyer. I was not disappointed. I
had received my share of flowers and cards. Among the well-
wishers were El Paso's state senators, Tati Santiesteban and Joe
Christie, and U.S. House Representative Richard White. White
wrote, "I am assured by people who know you well that you have

the beauty, poise, and intelligence to be a foremost contender for the title of Miss Texas." No pressure.

There were other flower arrangements as well—bouquets from my sorority sisters, Miss El Paso Guild members, my high school principal, and old friends from Hereford. Ellen Rhey, married to the Syrian American businessman Willie, wrote on her floral card in her distinct German script, "Our thoughts will be with you this week." The Rheys had come to Fort Worth to watch my competition. Even the Northeast YMCA staff wrote a note, attached to their flowers, saying, "Best Wishes to our Hippy Lifeguard and Our Choice for Miss Texas!" I grinned. Then my smile disappeared.

Guy had also sent flowers with a card that read, "*We love you!* Please stay on your diet *one* (1) more week! Good luck, Guy." He had added the digit to make certain I got the point. There was another card reminding me not to eat, another card, and still another. Obviously, Guy and Rex had enlisted help from the El Paso contingent after witnessing the daily carb feast in Sherley Hall. This was an organized assault, and, frankly, it was embarrassing. Then, I recognized my father's handwriting on an envelope. Inside was a hastily written note.

Janey:

I know things are going to be rough on you, but this is the time for you to buckle down. There are going to be all kinds of temptations (food) placed before you every night and if you should slip now and not be able to wear your clothes and lose your figure after all the work and time spent, it would disappoint us all.

Think! Before you do anything.

*Don't forget—I will buy you anything that you want to eat
Saturday night. Mother and I are very proud of you, and we
love you very much!*

Daddy

They would be disappointed? Had I not been buckling down
for weeks? Why had Guy and Rex even made the waists in my
gowns smaller than my own? I was set up to fail, didn't they
realize this? It was déjà vu. My parents, while celebrating with
their old friends, didn't want any flaws exposed in their perfect
crystal. Niggling my thoughts was a feeling that Mother had co-
erced my father into sending the note. An hour later, at the
Downtown Lions Club luncheon, I pilfered a greasy hot roll
from a basket of bread placed before me, wrapping it in my
napkin for later. Guy and Rex never saw.

With barely enough time to digest our lunch before being
herded to the convention center, we set up for another rehearsal.
This time Phyllis George arrived to dance in several production
numbers. Joe DeVito, the featured vocalist, and Bellinda Myrick
were also principals, practicing their songs on stage. Emceeing
the rehearsal was Maria Beale Fletcher, a former Miss America.
She had danced her way to the crown, edging out Miss Texas in
1962. Along with Maria was her ten-month-old daughter, the
child already a national television diaper model.

We couldn't make any mistakes. We were told that all four
nights of the pageant were almost sold out. Slaughter, reporting
again for the *Fort Worth Star-Telegram*, wrote that the Miss El Paso
delegation had purchased their fair share of the tickets. More

pressure. As the professional show began to take shape, the producer barked orders, photographers snapped pictures, and, from the audience, our drivers rooted for their favorite contestants. Soon a few girls figured out that photographers gravitated toward me, and they began to stand or sit near me to include themselves in camera shots.

After a catered dinner, an orchestra arrived to accompany the various production numbers, and we received our costumes for a final dress rehearsal. There had been no time to relax, not even to answer questions between bites of barbecue. Our hostesses tripped over each other trying to deliver our dresses and get us back onstage at the proper time.

Worse, the "hoedown" costumes were hideous, mine an unattractive large-checked lavender peasant blouse and skirt trimmed with black ricrac. The grueling rehearsal finally ended. "I bet if we didn't have to be out of here at midnight, he [the producer] would still have us here," someone grumbled.

When we walked through Sherley Hall's lobby afterward, we were utterly exhausted. Again, local restaurants had provided a smorgasbord of carb-rich foods for us. Catching my eye was a huge cake in the shape of Texas, filling half of one banquet table, our geographical areas and representative cities clearly marked on its frosting. The cake, a gift from a contestant, was to be our treat the next day to celebrate the Miss Texas pageant's opening night.

Ironically, the Miss Texas Board had a new rule that none of the girls could gain more than five pounds over the weight the board set for a girl's particular body type. How would they even know? What was my body type? Anorexic?

Back in our rooms, girls washed and set their hair while others pressed dresses for upcoming judges' interviews. Some just

stayed up and talked. The next day was my interview, too, as well as my evening gown competition. I should have been reviewing all my El Paso facts for the judges, but, instead, I had gone to find the piano. And I had just discovered it still didn't work.

At 2:00 a.m., lights were out and our alarm clocks set for 5:00 a.m. I lay awake in bed with my stomach in a tight ball. It had seemed that the more our room filled up with flowers, the emptier my belly became. My roommates whispered about the cake downstairs. I don't recall who made the initial suggestion. I'm certain my frustration about the piano and diet contributed to our shameful plan.

The four of us got out of bed and silently tiptoed through the hallway and down the stairs, quiet as pantry mice. Except for muted emergency lights leading toward the front exit, the foyer was dim. The Texas cake beckoned us in the darkness.

Someone found forks from the other food-laden tables, and we carefully unwrapped the huge cake, trying not to smear the frosted lettering. We didn't bother to cut pieces but gouged our forks into the geographical areas we each represented. I am not ashamed to say, I devoured ALL of West Texas—the *true* West Texas. Still not satisfied, I announced that since the other girls were from primarily North and South Texas, I claimed the Pan-handle as well. After all, I had been born there, in the "town without a toothache"! I savored the sugary frosting, gorging on cake from Dalhart south to Big Spring, then Muleshoe east to Childress. Only then was I satiated.

The next morning, Wednesday, July 7, the last syllable of a typically monosyllabic word soared upstairs to our ears. We could hear a girl downstairs screaming in her East Texas accent, "My ca-ake! My ca-ake!" Coincidentally, East Texas crumbs were all that remained on the banquet table.

My cohorts in crime and I smirked at each other as we passed by the cake's remains on our way to breakfast in the cafeteria. Shrugging away my guilt, I forced some eggs down my throat since the sugar high from the night's activity had not subsided.

My swimsuit pictures made many of the state's newspapers by morning. When I looked at my photo in Fort Worth's local news-papers, I realized that my youthful face was gone. I imagined that I looked older than my eighteen-almost-nineteen years. The *El Paso Herald Post* also ran the photo in its society section, along with Hilda Harrell's story that I had been giving numerous tele-vision interviews and that the pageant was becoming more a test of endurance. Juxtaposing a beauty pageant to the unrest in the nation, the previous evening's *Post* ran my photo on its front page, next to a young woman holding up her fist in a Vietnam War protest somewhere in Nebraska. The caption read, "Doing their thing from beauty pageant to riots!" Though my photo cre-ated a far different sentiment, I, too, was feeling militant after the night's rebellion.

To manage the enormous number of beauty contestants sent to Fort Worth, we separated into three groups—A, B, and C. The groups would rotate the next three days between evening gown competition and interview, swimsuit, and talent. From these preliminary competitions, judges would select three preliminary swimsuit and talent winners and a "top ten" list of contenders for the final pageant night. Their goal was to narrow the field; our goal was to make one of the upper ten spots.

At 8:oo a.m., I rushed to the convention center with girls assigned to groups A and C. Unfortunately for me, among my

Group C were top contenders, six of whom made the top ten in the 1970 Miss Texas pageant and had been invited back to compete this year. My stomach sank when I realized that it would be nearly impossible to be a preliminary swimsuit or talent winner in my group.

After our group rehearsed evening gown competition, we were able to watch a portion of Group B girls rehearse their talent with a full orchestra. My ears hurt when Miss Big Thicket sang a medley of "dream" songs, the most prominent being the Everly Brothers' "All I Have to Do Is Dream." Again, the strong East Texas accent overshadowed her words. If I had a slight Mexican accent, I wondered, would my judges be put off?

Lunch was in a local cafeteria where I could choose my food selections. Not surprisingly, I no longer craved sweets and had no desire to fool Guy's or Rex's eyes while they stood nearby with the other drivers. Besides, I had received more reminder bouquets and notes. Among them was a note from my parents: "Stay slim, kid. Good luck!" Barbara Barrington reminded me to walk ramrod straight in evening gown competition: "Dearest Janie, the very best of luck. PS. Don't *ever* drop that bean bag." Rex had remembered me with flowers, too, and since his nature was not to be critical, his card simply read, "Best in Fort Worth!" Still, I had been checking my waist all day long and, though I hadn't detected any changes in my stomach, I feared the moment I would be zipped into the scarlet competition gown.

With news that the piano had finally been repaired, I rushed from my judges' interview to the commons area in Sherley Hall to see for myself. To my dismay, several girls waited to take their turns on the keyboard. No longer did I have the luxury of time for practicing. I begrudgingly changed into my Southwestern outfit—the drapery affair—for an early dinner, once again for Mexican

food. Unbeknownst to me, Miss Texas pageant officials, including a former business owner of El Paso's Pancho's Mexican Buffet franchise, were courting Guy and Rex for their participation on the Miss Texas Pageant State Board. If I had known, the pressure would have been almost unsurmountable. Though I bucked the boys, I wanted them to be successful too.

While the other girls were getting their makeup and hair ready and with just two hours until the first night of preliminary competition, I again tried the upright down the hall from my room. Besides, Barbara would come to my room last to check my own job with makeup and hair. The old piano begrudgingly gave way to my hands, but my fingers seemed sluggish and the piano keys stiff. The intricate piano melody that should have flowed quickly from key to key was dull and laborious. Once I began making mistakes, my playing only got worse. I was devastated.

At 8:00 p.m., the 1971 Miss Texas pageant officially opened in front of a full house of 3,000 spectators with a parade of contestants from all over the state. Each preliminary competition night mimicked the schedule of the final night when the new Miss Texas-Miss America would be crowned. Enhanced with brown sateen evening gown gloves, I wore the full skirted, chocolate-brown chiffon gown with the gold jeweled halter. Hilda Harrell later described my look as "outstanding" for the *El Paso Herald Post*. Another journalist noted that when Miss El Paso walked onto the stage in "an original Guyrex creation of El Paso," the audience's "oohs" and "aahs" became a collective muffled gasp of disbelief. No one had a gown this color nor with such a unique design.

I waited anxiously backstage for the Miss Texas-Miss America
pageant's opening parade of cities while wearing the Guyrex
chocolate-brown gown. This initial showing later helped put
Guyrex in the national spotlight as evening gown designers.
(Author's Collection)

Backstage, Barbara helped me change from the chocolate
dress into my scarlet competition gown. Remarkably, my midriff
required no squeezing to fit the dress's nineteen-inch waist. It
zipped perfectly, and Barbara stood back, beaming. By the time I
appeared in my turquoise designer gown with the silver beading
for the evening's finale, there was no doubt that Guyrex had awed
Miss Texas pageant officials, audience, and other contenders.

A newspaper reporter noted that residents of Dallas-Fort Worth, who primarily shopped at Dallas's Nieman Marcus and were the "oft-lauded cream of Texas culture, simply could not believe that El Paso had freeways, buildings over five levels, and especially formal dress designers of 'original creations' as that worn by Miss Little."

At home, a week later, the El Paso Del Norte Department Store advertised imitations of Guyrex's designs for its customers, starting with the chocolate gown. While Miss West Texas and Miss Waco won the first night's swimsuit and talent competitions respectively, I had dazzled an incredulous audience in my evening gowns, and the boys couldn't have been more pleased.

The old piano sat in the corner of the commons daring me to conquer its yellowed keys. I sat on its scarred wooden bench and began to play. When I reached the third transition in my piece, my fingers stumbled. I tried again. This time my blundering brought tears. Though I wasn't worried about my waist anymore, I was exhausted from the previous days' schedules and lack of sleep. Performing my talent competition well was all that mattered now. I repeated the music again, and again, but I could not play my piece mistake-free. Why should I have played the medley perfectly? I hadn't successfully performed the piece—ever. Was it karma? I bent my chin to my chest and prayed.

"Please, Lord, let me get this right."

But I didn't get it right, and it was 3:00 a.m. I turned off the light and made my way back to the dorm room. I had less than three restless hours of sleep before everything would begin again.

Chapter Eighteen

Wild Imaginings

The ballet dancer suspended briefly en pointe, her arms
held wide above with her fingers spread delicately down-
ward as if beginning a karate crane stance. As the dancer prepared
to spring, amplified strains from an orchestra filled the enormous
cavern of the Tarrant County Convention Center Hall. Memory of
an earlier talent act with a lethargic cheetah flashed through my
mind. At the time of the Miss El Paso pageant months earlier, I
never would have dreamed I would be watching another rendition
of "Born Free," let alone worrying about a new talent performance.

It had been Group C's time for a morning talent rehearsal,
with many contestants incorporating the Miss Texas pageant or-
chestra's musicians. Earlier, Guyrex had sent a prepared orches-
tration for my presentation. The plan was for the musicians to
provide accompaniment at key dramatic points during the *Love
Story* piano medley. This was problematic. When it was finally my
turn on the stage, the musicians had difficulty keeping up with
my playing. I muddled the piece from beginning to end, rushing
through the missed keys, much like my earlier local preliminary

performance. The new sound system in the convention hall picked up every missed note.

The official Miss America pageant brochure had stated that talent "is actually believing in what you are doing, to the point that you sell that idea to your audience." Thelma Hurd had collaborated with me on facial expression and dramatic body language while my fingers were to fluidly dance across the piano keys for a convincing performance. The audience wouldn't just be listening. They would be watching me and supposedly feeling the pain of actor Ryan O'Neal's character as he both acquired and lost his love in the movie *Love Story*. But I was not like Guy and Rex. I was no illusionist. I may have shown like a professional contender in the evening gown competition, but Group C's girls sitting in the auditorium now breathed a collective sigh of relief. I was no threat in the state talent preliminary.

Exuberance was clearly lacking when we stepped back into Sherley Hall. Most girls were bone-weary and looked forward to a few hours rest before an early dinner at Jimmie Dip's, a local Chinese restaurant. No feminine squeals sounded as we robotically walked to our tables to pick up cards and flowers, not even a squeak. At my table among a scattering of cards was a red rose bouquet. Its card read, "To Janie, Miss El Paso, wishing you luck tonight. Miss America 1971, Phyllis George." Though I should have been thrilled that Phyllis had taken time to wish me well, the knowledge that one more person would soon witness my shortcomings did nothing to lift my spirits. I felt like a fake.

Guy and Rex, meanwhile, had already proven their proficiencies through our grand entrance, my wardrobe, and personal appearance. Talent was on me, my responsibility. Several years later, a more experienced Richard Guy would observe, "We can't create talent. Judges shouldn't support someone who's a trained

seal." Yet, in their first year of the boys' beauty queen pageant business, like the seal, I was expected to perform beyond my natural abilities, balancing a sphere of pretense in my talent act.

The *Fort Worth Star-Telegram* included a full-page photo gallery of all sixty-three girls encircling a central advertisement for a fashion show at Leonard's department store. Half of us would be models the next day. I sat on my bed and studied the photographs. So many beautiful faces. I had already picked out my favorites, girls who were destined to win this week or in the next season of competition. They were elites who carried themselves with confidence and never appeared worn out, nor, like me, on the brink of panic.

I had not been able to talk to Mother or Daddy since we arrived, and conversations with Guy or Rex were one-sided. I wished they could see the old piano. Then, I changed my mind. Guy, especially, would be sick to his stomach if he knew my struggles. Sighing, I left the room to find the piano for one last attempt at salvaging my talent competition. But again, my fingers couldn't strike the right notes.

After dinner, we headed back to the convention hall. This evening was the second preliminary competition in all categories. Group A would compete in evening gown, Group B in swimsuit, and my group in talent. We opened on stage with the parade of cities, I in the turquoise gown, then another production number, and the competitions, with Maria Beale Fletcher emceeing and Phyllis George making a special appearance. The hall was jam-packed again, the boisterous El Paso delegation sitting in the center of the audience.

Backstage, just before the talent competitions began, Barbara pulled the pink gown over my head and shoulders. I looked at my reflection within a brightly lit mirror. A fairy princess, with ash-

blonde hair framing an anxious face, looked back at me with wide blue-green eyes. Her illuminated skin was flawless, with tanned naked shoulders rising above a bouquet of pink roses. Hard to imagine that at one time, I had been so curious about the abundance of freckles on my face that I resolved to count them. Taking a ballpoint pen, I put a dot on each freckle as I counted. By the time half my face shown purple like a wild plum, I gave up. Mother had scolded me for making a mess of my skin. My "guinea egg" freckles would fade in time, she said. And she had been right.

I straightened my spine without Barbara having to remind me when I noticed other girls staring at my back in the mirror's reflection. They had halted their own preparations, their mouths agape with wonder. If anything, this was my moment, standing among the other contenders in a gown they couldn't have imagined wearing. Even if I flubbed my talent presentation, this moment— wearing the pink dress specially designed for me amid the other envious girls—made all the starvation and hassles worth it.

Barbara set aside my special pink pumps for later, ones that she had painstakingly covered with individual rose petals. "Don't forget to put these on," Barbara cautioned. But I never remembered to change out of my turquoise satin shoes.

The curtain opened with me sitting at an ebony Steinway grand piano on a vast stage against a backdrop of midnight-blue velvet. A newspaper the next day reported the backdrop complemented the pink rosebud gown and that Miss El Paso was "breathtakingly beautiful." But this wasn't a beauty contest. It was about talent.

I turned to the audience and nervously smiled into a blackness that suddenly became silent as a tomb. I knew there were thousands of spectators sitting beyond the stage lights, and among them,

my mother who expected me to achieve, as I had always done in the past. Taking a deep breath, I whispered a small prayer and placed my hands on the keys.

My fingers gently began to play the poignant *Love Story* theme. "Where do I begin to tell the story?" the lament filling my brain as I mentally sang the song's opening lyrics, and my hands began to move over the keys. From out in the black abyss, flutes and strings softly played with me. "With her first hello, she gave new meaning to this empty world of mine."

As I approached the first orchestrated shift in the medley, something strange began to happen. My fingers began to take over without my deliberate input, much like an athlete's muscle memory. "She fills my heart with very special things, with angels' songs, with wild imaginings," the words exploding in my head. I stared down at my fingers flying across the keyboard, wildly imagining myself as an observer of another pianist's hands. Immediately, my hands shifted to a waltz, a portion of the medley that had been quite easy to play. I moved my body with the music, just as Thelma had taught me, while my fingers played on.

After weeks of trying to conquer my piano piece for talent
competition, I played the *Love Story* medley flawlessly while
wearing the pink dress. (Author's Collection)

By the time I reached a section containing the classically
complex "Sonata in F Major," I no longer even heard the Miss
Texas pageant musicians. Instead, I stared at my fingers' reflection
in the piano's polished black fallboard, mesmerized at their
rapid movements. I wasn't doing the playing—another entity had
taken over. Perhaps an invisible angel? So profound was this
happening, that the memory of viewing my hands as an out-of-
body experience would still be vivid fifty years later.

When I returned to the initial theme from *Love Story*, I relaxed,

singing the final lyrics in my head, "But this much I can say, I know I'll need her 'til the stars all burn away. And she'll be there."

The piano piece over, I rested my hands. I had hit *every single note*, dead-on.

The applause was deafening. I rose slowly, as if in a dream, with an enormous smile on my face. Then I remembered to bow and walked off stage in my turquoise shoes, my pink gown flowing behind in soft layers. Thelma, sitting in the audience next to Mother, burst into tears. Though I would not win the talent competition this evening, I had been perfect in the pink dress, and that was enough for me.

Chapter Nineteen

The Dealmaker

*E*arly the next morning, I woke from a hard sleep. Only swimsuit competition was left unless I placed in the top ten. Then I would repeat all three contests on Saturday night. I decided not to borrow trouble, resolving to enjoy an easy day after breakfast and morning rehearsal. I looked forward to being a novice model for the Miss Texas Fashion Show at Leonard's department store in Hurst, a suburb of Fort Worth.

Guy, Rex, and Barbara, ecstatic over my performance, had not shadowed me at breakfast or at rehearsal. I didn't even see them at the fashion show where the current Miss Texas, Bellinda Myrick, emceed. I don't recall what I modeled or how I felt when I walked among the chairs filled with shoppers. But I do recall Phyllis George who performed "Raindrops Keep Falling on My Head," from the popular *Butch Cassidy and the Sundance Kid* movie.

Phyllis began playing the piano piece that helped her win Miss America the past September. She bent over the keyboard with a serious look on her face and immediately made a mistake. Her brow furrowed, and then she hit another wrong key. She

looked out into the audience—and toward us—and smiled sweetly. Then she exploded into the musical piece, almost laughing at her joke, her famous dimpled grin crinkling her face, as she played flawlessly. Why hadn't I noticed her schtick before? Had she endured problems playing her piece at one time and developed a way to compensate for future errors?

Later that night, during the third preliminary talent competition, the contestant from White Settlement received a three-minute ovation after singing "The Kiss" from the Italian opera *Il Bacio*—without a microphone. Just like Phyllis, the girl had managed to capitalize on a mishap, the convention center's equipment failure. Miss White Settlement won the third and last talent preliminary.

After my performances (including a perfect swimsuit presentation), more cards, local newspaper clippings, flowers, and other well wishes blanketed my designated table. Political figures promised to assist me when I returned to El Paso, the staff for the *El Paso Times* society pages let me know they were proudly following my every move, and others noted my parents' success in raising such a fine daughter. Mother and Daddy sent flowers with a note that said, "Miss El Paso, you're looking good!" Molly Coyle's parents, who surely were disappointed that their daughter was not at the pageant, sent a card that read, "We are sending you the possessions that count in life, Faith, Hope, and Love." I marveled at their kindness.

A myriad of assorted souvenirs, sweets, and good luck items from many of the sixty-three contestants covered my table. By now, another competition was full-blown behind the scenes, that of Miss Congeniality. I regretted that I had not brought tokens from El Paso. But Guy and Rex intended me to win Miss Texas, not Miss Congeniality.

On Saturday morning, July 10, the daily wardrobe list next to my closet door was brief. I would have only two changes before the final segment of the Miss Texas pageant. At our last breakfast in the TCU cafeteria, girls walked from table to table, handing out flowers while wishing their competitors good luck. My hostess gave my roommate and me large cards that she had gaily decorated, telling us how she enjoyed being our hostess. I, too, was ready for goodbyes. I truly didn't believe I would be named Miss Texas, but I knew I had shown well during the week. I was expecting more action to come, and so did the press that was covering me.

Another morning rehearsal at the convention center brought us all on stage for a new set of instructions. While the last three evening competitions had been in front of packed audiences, tonight's final competition would be televised in eight million Texans' homes as well. From Amarillo to Port Arthur, the broadcast would reach sixteen cities. For some reason, the El Paso market was snubbed. The telecast reached only as far west as Midland-Odessa.

The event had less than three hundred tickets available the previous evening, and the production promised a sellout. Contestants' photos were dispatched all over the United States, and newspaper reporters from Texas and beyond keenly awaited the final moment when the new Miss Texas was crowned. By now, we were accustomed to programming, production acts, and our judges, including former Miss Americas and Miss America pageant officials. But the Miss Texas pageant officials threw a kink into the novice contestants' path.

The top ten contestants would be announced early *before the telecast* at 10:15 p.m., though a portion of the evening's show, including final swimsuit competition, would begin in front of the convention center audience only, just after 8:30 p.m. Once

the telecast program began, we were instructed to act surprised as the semifinalists' names were called out for a second time. The audience, watching the 1971 Miss Texas-Miss America pageant in their living rooms, would have no idea.

I was alarmed and confused. The announcement would be delivered twice in humiliating blows unless I was one of the girls named semifinalist. Because of Guyrex's blanket marketing, El Paso supporters expected my continued success. More importantly, I coveted being honored a Miss Texas pageant semifinalist.

I plodded through morning rehearsal, agonizing over the evening's plan. For once, I couldn't eat when a caterer delivered our lunches. With my stomach in knots, I joined the others repetitively rehearsing the parade of cities, various production numbers, and what to do when the top ten were called out. I saw Guy and Rex conversing with B. Don Magness at several intervals during the day, all with big smiles on their faces. Had B. Don told the boys that I had done well? That I was in the running? At 5:00 p.m., when we finished rehearsal, I peeked inside another catered box dinner, but its greasy KFC aroma turned me off. What was wrong with me?

An El Paso KTSM television reporter, who had waited pa-tiently for me to finish rehearsal, asked how I felt about the evening. In answering him, I realized that I desperately wanted to be among the top ten for Guy and Rex, my parents, and the city of El Paso.

I didn't want to return home a loser.

At exactly 8:30 p.m., the Miss Texas pageant orchestra began its "Celebration" overture, while all sixty-three girls stood divided in the stage's opposing wings, ready to walk out during the parade

of cities. When the curtain opened, we marched in the pattern we now knew so well, each of us finding our final mark for the opening ceremonies. A heightened sense of anticipation and fear pervaded the atmosphere.

Wearing my scarlet gown, I stood in the back row while former Miss America and emcee, Maria Beale Fletcher, welcomed the audience and began introductions of visiting state queens and other former Miss Americas in attendance. Without delay, she announced the Miss Congeniality winner, and everyone clapped politely for Miss Big Thicket, though we had enough butterflies in our stomachs to float to the rafters. The semifinalist announcement was next.

Fletcher began calling out the girls slowly, each stepping down to the stage as we cheered with false hearts. Miss Denton, Miss Southwest Texas State University, Miss Rusk County, Miss White Settlement, Miss Dallas, Miss West Texas.

I looked down at my toes. This did not bode well.

Fletcher continued. Miss Fort Worth, Miss Waco, Miss Haltom Area, and Miss West Texas State.

No Miss El Paso.

A feeling of extreme disappointment—no, despair—turned my stomach sour as my frozen face tried to smile. My lips twitched and tears welled in my eyes. Like the other girls, I mechanically clapped. For me, the pageant was over, though I would have to repeat the last thirty minutes for the television broadcast and dance the despicable hoedown production number one more time. Bearing our obvious disappointments, we were ushered off the stage while a production number entertained the audience so that the semifinalists could prepare for swimsuit competition.

The televised parade of cities and announcement of semifinalists repeated forty-five minutes later. And while the top ten

prepared for their talent competition, the rest of the contestants were sent backstage again. This time Barbara was waiting for me in the dressing room. She smiled and said, "Janie, quickly put on your pink dress!" I didn't ask why since by now I was just following the motions—emotionless—like a made-up automaton. Barbara knew something that I didn't.

Miss America Phyllis George, a former Miss Texas, was featured guest at the 1971 Miss Texas-Miss America pageant.
(Author's Collection)

Special guest Phyllis George glided out on stage to the tune of "We've Only Just Begun," and joined Maria Beale Fletcher. After

small talk, Fletcher explained to the audience that the talent competition portion was about to begin. Then she turned to Phyllis and announced, "The judges selected two nonfinalist talent award winners! Should we call them out?"

"I think so!" Phyllis grinned to the audience.

"Please come out, Miss El Paso Janie Little and . . ."

I recall feeling numb, right down to my toes, as I walked out on stage in my pink dress to receive a trophy and a scholarship. Phyllis smiled at me, and I looked back at her, embarrassed. I didn't deserve this award. I knew that for a fact.

At the end of the pageant, Janice Bain, the Miss White Settlement opera singer and second runner-up from the previous year, won Miss Texas. The first runner-up, Miss Fort Worth, had been third runner-up the past year. Of the ten semifinalists, six were from the Dallas-Fort Worth area. As for my Tri Delta sisters' expectations back in El Paso, Janice Bain was a Zeta.

Afterward, my family members, the Barringtons, and Guy and Rex huddled together in a receiving area outside the hall. Mother smiled at me and then turned to talk to my aunt. Smiling with pride, Daddy reached out to hug me now that the onerous rules no longer mattered. He began telling me how proud of me he was, promising to take me anywhere I wanted, to eat anything I wanted. But I didn't feel much like eating.

When I looked at Guy, I saw that his face was tight with shock. His dark eyes looked much like they did when he told us about Molly Coyle's exit from the Miss El Paso title. He tried to smile, but it was pointless. We shared the same grief.

Then B. Don Magness approached me, smiling as he began a profuse apology. Guy and Rex had already heard his confession,

and they stood by expressionless like stone statues. I was stumped. What did he have to be sorry for?

"Janie, I am so sorry. I thought you were within the numbers for the top ten, and when we pushed another girl up, you dropped out of range. The judges were just as shocked as I was when they discovered what had happened. But congratulations on the Talent Award. I hope you will come back next year," Magness said, presenting his charming smile.

Mother had paused her conversation with her mouth hanging open, followed by her lips silently forming, "Whaaat?"

I knew that look and avoided glancing toward her face as she tried to puzzle someone else's mistake.

So that was it. In manipulating points to get certain girls into the semifinalist group, my position dropped to number eleven. And just like I thought, the Talent Award was a consolation prize that I did not earn. By recognizing El Paso with the award, Magness had made a sly deal, in hopes of keeping Guy and Rex engaged with the Miss Texas pageant.

A vaguely familiar man with glasses abruptly interrupted Magness, cutting into our conversation, providing an opportunity for Magness to make a quick departure, his diplomatic errand complete. The gentleman grabbed my hand and vigorously began shaking it, at the same time introducing himself as one of the pageant's judges.

"You were wonderful, just wonderful this week! I want to congratulate you. In fact, you should have been a finalist." He paused. "Is there any way you would consider selling the gown you have on? My wife has fallen in love with it!"

The pink dress. I dully declined. Turning to my father, I said, "I think I'll have a stack of blueberry pancakes now, and some cheese, and maybe a chocolate bar."

Chapter Twenty

The Texas Sidestep

*T*he telephone rang on the wall in our kitchen on Bastille Street. Just as in high school, I raced to be the first one to answer. It was Tuesday, three days after the pageant concluded and one day after my nineteenth birthday. I plopped into an easy chair sitting below the phone, the lounger sliding backward into a paneled wall with a familiar *plunk*. Several bullet-like holes smudged with pencil lead peppered the chair's right arm where I spent endless hours talking to friends while twisting a pencil into the tan Naugahyde. Mother hadn't cared. In the kitchen, she could monitor everything my brother and I chatted about. I stretched the coiled phone cord and leisurely leaned back. Mother was nowhere to be seen.

"Hello?"

"May I speak to Janie?" a man's soft voice spoke on the other end.

"This is she." I remembered my proper English.

"Have you found work for the summer?" the voice turned creepy.

"Who is this?" I queried, losing any politeness. I had expected birthday congratulations.

Ignoring my question, the speaker continued. "I'm a mortician at [indistinguishable] funeral home and want to offer you a job." The caller giggled, followed with a morbid joke about the dead. Instead of hanging up at the prank, I froze, waiting for more.

Then the man began laughing outright.

"Janie, this is Jay Armes. Would you be interested in working for me this summer?"

A moment of relief. I knew him to be gracious, but he had unsettled me with the macabre approach, even scared me. I had received several job offers before the Miss Texas pageant. But one place I would never work would be at the Investigators, Armes's agency. Nothing personal to Jay Armes, but I wanted to steer clear of anyone associated in any way to Guyrex.

I paused to frame my response.

"No sir, I'm going to work for my dad," I firmly answered. Then I remembered to add, "But thank you for asking," as if the employment offer had been normal.

With a job at my dad's accounting office, there would be no drama, and I could retreat, as was my habit in uncomfortable circumstances. In retrospect, working at the famous private eye's agency might have been enormously interesting in view of what would happen during the next year for Jay Armes.

Daddy was still beaming about my performance at the pageant. At work, he could show me off. While I typed quarterly forms, W-4s, and performed mundane office tasks, his secretary, bookkeepers, and clients complimented his extraordinary daughter in his presence. He was no gloater, just extremely proud. Mounds

of congratulatory letters and cards, often with attached newspaper articles from dignitaries at home and across the state fueled more celebrations at the office. When Hurd Distributing dropped off its copy of the annual chamber of commerce magazine, *El Paso Today, Guide to El Paso and Juárez*, we put it on the visitors' table open to where I was pictured and described. And, Dad had just taken on Guyrex Associates as a client.

But life had not returned to normal at home following the Miss Texas pageant. Though my parents were still searching for a property over the Franklin Mountain in El Paso's Upper Valley, Mother had lost interest in me. She no longer monitored my activities or asked questions regarding my private life. Perhaps it was the Valium.

Her earlier "care" of me had often been extreme, based on accusations that she had conjured up as she spent hours alone at home imagining my failings. My father's abrupt absences for hours at a time and weekend fishing trips with "the boys" negated any preplanned punitive responses. My "attitude," however, was always an attention-getter.

My last whipping occurred when I was fifteen, but Mother now resorted to slapping my face when I spoke back to her defiantly. Quite frankly, I probably needed an attitude adjustment, but being smacked in the face was about as demeaning a punishment as anyone can dispense. Recently this, too, had come to a halt after I finally caught her arm midway during an impulsive assault. I looked directly in her surprised eyes and calmly told her, "Never again. Don't you dare slap my face—ever again."

Our relationship strained like a circus tightrope, and there was no safety net to prevent total destruction. I didn't care. I was too old to throw myself on my bed in my room where I could turn up my hi-fi to loud decibels and tune her out. The thought of

moving out on my own never occurred to me. I couldn't earn enough to pay expenses even though the Miss Texas and Miss El Paso pageants' scholarship awards helped finance my coursework.

While I had begun receiving various marriage proposals in the mail and over the telephone (thanks to a final count of twelve million television viewers and not exactly what my mother had envisioned), Richard Guy and Rex Holt basked in their newfound success extending nationally. In one newspaper article, Guy claimed that Phyllis George had told him that she "had never seen a more beautiful and complete wardrobe, even in the Miss America contest, than that of Janie's." In another interview, Guy gave credit for my appearance and poise to Barbara Barrington, "a former Miss El Paso, who spent several weeks of twenty-four-hours-a-day training and grooming [me] for the contest." State officials noted that "Miss Little's wardrobe was the finest ever seen in a Texas pageant."

Now both Phyllis and Janice Bain, the new Miss Texas, would be fitted for new Guyrex gowns in the coming days, both dresses to be worn at September's Miss America pageant in Atlantic City. The women weren't shopping at high-end department stores in Dallas but coming to the far West Texas town of El Paso. B. Don Magness's shrewd deal was about to come to fruition, and El Paso would join other Texas cities on a state map of sophistication, much to the delight of the city's leaders.

While we awaited Janice's arrival in late July, Guy and Rex scheduled my personal appearances for the rest of the year, part of a marketing campaign that would culminate with the next Miss El Paso pageant. A magazine article later quoted them as stating, "Miss El Paso is at the beck and call of the city. She doesn't give kisses away in a bazaar, but those who want her to make an appearance may arrange it." And, they had.

Janice, along with B. Don Magness, flew into El Paso midday on Wednesday, July 28, just two weeks after the conclusion of the Miss Texas pageant. I can only imagine what Janice thought when she saw the barren landscape under cloudless, azure skies, excepting a scattering of greasewood and creosote bushes slowly looming from the desert floor. The rocky Franklin Mountain, sage green at noon, would have captured her attention, and then, as the plane circled, poor Mexican adobes strung along the brown Rio Grande like earthen clay beads. Interstate 10 separated the Mexican shacks from downtown El Paso where twentieth-century buildings pinnacled above frontier brick and stuccoed-adobe businesses.

Janice would stay at the Barringtons' while she was in town for her talent competition gown fitting. B. Don, who had overseen each Miss Texas's wardrobe for the past ten years, had previously sent Guyrex Associates her measurements. The plan was for Barbara to work with Janice on makeup, hair, and walk while I entertained Janice in her free time—time that I knew from my own experience would be limited.

At twenty-one years old, Janice Bain was an experienced competitor, having participated in the Miss Texas pageant multiple times before finally winning the crown. Brunette and taller than I, she exuded confidence, which was good considering she was about to meet an eclectic array of El Pasoans. Guy and Rex had planned a reception and party at their 1304 Montana Avenue headquarters to show off Miss Texas and their successes. Janice was also an entertainer, and the guests would not be disappointed.

That evening, a receiving line formed with me standing next to Janice, she in a full-length skirt in autumn colors, and I, in my red, white, and blue hostess gown. "Slim columned," a newspaper had called my dress, which, obviously, pleased me. I struggled

with my task to introduce Janice to the 125 guests who attended, crowded onto the black-and-white checkered floor. My parents stood in a tangle of cocktail dresses, suits, and ties, and I spotted the Rheys and Chagras, decked in metallic and beaded formal-wear and black suits. Guyrex Associates had also invited former Miss El Paso pageant contestants, several of whom brought their parents. Like the Miss Texas pageant and its rotation of competitors, the boys hoped to entice previous contestants to compete again. If B. Don or Janice originally believed El Paso society was provincial compared to Dallas-Fort Worth, they concealed their surprise.

As soon as the last person made it through the gauntlet, I gave a general welcome and introduced B. Don Magness, chairman of the Miss Texas-Miss America Board. He assumed a prominent position on the first steps of the foyer staircase above a packed audience. Taking his trademark cigar out of his mouth, now soggy from chomping, B. Don smiled at the Guyrex fandom. His flamboyance was now known, as was his penchant for colorful jokes and self-promotion, including a T-shirt that read "Matthew, Mark, Luke, and B. Don."

When I reminisce about the moment now, I hear B. Don's voice, so like that of actor Charles Durning's when he sang, "Oooh, I love to dance a little sidestep," in the movie musical *Best Little Whorehouse in Texas*. Like that scene, I would not have been surprised if trumpet fanfare had announced B. Don's magnificence before he gave his momentous remarks. (With such a flourish, Durning had opened with, "Fellow Texans, I am proudly standing here to humbly see. I assure you, and I mean it. . . . Fellow Texans, I'm for progress, and the flag, long may it fly!")

But there were no trumpets. Just a room full of eyes frozen on the stout official resembling Durning. The king of pageants

was about to announce progress in the realm of Texas pageantry.

He first congratulated Richard Guy and Rex Holt on Miss El Paso's performance at the state pageant. Standing to the side below, Rex smiled widely and Guy grinned nervously. They knew what was coming next, and Guy's dark eyes revealed pure joy.

"Because of Janie's performance and preparation," B. Don paused, "Guy and Rex have been elected to sit on the Miss Texas-Miss America Pageant State Board of Directors." The room gave a collective Texas whoop. B. Don continued, his manicured hands quieting the audience. "Their cooperation and talent are reasons for El Paso's inclusion in the statewide board governing Miss Texas. A wonderful honor," said B. Don. Smiling toward Guy and Rex, he added, "There are only six members sitting on the board." I wondered who had been voted off to make room, not unlike my own experience.

The audience clapped furiously, and B. Don Magness side-stepped his way among the guests, cigar back in mouth, while people patted his back. The "little error" made in my judging at the Miss Texas pageant had been assuaged. El Paso now had a major voice in one of the most prestigious Miss America state pageants. And, that pageant had gained a creative genius for set designs, costuming, gowns, and queen preparation.

As if to confirm the benefits of the new arrangement, Janice Bain, who had disappeared upstairs as soon as B. Don began his remarks, descended the stairs in her new Guyrex creation. The gown was made of chiffon and lamé, like layers of sheer tissue in rich shades of scarlet and gold, as one reporter described it the next day. Circling Janice's waist and separating her breasts was a wide band of handsewn sequins, my mother's design. Unlike my gowns, Janice needed no augmentation. Her full bosom within the low-cut bodice rose and fell as she began to sing.

Beginning with two old-time but popular favorites, "The Kiss Waltz" and "You'll Never Walk Alone," Janice concluded with the operatic Italian art song from *Il Bacio*, the one she performed without benefit of a sound system during preliminaries at the Miss Texas pageant. She planned to perform all three numbers at the upcoming Miss America pageant. Janice's gown would be a first for El Paso when the creation would be worn on the runway on national television. Her strong, soprano voice dominated the ballroom at 1304 Montana Avenue. Afterwards, the audience left fulfilled and honored that Texas's East had come West.

The next day, Ellen Rhey took Janice and me across the border to Juárez. Though she had previously given me a pearl and golden evening bag to accompany the scarlet evening gown, Ellen purchased a gold ring set with a large garnet for me. She also gave a gift to Janice to memorialize her first trip to El Paso. Later, at a restaurant, we were served fine fare, serenaded by a Mexican trio of guitars and photographed. Though Janice initially may have been uncomfortable with Ellen's kindness, she would return to Fort Worth with proof of the generous support and cultural diversity that cosmopolitan El Paso had to offer.

After completion of Janice Bain's gown, Guy and Rex turned to their Texas Avenue warehouse. They had already begun work on various floats for the upcoming New Year's Day Sun Carnival Parade. As for me, I finished out July at an opening for a local Cashway, a building supplies store. A drawing had been promoted for weeks, advertising one winning ticket for a brand-new GMC truck with a camper.

A crowd had turned out to celebrate the climax of the month-long opening celebration. Shoppers pushed their baskets near the front of the store at 2:00 p.m., the advertised moment for unveiling the lucky winner. A store manager presented me

with a cascade of red carnations and ferns. Then he dramatically shook the barrel container holding promise for one lucky person. My job was to draw the winning ticket and call out that name.

I stuck my hand deep in the tub, swirled around the tickets, and smiled at the families gathering around. I selected one ticket, lifted it up to my eyes, and tentatively read the name.

"Gee-sus . . ."

Immediately the manager grabbed the ticket before I could read the last name. The winner's first name was Jesus (hay-SOOS). I, an El Pasoan, had read a common Spanish name incorrectly. Shame flushed my cheeks. I should have known better, and I have never forgotten the embarrassment.

The rest of the year would be filled with more advertisements, personal appearances, television commercials, grand openings, and anything else Guy and Rex demanded of me. Besides these obligations, there was one more pageant—the Miss Texas USA pageant in April 1972. I wasn't finished by a long shot.

Even more confounding, strained relationships with my parents and Guyrex would continue to rend and pull at my life story like torn, loosened leaves falling out of an old book.

Chapter Twenty-One

Super Mex

ewspaper headlines shouted, "Astronauts Link Up Moonship!" on Monday morning, August 2, 1971. An El Paso geologist, Dr. Farouk El Baz, had helped plan the mission. On television, El Pasoans watched astronaut David Scott trip over a moon rock and fall into moondust. The event was certainly a momentous contribution to space lore, but an El Paso city proclamation had just stolen the bulk of the media coverage. The Super Mex, El Pasoan golfer Lee Trevino, had recently won the Triple Crown—that is, three major golf tournaments in one year. Only Lee and Tiger Woods ever accomplished the feat, the latter nineteen years later. The sister cities of El Paso and Juárez had coordinated a series of events for the next day to honor the famous Mexican American.

I had been in at least one of El Paso's newspapers almost every day for the past week marketing the events. Two days earlier, readers of the *El Paso Herald Post* had peered at me, modeling "the fashion trend for Tuesday's Lee Trevino Day," that is, white hot pants and a white T-shirt imprinted with an outline of a black sombrero. The shirt read "Lee's Fleas, El Paso, Home of Lee

Trevino." *Lee's Fleas* was the name Trevino had given his followers.

The shirt and hot pants had bled a solid white in the news-
paper, making me look all legs on white high-heeled sandals.
Except for Lee's famous red golf cap with its black sombrero
crest, tilting haphazardly on my head, I looked comfortable with
one hand on my hip and the other holding a golf club. The caption
urged everyone to dress in casual or golf attire, in red and black,
Trevino's favorite colors.

Dad had been thrilled with the most recent coverage. A
golfer himself, he wore my newest publicity like a badge among
his friends and clients. As for Guy and Rex, they had agreed to
my participation in the activities but didn't seem to have any clue
as to the enormity of Lee's popularity with El Pasoans and
Juareños. With their preoccupation at the warehouse, where a
Miss El Paso float was taking shape, I, alone, would attend the
events. I had been naïve as well. I had no idea that Lee Trevino
Day would be the highlight of my year as the first Guyrex Girl.

The next day's schedule included a morning parade from El
Paso into Juárez, a noonday luncheon at the Sheraton Hotel on
Mesa, an afternoon golf exhibition at Ascarate Park (only nine
holes to allow for Lee's clowning around), and a star-filled Lee
Trevino Appreciation Show in the Sun Bowl in the evening.
Singers, comedians, and actors Elena Verdugo, Charley Pride,
Bobby Goldsboro, Bob Newhart, and Jim Backus had been lined
up to entertain.

News media included *Sports Illustrated*, *Time Magazine*, and
the Associated Press. All three El Paso television stations would
cover the event, with plans to pool video for a nationally televised,
one-hour package. The special would include remarks from
Lee's friends, comedian Bob Hope, and golfer Jack Nicklaus,
filmed at an Ohio golf tournament a day earlier.

I arrived at McKeon Dodge on Airway Boulevard at 9:00 a.m. where I was given a name tag with a bright green ribbon and an official sponsor parking pass. The skies were slightly cloudy, but a weatherman had promised that our day would be the 293rd consecutive sunny day in the Sun City with a high of about 85 degrees.

The motorcade was supposed to leave at nine thirty, but we were fifteen minutes late after Lee Trevino, his blonde wife Claudia, and their children arrived, causing a stir. El Paso National Bank President Sam Young and El Paso Mayor Bert Williams had delivered Lee back to El Paso from the Ohio golf tournament on Young's corporate jet in time for the celebration. Lee hadn't been home since April. He shouted, "Whooee! I'm so glad to be home!"

The golfer certainly didn't have the look of an athlete to me, though he had won the US, Canadian, and British Open golf championships in a four-week span. A "fat guy" he had even called himself. He told one reporter, "Some of my friends call me a tanned *gringo*, but I'm Mexican, and I'm proud of it!" I was enthralled with his enormous personality.

Texas Governor Preston Smith, wearing a cowboy hat, greeted Lee. "I speak for all of Texas in expressing our gratitude for the tremendous relations you've brought for our state." I wondered if Governor Smith was wearing the hat Molly Coyle had presented him last April.

Lee shrugged. He said, "The more I practice, the luckier I get!"

When it was my turn to be introduced to Lee, he joked and winked at me. Obviously, this day was going to be fun. And Guy and Rex wouldn't even be around to see.

Lee Trevino's populist appeal was everywhere in the city. At that moment, "Trevino Country" flags flew on prominent build-

ings, and yellow bumper stickers could be seen on cars on both sides of the border.

Akin to a Cinderella story, Trevino had grown up in poverty in Dallas, born in a shack to a mother who was a maid and raised by a grandfather who was a gravedigger. He had dropped out of school by eighth grade, done a stint in the military, and discovered golf while shagging balls. After moving to El Paso in 1966, Trevino was named 1967 Golf Rookie of the Year. Then in 1970, he was named Top PGA winner. He had been only thirty years old.

Lee Trevino had become the embodiment of the American dream. But to me, a naïve nineteen-year-old in 1971, the personable, stocky Mexican American, clad in a blue Western outfit and cowboy boots, looked like he had dressed to perform in a mariachi band.

In front of a string of chauffeured cars, the Trevino family climbed into the seats of the first white convertible, Lee taking his seat on the vehicle's trunk. Governor Smith sat inside a second vehicle. Next was El Paso Mayor Williams inside his car, and then the Miss El Paso convertible.

I had never been in a parade before, at least one that I could recall—certainly not as one of the "dignitaries." I stood up on the seat, planting my bottom on the back of the car. I had dutifully dressed in Lee's favorite colors, a short red golf skirt with a white tank top. The lettering on my Miss El Paso 1971 sash added the required black accent.

Behind me were other VIPs, including Ted Karam, El Paso Chamber of Commerce president, and various city government officials in their cars, completing the twenty-car motorcade. A mariachi band decked out in traditional Mexican dress, their broad sombreros glittering in the sun, took its place in front of Lee's car.

With an El Paso Police motorcycle escort leading the procession, red lights blinking and sirens wailing, we slowly advanced west to Montana Avenue and then east on Mesa. People lined the course in the thousands, many waving homemade signs. Trumpets and guitars played Mexican street music to the front of us, competing with the sirens and joining the cacophony to the rear, military brass and percussion playing traditional American music. Amid the clash of musical genres, human voices united in their cheers.

¡Viva Trevino! Long live Trevino! *¡Bienvenidos!* Welcome!

The crowds increased as we neared the heart of downtown. Near the YMCA, boys and girls, who should have been in school, played drums made of empty ice cream tubs, painted in wild colors.

Ahead of me, I could see people surging toward Lee's vehicle, trying to touch him or get autographs on scraps of paper. He tried to accommodate them as best as he could in the moving vehicle. His car had to stop altogether when we passed San Jacinto Plaza.

During the Lee Trevino Day parade, our procession halted
because of autograph seekers, especially children. Moments later,
across the Stanton "Friendship" Bridge, government and other
civic representatives toasted Trevino in the *Palacio Municipal* in
Juárez, Mexico. *¡Qué Viva Lee Trevino, El Super Mexicano!*
(Courtesy of AP Images)

Business employees stood at their building doors and within
the masses crowded the curbs, waving. One lady emerged from a
beauty salon with curlers in her hair to wave at us. Others leaned
out of windows and shouted, "*¡Viva Lee!*" Lee returned shouts in
both Spanish and English.

I realized that I felt unfettered in the pandemonium. We
passed Guyrex headquarters earlier, but the boys weren't even
there. Guy and Rex were buried in fabrics and steel framing on
Texas Avenue. I waved until my arm became numb and my face
hurt from continuous smiling.

At the corner of Mesa and San Antonio Avenue, we turned
south and then moved east toward Stanton Street. At that point,
most of the marching and motorized units continued southward

to Paisano Drive. Only the first five cars proceeded toward the international border.

By the time we reached the Stanton Bridge with our police escort, the backs of my knees and thighs had begun to stick to the top of the backseat. In front of us, "Trevino Country" banners flew below United States flags, as ordered by the US commissioner of the International Boundary and Water Commission. We began crossing the international bridge but stopped midway. Mexican officials stood next to parked cars with their police escort rumbling behind them at an invisible demarcation between the Mexican side and American side. Juárez Mayor Bernardo Norzagaray and a Juárez city attorney formally welcomed Lee to Mexico and presented flowers to Claudia. Other civic representatives briefly honored Lee with a Juárez golf membership.

After crossing the international "Friendship Bridge," as Stanton Bridge was called, a new mob of Juárez's Lee's Fleas cheered our motorcade, now led by the mirror Mexican delegation. Little girls ran to my car, presenting me with paper flowers and wanting to touch the *gringa* with a crown on her head. Like El Pasoans, Juareños had turned out in the thousands. Later, our city police estimated there were over 30,000 people combined along the two parade routes.

According to a writer the next day, those who cheered the motorcade included "long-haired students and short-haired caddies, the country club crowd and kids who shagged balls on driving ranges. Women who never held a putter in their hands. Business and civic leaders. Sunday duffers and Saturday wingers. Miniskirted dolls with waist-length hair." I would have added ragged Mexican children running alongside our cars, bewildered Tarahumara Indian women on sidewalks, Mexican shopkeepers and bar owners, and entire families.

Our next stop was the Palacio Municipal, Juárez's city hall, the site of civil authority for centuries. It was behind the Our Lady of Guadalupe mission and cathedral, not that far from where Guy and Rex took me to the bar two months earlier.

Our motorcade stopped in front of the two-story structure, an impressive adobe building with inlays of sawn lava rock checkering the facade. On either side of the main building, single story wings extended out, previously housing for troop garrisons protecting travelers against marauders along El Camino Real. The garrison windows looked to be shuttered with their original wood and iron. I loved this history and could not wait to enter the building.

Above us, pigeons sat along the tall, flat roof, overlooking an ornately carved, oaken door on the second floor, its arch centered between two similarly magnificent windows, each with its own classical balustrade. In true Southwest form, above the door was a bell, and crowned above it was the Juárez coat of arms with the words *Palacio Municipal*.

Our little procession entered through a pair of arched, heavy oaken doors below, set within ornately carved stone scrolls. In front of us, a pair of sweeping staircases appeared opposite each other with murals of Mexican national and local history along each sidewall. I was swept upstairs to the inside of the mayor's office, along with the rest of the delegation members. White-gloved hands thrust a chilled champagne flute in my hand, and I stepped as closely forward as I could squeeze myself to watch proceedings.

Juárez Mayor Norzagaray stood in front of one of the upstairs windows, the light providing a soft glare behind him. To his side was Chihuahua Governor Oscar Flores. Norzagaray began, "We welcome this man who has strengthened international relations

between our two countries." The mayor then presented Lee with an engraved silver tray with a large, silver golf ball within. Then Norzagaray exclaimed, "He is American-born, but strong Mexican blood flows in his veins!"

The room immediately toasted. *"¡Qué Viva Lee Trevino, El Super Mexicano!"*

I took a small sip of my champagne, savoring the sweet, effervescent liquid on my tongue, the first I had ever tasted.

Texas Governor Smith piped up about the immense crowds in a celebration of two cities, recognizing Mexican citizens alongside Americans. Another toast.

Lee, standing in front of a dark portrait of former Mexican president Benito Juárez, thanked the mayor in Spanish. Then he paused—apologized for his lack of fluency—and switched to English.

"Only in a great country like the United States can a poor Mexican American like myself get where I am today."

"¡Salude! ¡Qué Viva Lee Trevino . . . ser un campeón complete!"

Champagne bottles appeared to refill glasses, while I nursed the contents I began with. Lee Trevino certainly had the gift of gab. I couldn't count how many toasts we made before finally departing.

"I thought I had had some thrills, but this is something," Lee said afterwards. I certainly felt the same.

The motorcade, along with the Mexican governor, returned to El Paso and the Sheraton Hotel for a luncheon. There, Lee received more accolades and an enormous diamond ring. "I think I'm going to go into the hock shop business," Lee quipped when he tried on the ring.

At Ascarate Park, the golf exhibition was to follow. I looked for actors Fred MacMurray and Jim Backus and comedian Dick

Martin, who had been invited to participate. Instead, Lee introduced me to singers Bobby Goldsboro and Charley Pride, the pair good friends of his. I knew Goldsboro's music intimately and was in awe at his celebrity. Slightly built with a head of dark hair cut like the Beatles, he appeared quiet at first, incongruent to the others.

Charley Pride instead filled the space with his warm personality. A jokester, he was gracious and funny. "Who do you listen to? Me or him?" He pointed at Goldsboro. I mumbled that I liked "Honey." Goldsboro smiled. Laughing, Pride offered me several Charley Pride albums he had been carrying to hand out to spectators.

The golf match began, and I drove home, looking forward to a relaxing bath. I heard later that some of Lee's Fleas became a little rowdy, and the match was cut short. As for me, this had been the best day of my Guyrex Girl life.

Part Three

We're the best now . . . we've created history.

—RICHARD GUY AND REX HOLT

Chapter Twenty-Two

Miss El Paso's Banner

Early in October my parents finally purchased an Upper Valley property, far from the Bastille Street Ladies' Club and their malicious gossip. The adobe house, built about 1915, sat on one and a half acres with its outbuildings and corral in the middle of a cotton field. To say the adobe was a fixer-upper is an understatement, even with the addition of a concrete-floored foyer and its two side bedrooms decades earlier.

Now, instead of west, the omnipresent Franklin Mountain loomed oppositely, beyond a row of stately Chinese elms shading our small yard. Adjacent to the yard, running north and south, an irrigation levy and dirt canal carried water from the Rio Grande two miles away. The canal also fed the fields, typically cotton and alfalfa, that abutted our land during planting season. Extending their roots into irrigation ditches sprouting from the canal, a smattering of ancient Fremont cottonwoods, their leaves now yellowed, promised a verdant summer oasis compared to North-east El Paso's desert landscape.

Still, the new home was twenty miles from our previous address, three-fourths of a mile from the New Mexican border, and

about five miles from Mexico as a crow flies. If Dad had intended to isolate Mother, this was about as lonely a destination there was to end a marriage. Mother just didn't see it coming. As for me, I continued to ignore their moments of marital discord. I loved the old house. It had history.

I tiptoed into the front foyer of our new home one mid-November evening, trying not to let my shoes click on the burgundy painted concrete. The room was cool and, like the rest of the old adobe, had no modern central heating or air-conditioning. I had been on a date, Guy and Rex having relaxed their rules regarding my social life after a dearth of personal activities. I stepped onto the original longleaf pine floor through two exterior French doors, which were now part of the interior of the house.

To my right, my parents' bedroom door stood half open. Soft light from a television sitting atop a tallboy reflected on their bed. Mother was curled up on her side facing the door, eyes scrunched shut. On his side of the bed, Dad was sitting up, his head leaning against a gold, crushed-velvet headboard, stained from his hair tonic. His glasses tipped toward the end of his nose, Dad was watching Johnny Carson and reading a Louis L'Amour simultaneously. Lazy curls of cigarette smoke furled from an ashtray in front of a reading lamp.

"Any problems?" Dad asked. Mother didn't stir.

"Nope." I said, pausing briefly at their door.

Before he could ask anything further, I cut the evening's ritual conversation off and scurried toward my room, not wanting to share details of my night.

Privacy had been at a premium. Our telephone sat in a kitchen wall nook. My new bedroom, directly off the living area, shared a Hollywood bath with my parents—the one bathroom in the house. Traffic streamed through my room. Worse, there was a

skunk inhabiting the crawl space under my bedroom's floor, a nervous rodent that sprayed every time it heard noise above, like at this moment.

Still, I counted my lucky stars, as Mother had always admonished me. With Guy and Rex preparing for January's Sun Carnival Parade and after months of promoting El Paso, my dad had tentatively promised that I could finally own a horse. I anticipated a sorrel with white stockings, just like the horse John Wayne rode when playing cowboy in the Westerns we watched at the Cactus Drive-In. Yes, despite the skunk odor and cigarette smoke, everything was finally going swell.

A slew of scheduled personal events in the previous weeks had occupied my fall evenings and weekends. I posed with pros at Ascarate Golf Course, judged a local beauty contest, cut ribbons at business openings along with the El Paso mayor, and participated in a Boy Scout event. Looking like June Cleaver, I posed in front of a spacious Tappan electric range with a 100-pound roast inside and, while wearing a swimsuit, perched on the top of a diving board over an imaginary swimming pool in 45-degree weather for a new YMCA groundbreaking. The organization had forgiven my juvenile Tri-Hi-Y infraction despite the Bastille Street Ladies' Club gossip.

Juárez had continued to claim Miss El Paso's celebrity. At the city's racetrack, I presented a trophy to a nondescript greyhound. The next week, a color spread boasted the relationship between Juárez and its sister city in a local newspaper. Under the headline "¡Córranle! ¡Ya Está Aquí!" (Hurry! You Are Here!), I smiled while wearing my Miss El Paso banner, which probably should have read "Miss Juárez."

In October, El Paso periodicals had continued the rallying cry "Miss El Paso, You're Looking Good!" unifying clubwomen, the military, and local merchants. On the front of the *Veteran Voice* newspaper, a photo captured a wistful US Army radiotelephone operator in Vietnam, "lost in thought." A banner above read, "It may or may not be our war, but they are our sons—pray for them." On the back of the newspaper was a quarter-page photo of me dressed in a new tweed suit, complete with white go-go boots and a miniskirt. In a disconnect, I held college textbooks to coordinate my look. College draft deferments had just ended for our American boys.

On another magazine cover, the *Southwest Clubwoman*, I was featured full-length in my scarlet competition gown with my Miss America crown and scepter. Inside was a recap of my preparation and performance at the recent pageant. The writer lauded Richard Guy and Rex Holt for my wardrobe. I now possessed $3,000 worth of clothes and accessories, awarded by El Paso's merchants, the same I had been wearing while promoting El Paso.

Two weeks after that, Guyrex's official Halloween Costume Ball at the Hilton Inn had brought all the original Miss El Paso regulars together. The fantastical event was the first of many parties, all of which the boys now called "balls," each with an entertaining theme, reminiscent of their early dance-o-ramas. The usual people attended.

At the door, the boys, dressed in black, greeted costumed guests who had prepaid twenty-five dollars a couple toward the Miss El Paso Scholarship Fund.

Guy exclaimed more than once, "You look MAAARvelous!"

Rex, cigarette in hand, grinned and giggled at the shenanigans. I suspected most costumes were borrowed from last year's Story Book Heroes themed float décor. Much like a Cinderella or

Dorothy from the *Wizard of Oz*, I was, as determined by the boys, to play hostess in an everyday dress and wander among the fantastical characters in their fairy tale attire.

My parents did not attend the Halloween party. They were consumed with remodeling the Upper Valley property. While Mother tackled inside the house, my dad and brother knocked down smaller outbuildings. After discovering spent Mauser shells in the fifty-plus-year-old adobe bricks, the clay taken from an area apparently where Pancho Villa had one of his skirmishes, I also chinked away with a sledgehammer, unconcerned with any bruises I might earn. We planned to add a swimming pool, and my father began building cinder block walls to encompass the yard. The combined efforts to restore the house and property should have indicated a refreshed family unity, but the old house couldn't remedy my relationship with my mother.

After saying goodnight to Daddy, I walked into our shared bathroom to prepare for bed. A waft of skunk lingered, overwhelming a Dove bar's dregs from an earlier bath in our iron tub. Across the small room, Mother's toiletries—eye pencil, eyelash curler, Maybelline mascara, assorted red lipsticks, and especially her treasured *Evening in Paris* perfume—scattered across a gold-flaked white Formica vanity—largely unused.

Recently, Mother had begun ignoring even basic hygiene when she arose in the morning, such as combing her hair and wearing deodorant. I stepped over her paint-splattered clothes, now her daily dress, on the dingy tile floor. As on other evenings, Mother hadn't bothered to change into fresh, clean clothes for my father before he returned home from work. I thought about his secretaries in their tight pencil skirts and

high heels and, if I could have, would have shaken some sense into her.

As in the past, my parents' arguments continued intermittently, often because Dad picked fights so that he had an excuse to leave, his shaving kit already zipped and waiting in the bathroom. When Mother predictably burst into tears, Dad would stand up, roll his eyes, and mutter something about a "goddamn mess . . ." and leave.

No one had any idea of Mother's increased dependence on Valium. Not surprisingly, any upcoming Miss El Paso appearances were out of her periphery now. Instead, my mother was in her own world, her mind set on having the old house ready for the Thanksgiving holiday.

In preparation for new carpet installation over the old floor, she prepped and painted and drank her Scotch and waters. Outside in frustration, Dad busied himself, tossing empty, crushed Budweiser cans into the crooked cinder block wall he was building. There was no escaping my witness to the inevitable dissolution of my parents' fractured marriage.

My heart skipped a beat when I discovered an ad in the newspaper for a horse sale at Indian Cliffs Ranch, a popular steakhouse and dude ranch east of El Paso, the week before Thanksgiving. I immediately cajoled my father into giving me cash for purchasing a horse. No judge of equine flesh, I had a friend with the knowledge to help me, and I was a decent rider. Besides, the house was ready for Thanksgiving and Mother was more relaxed. But not for long.

Daddy pulled five twenties out of his billfold. He grinned at Mother's shocked face. "Don't worry," he said, "the only horse she'll be able to afford is a one-eyed nag."

I sensed resentment immediately from Mother whose monthly house allowance had just risen to $350 a month.

At Indian Cliffs Ranch, a wrangler showed me horses that were for sale. None of them were sorrel. My friend and I walked among other enclosures, and then I saw him, a beautiful red face with a white blaze and intelligent eyes. He wore three white stockings. I dug through my memory about an old verse regarding horses with white feet.

One white foot—buy him,
Two white feet—try him,
Three white feet—look well about him.

A sign above the stable read "Red Baron."

We dragged the wrangler to the enclosure, and I asked if the sorrel was for sale. The man hesitated, "Well, my boss isn't here. He just told me to get rid of horses. The Baron wasn't supposed to be one of 'em. But I suppose we could sell 'em." Still, the cowboy was unsure.

The Red Baron was a seven-year-old quarter horse mix. He appeared sound when my friend examined and briefly rode him. She declared that the Baron was "a little hard in the mouth," as he resisted his bridle bit, "but that could be cured."

Disregarding how the horse worried the copper bit in his mouth, I asked, "How much will you take for him?" The twenties burned in my pocket.

"How much did you plan to spend?"

When I told the wrangler, he grimaced.

"This horse is worth a lot more than that. He's been trained to cut. He likes to run, and the owner uses him for polo."

My face fell.

The wrangler added, "We also call him Banner because when he runs, he holds his tail high like a flag."

My friend jumped up and exclaimed, "Miss El Paso's Banner! You can rename him!" Years later, an equine expert shared that it was bad luck to rename a horse. That would prove to be correct.

The wrangler deliberated a moment and then said, "Tell you what. I'll take $225 for him. Can you do that?"

Of course, I could! I stuck out my hand, sealing the deal. I would have spit in it if that had been necessary. But I would have to tell Daddy—away from Mother—that I had spent more of his money.

Because the deal was made just before Thanksgiving, we had to wait until the following Saturday to drive out to Indian Cliffs Ranch, a borrowed trailer in tow. With the additional cost, Dad still grumbled about the nag he was certain I had purchased. "Damn horse is probably blind and toothless."

"No, Daddy, he's beautiful. You'll see. He's healthy and young."

Dad looked doubtful.

It wasn't that my father was about to spend more money on a horse sight unseen—it was that I had even been able to make the deal. While the house had been made livable, we weren't prepared for a horse. No tack, no feed, just a broken-down corral.

Banner, as I now called him, loaded willingly, and we returned home with my prize, Daddy making smart comments the entire way. Later I stood in the corral, grooming my horse, and he nudged me to scratch his head. Daddy walked toward us with a drink and cigarette in hand. Banner stood still in his halter while I continued currying the dust out of his thick winter coat, his alert brown eyes studying the drink in Dad's hand.

"You are not to get on this horse until we get a bridle and saddle, you understand?"

I nodded absently.

The next morning, I pulled on my jeans, T-shirt, and jacket, and crept out of the house. A gunmetal-gray sky promised another dull November day. I only wanted to sit on my horse. At first, we walked and then trotted. But Banner had been taught to sprint. I was about to have the ride of my life when he suddenly began to run down the irrigation levy.

I squeezed my knees tightly against Banner's bare, red sides and crouched my head and shoulders over the animal's outstretched neck. My left hand futilely clung at a brown-and-white striped lead rope, so I clasped my other hand to a whipping shock of chestnut mane, the coarse hair twined around my fingers. I knew the irrigation canal ran through a couple of fields to the south of our Upper Valley house, dirty white with errant cotton debris—but little else. Had I been experienced, I would have known to use the lead rope to yank my horse's head sideways toward his flank, and he might have slowed. Instead, in my mind's eye, I ran with the horse. The levy of hardpacked clay blurred brown in sympathy below us. We flew as if racing an imaginary ghost rider.

For only an instant—the briefest of moments—I allowed myself to indulge in a thrill of self-autonomy. Unaccompanied, I had purchased the horse, proffering more money than I had in my pocket. And it had been I, alone, who made the decision to sit astride the untested animal—with no tack—disobeying my parents and ignoring my handlers' rules. A momentary thought of consequence worried my mind. I would pay for this rebellion if I survived what lay ahead. As for Banner, he flew because he sensed his mistress's need for reckless abandon.

We had gone about half a mile in the blink of an eye when we both saw it. Perpendicular to the canal levy, a paved road breached

our route. On the other side of the street was a three-strand barbed-wire fence. Beyond that, a five-foot deep, concrete culvert and then the canal wormed on. My horse unexpectedly sat back on his heels, rapidly sliding across the asphalt toward the culvert.

Then he decided to jump.

I leaned down and tucked my body tightly into a ball, my knees pressed upward as if pretending to be a small appendage growing from my horse's back. If Banner was going to jump the barbed fence looming ahead, then gluing myself to him was my safest alternative. I had already judged the out-of-focus ground to be a neck breaker, reeling silent static like an old, movie projector's fuzzy frames, and I was having none of that.

We almost soared victoriously over the fence, but the top strand, catching Banner's front legs, stretched, and snapped with a "pop!" Wrapping itself around my left ankle, the thorny wire jerked me backward like an outstretched coil spring while my horse catapulted above. Seconds later his back landed with a solid thud behind my head in the culvert.

After a pause, Banner jumped to his feet, lowered his head to sniff me as if to say, "I'm okay. Are you?"

Relief flooded me though I lay prostrate, uncertain if I could move my body. Only later would I realize that the recoiled barbed wire, painfully garroting my ankle, had saved me from severe injury, if not death.

I can't recall how we got out of the canal. I must have led Banner farther down to where we could climb up where the canal's dirt slope began. He had gashes from the thorny wire but no broken bones. As for me, I felt a numbness that was slowly transmuting to shame and fear. I didn't even notice my shredded blue jeans and my left shoe squishing sticky blood with each step I took.

Dad was furious. On the way to the hospital later, he declared, "I'm going to sell that goddamn horse to pay for your hospital bills!"

I grimaced with pain after Mother's old Camino hit every bump on the drive. But it was my heart that hurt the most.

The fence's barbs narrowly missed my Achilles tendon. With thirty fine stitches in my ankle and stretched ligaments, I left the hospital on crutches. It would take at least six weeks to heal enough to where I could walk unimpeded, perhaps longer. The Sun Carnival festivities were less than five weeks away. I was supposed to welcome headliner Phyllis Diller in my scarlet gown at a gala and stand on a float in a two-hours-long parade the next morning, New Year's Day, 1972. Guy and Rex would be disappointed in me, again.

In the end I kept Banner. We survived the escapade. But there would be scars. Unknown to all of those who tried to rein me in, my episode with Banner was a prelude. I was approaching the greatest stumble in my life with consequences I would have difficulty shedding

Chapter Twenty-Three

Three Queens and a Joker

Limping across a college campus on crutches has its
drawbacks. One downside is the certain tardiness to
back-to-back classes—certainly not good during finals week—
and the ensuing classroom interruption when the cripple fi-
nally arrives. She must find a front or rear seat, stretch out the
affected leg, and hide her burdensome crutches away from the
aisle. Another negative: everyone notices. On the positive side:
everyone notices.

It didn't take long before my affliction became a center of
attention for several UTEP football players. A couple of the guys
had sat in front of me in one of my history courses, where they
peppered me for explanations and answers to test and essay
questions. But now, a new face had joined our growing social
group. I became infatuated with the tall receiver, his curly raven
hair and ruddy face. Ace, as I'll call him, made me laugh.

Guy and Rex, who had demanded I forsake my social life
during the rigors of my reign, had no idea that they were losing
control once again. In fact, I had been severing my royal tether in

small increments since the past August while Guy and Rex became immersed in float preparations for the upcoming Sun Carnival Parade.

Now all poor decisions were on me. My grades for seventeen hours of coursework had plummeted, dropping below a 3.0 for the first time in my life. Later, I would have given just about anything to maintain the 2.56 GPA I was about to carry. Arriving late to class, begging special accommodations for missed lecture notes, and reduced test-taking time was not in my nature and did not motivate me. Meeting new boys did.

Though Guyrex had been in the float-building business for only four years, the whole affair blossomed into a lavish spectacle in conjunction with Miss El Paso's successful first year. In 1968, they had produced one entry, winning the coveted Sweepstakes Award. Of two entries in 1969, a float themed Cinderella won top honors again. Four unique Guyrex creations paraded down Texas Avenue in 1970 and six floats in 1971. For the upcoming Sun Carnival Parade, they were feverishly building at least fourteen of the twenty-two participating entries supporting the theme Once Upon a Time—quite a feat.

Some believed Guyrex designs worthy of competition in the prominent Rose and Orange Parades because their lavishly garbed characters brought national acclaim for design and originality. Guy boasted later, "Every New Year's Parade has a float theme, such as roses or oranges. Our theme is costume elegance!" The *El Paso Times* bragged that Guyrex's "costumes and set designs were as good as Broadway." Rex humbly emphasized that their designs for the El Paso parade just added attraction to an already glamorous event. Still, the clothing was so coveted by other cities that

Seattle had purchased the 1968 Cinderella costumes for its Sea-
farer Parade. Two hundred and forty original costumes plus their
Camelot attire from a guild's production the prior summer would
grace Guyrex floats for the 1972 Sun Carnival Parade.

As was their habit, the two men held a parade preview party
in the Crystal Ballroom at the Hilton Inn for sponsors and parade
participants at 8:08 p.m. on Wednesday, December 29, 1971.
After a formal showing of their famous float dress for hundreds
of press people and participants, everyone danced to the orches-
tral theme music of the Kingsmen. Guy later pointed out, "The
idea in having a preview modeling show is to make people want
to come out and see the floats in person on parade day." He
would apply the same principle to all future Guyrex pageants and
their finalist activities.

As in the past, the boys depended on the same supporters,
donors, and players, primarily from the Festival Theater Guild,
to participate in the parade—and that included Miss Texas Janice
Bain and me. Always scheming with grandiose plans, Guy claimed
he would have Miss America and Miss Universe on Guyrex floats
in the upcoming year.

I'm sure I attended the party on an unstable ankle, but I don't
remember the details. I had already begun burying dark moments
in my subconsciousness, with no plans to revisit certain events,
people, and words. Still, the next day—the last day of 1971—was
memorable when Janice Bain and I attended the Sun Carnival
Queen Coronation and Ball.

"My mother-in-law had a pain beneath her left breast. Turned
out to be a trick knee."

When comedienne Phyllis Diller delivered the lewd punch-

line, a packed house in the El Paso Coliseum erupted with raucous laughter.

The special event had begun earlier with a choral rendition of the National Anthem and announcement of dignitaries. First Miss Texas, and then me, followed by those in charge of the coronation. Immediately after the 1971–72 Sun Carnival Queen was proclaimed, officials placed a heavy crown upon her head, attached a white jeweled train to her shoulders, and thrust a scepter in her hands. I recall Dolores Pellicano, the new Sun Queen, looking like a deer in the headlights.

A choir had sung "Magic Moments" when the Queen of Laughter—more like a joker—ambled into the spotlight. Diller immediately complained about her state of life. She swiveled her head to assess her audience. Teased tufts of platinum hair interspersed with pink feathers exploded from her scalp.

The audience saw a slight woman wearing a hideous dodo-birdlike outfit. Diller's pea-green one-piece with a heavily jeweled yoke terminated into bell-shaped bloomers, and bedazzled butterfly wings jutted out of its back. At the ends of her bare, skinny legs were pink, sparkly ankle boots.

"Do you realize we are living in the middle of the world's greatest sexual revolution? What do you wanna bet that I end up on the losing side?" Diller quipped while pretending to flick imaginary ashes from a long, bejeweled cigarette holder.

She continued, cackling before and after a series of off-color one-liners.

"Something's happening to me and it's old age—and I'm too young to handle it!" Diller added that her figure "was silicone from the waist up!"

The comedienne was rapid firing jokes when Janice and I stepped onto the stage to share the spotlight with Diller and Pel-

licano. Janice wore her white Guyrex gown, almost identical to my scarlet one. Though Diller's garish makeup matched her zany performance, on closer inspection, she was a pretty woman. I shook her hand, and then she made mock exaggeration of our bosoms. Raising her eyebrows over widened eyes, Diller held a hand to her own breasts and sneered.

"I finally had a ship tattooed to my chest. I wanted something on it."

The audience roared.

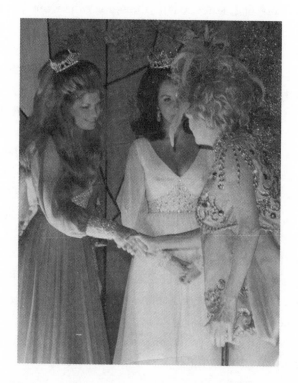

New Year's Eve, with Janice Bain, Miss Texas 1971, and comedienne Phyllis Diller at the Sun Queen Inauguration and Ball (Author's Collection)

Guy and Rex, standing at the foot of the railed stairs where they had assisted me to the top of the stage earlier, were delighted, their smiles wide. I had not expected the bane of my body—which only they and Barbara knew—to become the brunt of a joke. Future Guyrex Girls would eventually train the boys into becoming more tolerant designers. Rex even noted later that the "braless look is fine if in good taste and the woman is flat chested." That shocking revelation would be too late to remedy my self-image.

There had been no recriminations about my injury from challenging a barbed-wire fence. In fact, Guy and Rex were on an El Paso high the final day of 1971. They had produced the first Guyrex-Miss El Paso pageant and drawn widespread attention when they successfully presented a candidate in spectacular fashion at the Miss Texas-Miss America pageant. They had taken prestigious seats on the board of the aforesaid pageant and become darlings of the evening gown design business. They had created the majority of the Sun Carnival Parade's floats—more elaborate than most others viewed on national television—all the while courting and winning the adoration of El Paso society.

The next morning, Janice and I stepped into a car sent to deliver us to the Texas Avenue warehouse. Our floats awaited.

The New Year's Day parade was the finale of a month-long celebration. There had been the Sun Bowl football game, played between LSU and Iowa State (LSU won), daily races at Sunland Park and Juárez racetracks, a special golf tournament with "Super Mex" Lee Trevino among a turnout of hundreds of admirers, stock car races, pistol and fencing competitions, a steer roping contest, and a University Civic Ballet performance of *Romeo and Juliet*.

The early morning sky was leaden, promising rain, and chilly, with a temperature in the low forties. I struggled back into

my scarlet gown, this time wearing long john underwear underneath my skirts. My left ankle was stiff and sore from the night before, so I wore tennis shoes. No one would see my feet with my dress spilling over the float decorations.

Someone propped me in front of a stand atop my float. The 40-foot-long creation, shaped like an elaborate, curlicued fiddle, was embellished entirely in gold and white over a four-wheel go-cart propelling it. "Miss El Paso 1971" in large script letters arched high above and around me and "Leo's Restaurants" proclaimed its sponsorship on each side of the float along with seven white cherubs to complete the design.

Janice's float was far more spectacular at sixty feet long, five feet longer than permitted in the Rose and Orange Bowl parades. She played Beauty from the "Beauty and the Beast" fairy tale. Two overlapping tear drops formed the shape of the float, which was covered in glistening spun glass. A tall, mirrored staircase forming jeweled white doves led to where Janice and her Beast stood. Five Moorish horsemen assembled in front of the float with banners announcing their wedding. The Beast would shred his ugly beastly covering along the way.

We joined the 2.6-mile parade route, a "canyon of humanity," as one newspaper reported, beginning on Texas Avenue and led by Grand Marshal Lee Trevino. Thousands of spectators had arrived early; many stood six and seven people deep, trying to get a view of the twenty-two major floats, twenty-two bands, seventeen vehicle units, seven marching groups, and one Sun Carnival Queen carriage pulled by white horses. Immediately before me was a Kentucky high school band, followed by local favorite Edgar Griggs and his daughter giving a tandem bicycle exhibition. After my float, El Paso's Eastwood High School Trooperettes and band performed. A cacophony of sounds competed.

Early into the two-hour course, my toes began to freeze, the cold reaching my chest soon after. My teeth chattered while I tried to hold my right hand in the ubiquitous, beauty queen wave. The frigid air, hitting my bare armpit under the sheer, slit, jeweled sleeve, was as torturous as getting a tongue stuck to an icy pole. There was no relief. I squeezed my other arm to my side, trying to shield the cold. But it was useless, and nausea set into the pit of my stomach. I thought about Janice, who was at least nine units in front of me and who would be first to dismount her refrigerated ride. We were moving less than three miles an hour, partly because of Trevino. Later I found out that fans had swarmed his convertible trying to get his autograph and handshake. His driver slowed the parade in trying to avoid running over pedestrians.

Before we reached the intersection of Mesa and Mills Avenue, a man ran up to my float. Turning to his wife behind him, he whispered something, and then remarkably, she shed a three-quarters-length mink coat. He yelled, "Janie!" and tossed the life ring to me. I don't know who he was, but he saved me from freezing to death.

The coat made all the difference. I could ignore my toes now that I was swathed in fur. A photographer captured my bliss from a tall building on Mesa Street in a dramatic photo reminiscent of El Paso's history. In it, a hint of a marching band precedes me, and a procession of 1910s and 1920s cars follow not far behind with throngs of people to each side. Opposite is San Jacinto Plaza. Behind us looms the five-story Banner Building designed by famed architect Henry Trost and, just beyond it, the art deco Kress Building. Towering above both is the old Plaza Hotel constructed by Conrad Hilton. We seem frozen in another time, our presence appearing to be decades earlier.

Guyrex Associates won eight awards that day, including Sweepstakes with Once Upon a Circus and Janice Bain's Beauty and the Beast first place in the Industrial Division for float entries.

The men now looked forward to one more state pageant (Miss Texas USA), a second Miss El Paso pageant, and their newest queen, who would surely be more pliable than I. For me, 1972 had begun with one expectation—to survive the dramas my parents and the boys enacted in tandem.

Chapter Twenty-Four

Hollywood Invasion

Ciudad Juárez, Mexico, has always been the stuff of legends, whether regarding its famous college hangouts, visiting celebrities, dope and gun smugglers, or police extortions. As an example, in the 1960s, after the conclusion of a show at a local nightclub, my father and the husband of another couple left to retrieve their car, leaving my mother and her friend to wait alone on the Juárez "Strip." *La policia*, seeing the two women standing by themselves on a street corner, took them to the city's infamous jail. This made for a good story, my dad later bragging that it was cheaper to buy my mother a three dollar prostitution license than pay the more expensive vagrancy charge.

Hollywood discovered the old city's eccentricities decades earlier. Famous actors, filming cheap Westerns, and actresses, addicted to romance, arrived for quickie marriages and divorces—and Kentucky Club margaritas, the famous cocktail allegedly invented there in 1932. One only must remain a few moments at the Kentucky's original 1920s patinaed bar, drinking the powerful cocktail in front of an ornately carved backbar (custom made in

France), to understand the famous saloon's allure. Stretching from floor to ceiling with its huge mirror and softly lit assemblage of tequilas, rums, vodkas, and other popular beverages, barflies reflect on their mirrored selves. Their feet rest on a narrow-tiled "piss trough," reminiscent of the days when men relieved themselves as they drank, and, thankfully, no women were allowed.

Tens of dusty-framed black-and-white glossies decorate walls deep into the Kentucky's narrow recess, celebrating its most famous guests, local American and Mexican celebrities, politicians, and stars: Al Capone and Bob Dylan, Marilyn Monroe and Elizabeth Taylor, Tommy Lasorda and Oscar De La Hoya, John Wayne and Steve McQueen, to name a few. Even a Miss Universe stopped at the Kentucky Club, long after I was Miss El Paso, and possibly because of Richard Guy and Rex Holt.

A natural extension of Juárez's unique personality eventually spread to El Paso. When Marty Robbins recorded a hit song in 1959 about "a girl named Felina" working at Rosa's Cantina, El Paso became engrained in Western lore as an enduring frontier haven for desperadoes roaming dusty streets. Aside from my dad's fascination with western literature and movies, likely our family move to El Paso was influenced by this song. Eleven years later in 1970, when Lee Trevino put the city in the national spotlight, Juárez claimed him too.

After myriad international appearances in Juárez, both cities claimed me as well, thanks to Guyrex's genius marketing. In early 1972, a colorful international magazine called *Amigos*, which featured attractions in El Paso, Juárez, and the Southwest, displayed my pink dress photo with the caption "*Amigos* salutes Miss Janie Little, Miss El Paso 1971, who has done a Queen-like service to her community during her year of reign."

In fact, if I wore my Salome hair extensions, false eyelashes,

and merchant-donated garb, I couldn't get down a Juárez street
without being recognized by someone. If I dressed like the college
girl I truly was, as "plain Jane Little" wearing little makeup and
my Summer Blonde hair down, dressed in my jeans and T-shirt,
I could go anywhere, albeit with a few errant wolf whistles and
cat calls.

One night in early 1972, a blind date and I attended a show at
the Madrigal Club in the Juárez Rodeway Inn. Actor George Ma-
haris from the popular television series *Route 66* was performing
a six-night run. I dressed up, wearing my navy, red, and white
columned hostess dress and white sandals and my hair pulled
up, beauty-queen style. While my date was drinking more than
his share of zombies, a popular cocktail, someone recognized me
in the mass of bodies on the dance floor. As a result, Maharis
called me to the stage where he introduced me. I recall his pasty
face, heavy with makeup and ready-to-drip sweat beads. When
he tried to give me a friendly kiss, I dodged, making my escape
back to the table where my date had turned out to be a drunk. The
evening ruined, I drove his car, navigating Juárez streets to get
back across the border. I returned to dating the UTEP football
player, whom I believed to be a safer bet.

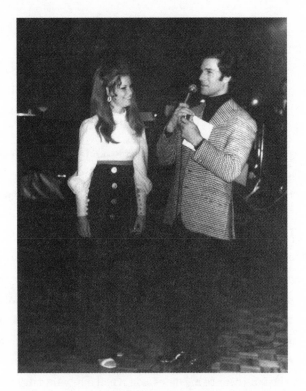

Route 66 actor George Maharis, performing at the Madrigal Club
in the Juárez Rodeway Inn, called me to the stage. I was
uncomfortable with this recognition. (Author's Collection)

Best of all, the same month, a new "You Could Be MISS
AMERICA" poster emerged advertising preliminaries, not of
Phyllis George, but of my smiling face, wearing the official Miss
America crown and holding the official scepter. The posters,
plastered all over town and on the UTEP campus, also revealed
other significant changes. Now scholarships, clothes, jewelry,
electronics, luggage, and even a land investment tripled the dollar
amount of gifts I had received. Even more remarkable, the new
Miss El Paso would receive a new car.

By March, more prizes had been added to the pot, including a modeling course, a spa membership, and one-year subscriptions to local newspapers for all Miss El Paso's scrapbooking.

The city of El Paso had rewarded Richard Guy and Rex Holt abundantly.

In the spring of 1972, Hollywood showed up, in the guise of director Sam Peckinpah, in El Paso—and not Mexico—as a first-time movie location for filming. One hundred technicians, artists, and actors descended upon the city, including Ali MacGraw, Slim Pickens, Ben Johnson, Sally Struthers, and Steve McQueen (probably when he first visited the Kentucky Club). After finishing *Junior Bonner*, a Jeb Rosebrook script, Peckinpah took a 25-cent Signet paperback titled *The Getaway* and its Walter Hill screenplay, and, along with coproducer David Foster, began filming in 114 locations with El Paso handling fifty percent of the action. One of the El Paso film sets was at my old high school hangout in Sunrise Shopping Center: the Oasis Drive-in, or the "OA" as we called it.

My former Northeast El Paso classmates were thrilled. One of my friend's fathers managed a jewelry store in Sunrise when filming began. The movie production had paid all stores in the shopping center to close early so a night scene could be filmed at the circular drive-in. After the parking lot was secured, my friend had the good fortune to be near the movie set, where Steve McQueen, in a white T-shirt and blue jeans, rode a bicycle around the parking lot, waving to onlookers. Peckinpah, sporting a scruffy mustache and beard and wearing a light jacket, ignored the watchers while he walked around between takes. The filming, lasting long into the early morning hours, naturally made El Paso

papers, as well as its shooting at the old Laughlin Hotel down-
town, near the Mexican border, and in Fabens nearby.

For two months, my photos in El Paso's newspaper pages
shared space with anything that had to do with *The Getaway*
production—dollars pouring into the city to pay for carpenters,
electricians, drivers, cleaners, car and truck rentals, food, the
extras, the actual filming with major actors, their Tony Lama
boots, and especially the national exposure El Paso was receiving
as a movie production site. "El Paso, You're Looking Good"
took another meaning as the city hoped for an updated image
from its Marty Robbins recording. An investor even offered to
build a street near the city, along the same design of Old Tucson,
to be used for future television series, Westerns, and other feature
films. One El Paso newspaper reported that El Paso seemed to
be "coming of age."

When the *El Paso Times* first covered the official arrival of
Sam Peckinpah's crew and his primary players on its front page
on April 7, 1972, just under the paper's banner, a photograph of
my rose-covered shoulders, tumbled hair, and smiling face—two
columns wide and ten inches high—also met El Paso readers'
eyes. Unbeknownst to me, a recent prison parolee and soon-to-
be bit player in *The Getaway* had already been following my
newspaper presence.

"Discovered" by Sam Peckinpah's wife, Tom Bush was an
accomplished artist who went on to play numerous roles in
cinema and television after filming *The Getaway* with Steve
McQueen and Ali Macgraw.
(1982 Press Photo of Tom Bush as Deputy Sturgess from the
television series *Bret Maverick*, Author's Collection)

Arriving in El Paso, fresh out of Huntsville Prison, in August
1971, Tom Bush quickly became the talk of the town. Not for his
lurid, criminal career—he most recently had served ten years of a
twenty-five-year sentence for white slavery, after kidnapping for
extortion an exotic dancer and holding her captive for thirteen
days before she finally escaped by swimming the Brazos River.
He had been known as the "Roughhouse Romeo" because of his
penchant for beating strippers.

But art had changed everything for Tommy Bush after trading
for a paint set with a bank robber in prison. Bush took every art

correspondence course he could get his hands on as he developed his talent and even won an art scholarship while incarcerated. Bush turned his life around even more profoundly and helped initiate the first annual Inmate Art Show in Huntsville, Texas, after meeting an influential Catholic prison chaplain, Richard Houlahan. Houlahan changed the trajectory of Tommy Bush's life, and the prison board saw fit to parole Bush under his custody.

Father Houlahan traded his Federal Bureau of Prisons job in Huntsville for a chaplain position at La Tuna Prison, twenty miles west of El Paso. Bush moved to El Paso as well, closer to the man who would oversee his road to redemption and inspire him to use his art as a means of getting back into society.

While Bush was giving exhibitions at places like UTEP or presenting lecture series on prison life to civic organizations, Sam Peckinpah's newest wife Joie Gould connected with him after spotting some of his artwork. The Peckinpahs had recently celebrated a quick Juárez marriage before *The Getaway*'s El Paso filming. When the famous director offered Bush a role as an extra in the movie—a drunken junkman's helper—Tommy Bush also caught the acting bug. Later, Bush sold one of his best art pieces to Sam Peckinpah.

Now politicians and actors wanted his work, mainly beautiful portraits in fine line or full pen. One of Bush's first pieces after arriving in El Paso was Steve McQueen's face. Bush told a local newspaper that his subjects had to have a message to say, that their eyes were his focal point. He began studying my eyes in the April 7 newspaper photo.

With that said, all the activities were taking a toll. I cut my classes to twelve hours, and still my grades were plummeting. To compound my intense schedule, I anticipated the Miss Texas USA pageant in April, before the next El Paso pageant. My dismay

appears in an advertisement I did for a fur company. Inside the same bedroom at 1304 Montana Avenue where the first finalists disrobed for dress measurements almost a year earlier, I posed in a full-length, tiger-striped fur dress with a wide belt wrapped around my narrow waist. A mirrored wall reflects my back as I sit on a dark-fur bedspread. The shadowed wall to my right is a panorama of hexagrams in assorted sizes and colors. The only skin showing is part of my face where my hair had been pulled to one side. My face is half lit, leaving the other side in shadows. I am not smiling.

Guy and Rex prepared the upcoming Miss El Paso pageant program with dozens of my photos advertising our sponsors. This photo, taken for an imitation fur company, displays my lack of enthusiasm. (Author's Collection)

Following B. Don Magness's model for circulating the same Miss Texas contenders until one ultimately wins the crown, Guy and Rex asked me to run in a new local pageant to get back to Fort Worth for a second stab at Miss Texas. They planned to create a new contest for me, Miss Sun City. I considered the proposal in the briefest of moments.

Like my split face in the fur ad, I was conflicted. I knew Guy and Rex wanted to continue riding our wave of success, even after the new queen was selected. But I also had in my mind's eye a new memory: my mother running in her bare feet down our irrigation ditch, a moon-lit wraith in a pale yellow, sheer nightgown. Except her specter was real—I could hear her crying.

In response to their request, I showed them my left hand, revealing a small diamond set on a simple gold band. I planned to get married in mere months.

Chapter Twenty-Five

The Meat Locker

*Y*es, I planned to get married after dating a guy only four short months. Don't be too surprised. In my world, friends sometimes married premed or prelaw students and worked to support their husbands' postgraduate education. Others married soldiers, enjoying comfortable communities on military bases while they raised children and their husbands trained and traveled. I was working on an English degree while considering a postgraduate education or a stint working in the Peace Corps overseas. Obviously, I was rudderless, only determined to defy the family's track of four generations of teachers.

Mother had hoped college might provide a promising husband, an education to assist me in the short term but one I wouldn't need if I married well. She taught only five years before quitting to raise a family. Though I never really considered her path, I thought I would fall in love, marry, and eventually be a stay-at-home mother too. In 1972, a woman could be judged by her ability to provide a comfortable home and children, a man by his ability to provide for a family. Lots of women sought MRS degrees.

In short, despite the era's women's liberation movement

pushing for alternative options, many girls anticipated short careers before motherhood. Looking in today's rearview mirror, no matter the traditional beliefs at the time, my plans were naïve—and it wouldn't take me long to discover that truth. But in the spring of 1972, the notion of advancing beyond Miss Texas and competing in the Miss America or Miss USA pageants was as alien to me as a woman riding a rocket ship to the moon. There would be no more handlers with their walls, beauty regimens, and personal limitations—no more photograph sessions and public scrutiny. I had myriad excuses not to continue with Guyrex, or so I told myself.

When I announced my engagement to my parents, there were no snide remarks about my choice in fellows ("He shakes hands like a fish") or sage counsel about choosing a mate ("Watch how he treats his mother—that's the way he'll treat you!"). My parents did not caution me about marrying someone none of us truly knew. Not even a "you're not ready yet." Nothing. My fiancé played football. That was all that seemed to matter.

Mother now had a July wedding in her sights while I prepared for the next state pageant, this time in San Antonio. When I wasn't studying my itinerary or El Paso facts for my next interview, I gazed at my ring finger, amazed that I was about to begin a new life of my own choosing.

On April 8, 1972, the day after my face boldly graced the front page of the *El Paso Times*, I attended my last marketing event for the city as Miss El Paso, this time for a Guyrex scholarship luncheon and fashion show held at the El Paso Country Club. I empathized with the exhausted finalists in attendance, all uniform in their dresses, and who would be competing in less than two weeks for the new title.

Confident with their recent pageantry showmanship, instead of an American or El Paso theme, the boys determined a Las Vegas-styled motif—French Circus—for the 1972 local pageant. The country club's waiters were garbed accordingly in clown costumes. Retiring my red, white, and blue wardrobe, Guy and Rex dressed me in a refreshing pink-and-white polka-dot dress. Along with women of the Miss El Paso Guild, I also modeled new Guyrex designs before finally *ahhing* the audience in my familiar pink rose gown. We had recently decided that the pink dress would be my competition gown in the upcoming San Antonio pageant.

The next day, along with Barbara Barrington, I was on my way to San Antonio, Texas, for the 1972 Miss Texas USA pageant. The winner would compete for Miss USA Universe in Puerto Rico on May 10. Guy and Rex, placing no importance on this state pageant, remained home in full throttle for the second annual Miss El Paso contest. They certainly had no idea that the San Antonio pageant would change the course of their lives much later.

Wearing swimsuits, my roommate (Miss Huntsville) and I stepped into an elevator on its way down to the ground floor in the El Tropicano Motor Hotel (today the El Tropicano Riverwalk Hotel) for a poolside press party. We were not alone and immediately recognized a short, chubby man from daytime television and movies. Leaning awkwardly in the corner was frizzle-haired comedian Marty Allen. Underneath the wild hair, his face held a silly grin.

Considered a San Antonio favorite, especially at the Fontana Club atop our hotel, Allen was known for his off-color characters, including Dr. Dirty Dave, who carried two stethoscopes, or as Allen quipped, twin nozzles for women. As others chattered,

swimsuit *beauty delegates*—Miss Texas USA pageant officials had made it clear we were not to be called *contestants*—boarded the elevator during our descent, and then an uncomfortable silence filled the tight space. The delegates sensed the man smirking from his corner. One girl whispered, "He was on the elevator when I rode up a while ago too. Who *is* he?" Apparently, Marty Allen, who wasn't even performing that night, was just along for the ride. And so was I.

San Antonio's Texas USA contest was no Miss Texas-Miss America pageant, at least in 1972. Half the size of the Fort Worth pageant, only thirty-nine women were contesting for the crown. A one-hour meeting the day before revealed the beginning of the pageant's deficiencies. I wasn't dismayed, just dumbfounded at the lackadaisical way the pageant was run. Since Guy and Rex weren't there, this competition would be fun, despite its shortfalls.

We each received a packet with a welcome letter from the Miss Texas USA beauty pageant. It was chock-full of misspelled words and typos. With no rule book, we were only warned to be ourselves and "not manufacture something that isn't there," whatever that meant. Judges would be mingling with us at meals and other functions to get to know us better. With no chaperones, we could ride elevators with men, talk to outsiders, including men, and even thrill Marty Allen with kisses if we so desired. With no talent to worry us, we would be judged solely in swimsuit, evening gown, and interview. My daily dress would consist primarily of hot pants and high heels. This was exactly the type of fresh meat contest that feminists had protested.

At first the lack of restraint was exhilarating, especially within San Antonio's River Walk, with its outdoor cafes and bars. Each morning we boarded river barges to travel to our rehearsals

at the Convention Center Theater (today's Lila Cockrell Theatre) in the Hemisfair Plaza, our senses exploding with Mexican music, coffee aromas, and the waterway's vibrant tropical flowers. The city's Fiesta of Flowers had begun, and the Miss Texas USA pageant was to be part of its main activities. There were no ridiculous hoedown dresses. Instead, we were fitted with official DeWeese aqua-colored swimsuits on the first day of competition week.

That same afternoon, photographers snapped pictures of the delegates in their new swimsuits, split into two lines on Hemisfair Plaza, a gauntlet of gorgeous women. I posed with girls whose titles did not necessarily reflect regions or cities but universities and provincial local festivals, including Miss Snake Charmer, Miss Space City, Miss Alamo City, Miss Queen of Soul, and Miss Buccaneer Days. Beginning with these photos, my likeness, almost always in a swimsuit, began to appear in San Antonio and El Paso papers. Guy and Rex monitored my participation from afar via the papers and Barbara.

The second day of the competition week, the day Allen shared an elevator with us, delegates had posed for the press in swimsuits of their choice, including bikinis. Our welcome letter had warned us to work with the press—no permissions required for newspaper and radio-television interviews or photographers— and to "please be cooperative, even if some of the questions sound dumb or repetitive." Their words again, not mine. Guyrex had sent a sequined, black one-piece suit with me, with cutout sides and an extremely low back. It was likely part of a float costume, but I looked more like a Las Vegas dancer. The press loved it!

Much like the previous state pageant, we were shown off across the city, almost always in our hot pants, at famous landmarks and eateries such as the Pearl Brewery, La Villita Cos House, and the

Plaza USO Club. After-five attire was required only for dinner at the Tower of Americas, a revolving restaurant set 650 feet high and designed like Seattle's Space Needle.

When we weren't sunbathing downstairs alongside the hotel pool amid captivated photographers, we rehearsed daily for a production number and preliminary competitions. With fewer beauty delegates, the pageant had divided us into two groups, A and B. Among twenty women in Group B, I would compete the first night of competition in swimsuit preliminaries at the Theater of Performing Arts. Judging my group would be two former beauty queens, Dallas Cowboy football quarterback Craig Morton, and two others.

Morton was unmarried, and already women vied for his attention whenever he attended our events. Though many of the beauty delegates were older, some already working in post-graduation careers, the atmosphere seemed high-schoolish. As for me, at Barbara's suggestion, I removed my engagement ring so that I, too, would appear available for Miss Texas-Universe events.

As a result of El Paso's newspaper coverage, Western Union telegrams and personal notes abounded. It didn't matter that a new Miss El Paso was about to step into my shoes and that the pageant was mere days away—the city was following my activities closely. The *El Paso Times*, its entire society section, editors and reporters, and KHEY Radio, with its on-air disc jockeys, kept El Pasoans abreast of my successes. On its front page, the *Times* had already printed another large photo of me in the sequined show-girl swimsuit, along with Snake Charmer and Buccaneer Days.

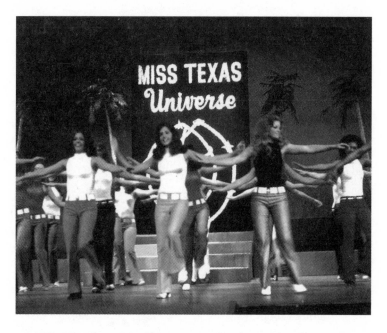

The Miss Texas USA Pageant opened with a jazz number, more
exciting than the Miss Texas-Miss America hoedown opener.
Author, front right. (Author's Collection)

On Friday morning, April 14, the *Times* reported that I had
won my spot for finals by winning swimsuit during the previous
night's competition. The accompanying image, captioned "Little
Bit-O-Beauty," also pictured my competitors for finals. Even
more photos were wired to El Paso papers and almost all placed
on their front pages, despite the Vietnam War, political unrest,
and protests. It was as if the city needed a diversion. Even San
Antonio papers appeared to focus on my images over other dele-
gates, with the *San Antonio Light* also placing photos on its front
pages. The publicity was enormous. Barbara sent all the reporting
to the boys.

I was all but guaranteed a place in the top twelve for Saturday night's final competition, and Guy and Rex were now on their way to San Antonio.

On Friday at two o'clock, my group was scheduled for the interview competition. Our pre-instructions in the welcome packet had been silly in their vagueness.

1. Wear what you want to interview.
2. Be prepared for some off-the-wall questions, but I kind of doubt it with the panel we have selected this year.
3. If a question sounds asinine [spelled *ass-inine*], turn it around, ask the judge who asked it, and what she or he thinks about it.
4. If you are nervous and your nervousness shows through your hands, glue them together or something.

And this is where I blew it, dissolving any chance of becoming Miss Texas USA.

I had not gone out of my way to court judges as some delegates had during the previous days. The judges did not know me except from afar. I don't recall what I wore to interview, but I did not choose hot pants. I expected a more formal experience, an assessment with serious interviewers and thoughtful questions.

When I walked into the room, the judges sat casually around a small table. I took my seat, sitting with my ankles crossed as Barbara Barrington had instructed. The group had been laughing, and it was obvious that the women's eyes were on Morton who had just said something funny. With sandy blond hair and blue eyes on a tanned face, the football star was a charmer.

I had revisited all my facts about El Paso that morning. I was ready to share her western history, statistics, how tall the Lower and Upper Valleys' cotton grew, and how red chilies were used to make lipstick. I was serious, but my judges were not. Instead, I was asked only one question.

"Who in the world would you most want to date if you could date anybody?"

The female judges giggled and looked toward Morton, who grinned. Was I supposed to say *him*?

I guess if I had read the morning papers, I would have seen a story in the *San Antonio Express* about how the Miss Texas USA pageant was entangled in a lawsuit. The pageant allegedly had refused to pay for trophies presented to the past year's winners. If the pageant couldn't afford trophies, maybe the judges with whom I interviewed had been hired on a shoestring.

After a long pause, I earnestly answered them. Looking directly into Morton's face, I said with a small smile, "There is absolutely no one I want to date. I'm taken." I left the interview feeling insulted for their not recognizing the brains I knew I possessed. Worst of all, I felt cheap.

Later that evening, I competed for evening gown with elegance. I knew that my interview likely knocked me out of finalist contention. I showed off my dress, the roses breathing pink above flowing skirts, while the audience and press took note. The next day, the *San Antonio Light* highlighted the evenings' competition of me in the pink dress on the Theater of Performing Arts runway. The image, breathtaking.

On Saturday night, April 15, 1972, Miss El Paso finally won her place in a finalists' competition in a state pageant. While I did not place in the top five, the Texas press selected me as Miss Photogenic among all the state's beauty delegates.

Guy, Rex, and Barbara headed back to El Paso with plans for the next queen. Their conversations likely discussed the future of the Miss Texas USA pageant along the way. It certainly seemed bleak. As for me, my fiancé had appeared at the San Antonio pageant, San Antonio being his home, though my parents had not attended. He took me to meet his mother. Afterwards, we, too, returned to El Paso with doubts nagging me along the drive. I had seen another side to my boyfriend but, as the miles passed, I buried my fears.

Chapter Twenty-Six

Breakups

As mentioned earlier, Jay J. Armes had rescued Hollywood actor Marlon Brando's young son out of a Mexican seaside cave via helicopter only three days after being hired, instantly propelling the private detective to fame and fortune. And I had just wrecked my well-known, canary yellow 1967 GT Mustang convertible, propelling my passenger into the windshield after running into a telephone pole. The accident occurred in the middle of the day, maybe two hundred feet from my home. I had turned to catch a dress flying out the back seat amid a tornado of food wrappers. Perhaps I should have taken the job with Armes's Investigators. My outlook might have been different.

Like the horse incident, Daddy complained about the consequences of my totaled car. How would I get to UTEP? He began dropping me off not far from the Porfirio Díaz exit, where I hiked sand dunes to class. My punishment became an inconvenience for both of us, and soon I drove another muscle car, a brown Buick Gran Sport.

Though my parents were unhappy with my stunt, the city of

El Paso was still singing my praises. The best accolade arrived couched within an editorial in the *El Paso Times* shortly after the wreck. The heading, simply titled "Miss Janie Little" and "Everyone likes to see a pretty girl!" congratulated Guyrex Associates for bringing a welcome addition to the various activities held in the city. By the time the 1972 Miss El Paso pageant arrived, my transgression was forgiven.

Mother, Dad, and I entered the pageant together, walking between two life-sized white elephant sculptures standing on either side of the doors to Hilton Inn's Crystal Ballroom. At a designated table near the dais, my parents began flipping through the pageant program—over forty pages with my image plastered on almost every page. Guy and Rex had promised their sponsors grand advertisement, and they had spent months preparing the illustrations with catchy phrases to showcase their supporters.

Photos of my piano performance while wearing the pink dress advertised a local piano company, while others were staged specifically for products, services, and businesses. From wearing a hard hat and overalls while standing on a ladder to wearing an evening gown, my toes buried in Jimmy Chagra's carpet, I played different roles to advertise our sponsors.

Two ads are quite memorable. In a full-page ad wearing striped prisoner's clothing—including a little striped hat atop my head—I stand behind bars in the El Paso County Jail. The apropos prison number on my uniform announces "4-22-71," the date I became Miss El Paso, and Guy and Rex's final joke on me. Above the photo, the ad reads, "Miss El Paso Says, 'When you are wrongly incarcerated it's Vic Apodaca to the rescue!'"

The other ad, sponsored by the local Budweiser Beer distributor, features me in an evening gown and crown with my father,

uncomfortably wearing a tuxedo with a frilly front and cuffs. His arm is outstretched, offering me a can of beer. With my fingers to my lips, I look away from him, exclaiming, "Oh Daddy, I'm not old enough! But when I am . . ." Oh, the irony.

After dinner and the French Circus-themed opening production, Hector Serrano emceed the pageant, professionally moving each segment seamlessly. Twelve finalists were introduced, and then their talent competition began. Afterwards, Janice Bain, Phyllis George, Dolores Pellicano, and I were introduced, sitting at our own table. B. Don Magness, who had judged the preliminaries, was not far from us keeping a practiced eye on the judges' table, which included actress Julie Adams and other Miss Texas officials.

Las Vegas entertainer Rouvaun sang for forty-five minutes amid black-and-white balloons and silhouettes of camels, lions, and elephants, when Janice finally joined him on stage to sing a duet. Then Phyllis spoke on the joys of her year as Miss America and the importance of the Miss America Project—its scholarship program for thousands of young women across the United States, in the face of feminist opposition.

When it was time for the farewell runway walk in my turquoise gown, Rouvaun sang "The Impossible Dream" from the recent musical *Man of La Mancha*. Waiting for me on the dais were Guy and Rex, both tuxedoed and beaming. El Paso jeweler Louis Peinado came on stage and presented me with a custom designed, diamond-encrusted, gold Miss America crown ring. A representative for Tom Bush surprised the audience and us with two portraits in the pink dress: one a larger, somber pastel, and the other in the fine line ink for which Bush was known. At the same moment, Bush was with the rest of *The Getaway* crew and cast, including Steve McQueen and Ali MacGraw, sitting in El

Paso's Pershing Theater's back rows watching a special premiere of Peckinpah's *Junior Bonner.*

These were goodbye gifts, and I realized with mixed emotions that Guy, Rex, and I were breaking up.

Shortly afterward, a pretty redheaded Bebe Richeson, another piano player much to Guy and Rex's consternation, was announced Miss El Paso 1972. Phyllis placed the official Miss America crown on her head, Janice arranged her royal robe, and I handed Bebe the Miss America scepter. The ball began, and Phyllis, after studying the new ring on my right hand, left the table to find Peinado. She had already asked me about the ring on my left hand.

Three weeks later, spring classes were out at UTEP, and I received my grades for the twelve hours I had taken: a 2.25 GPA. My cumulative GPA had continued to drop well below a 3.0. Something would have to give, but that would have to wait. Another breakup was looming: my separation with Mother and Dad.

Three months later, I married my fiancé in a fairy tale wedding wearing Chantilly lace and silk. Neither Guyrex nor Mother made my wedding gown; instead, I borrowed a jinxed dress from a cousin whose marriage had come to an end. Perhaps her divorce was a portent, but an old-fashioned hooped skirt was enticing.

After the wedding rehearsal the night before, my parents hosted a party at our Upper Valley home. The new swimming pool had been installed, and Mother had hung the larger Tom Bush portrait in a gilded frame over the white-bricked fireplace. Just as Bush promised, the portrait's eyes dominated the young woman's features, done in chalky pastels, her hair piled high in soft curls, and breasts and shoulders covered in translucent roses. Each time I walked past the portrait, the woman's eyes gazed

beyond me, as if avoiding eye contact. Had Bush observed re-luctance in my newspaper portrait's eyes?

Now, overshadowing the serene calm of our new living room, with its cornflower blues and lemon yellows—my mother's creation—boisterous voices and water splashes emanated from outside.

Besides my family, all of Ace's family attended from San Antonio—parents, brothers, sister, and spouses, most of whom I had never met. Dad, with his business connections, supplied an open bar. The wedding party and other guests played and sang music and obnoxiously drank hard. Another forewarning. At some point, I quietly sneaked away and went to the front bedroom, away from my own room where bathroom traffic streamed. I slipped into bed, exhausted and worried.

Daddy, noticing my absence, found me in the quiet room. He sat down on the edge of the bed, and said, "Janey Pooh, are you all right?" He paused and closely looked into my face. "You know you don't have to go through with this; it's not too late."

But to me, it *was* too late. Mother had gone to extreme lengths to make a perfect wedding despite her own demons. Besides, I made a promise. "No, Daddy, it's okay. It'll be fine. I'm just tired."

That was the last time my father ever tucked me in bed, calling me "Janey Pooh."

Exactly one week after the wedding, the trouble began at a hamburger cookout at my parents' house when my cat ate a ham-burger patty that we planned to grill. Ace threatened to shoot the cat with a loaded shotgun, chasing the frightened animal through the house. My mother, with shock on her face, fled from the kitchen. Daddy was not yet home.

Verbal threats—threats of violence from a booming voice—to me and my family would continue for over a year, as my new hus-

band's frustration at being married grew. My life wasn't the only
life to change. His had changed too. Curbing his late-night boys'
outings, Ace had to work a real job off-season from athletics.

We found ourselves in an ancient apartment on North Oregon
Street, not too far from the city's former redlight district. I helped
with Ace's classwork, dropping to nine hours that semester for
myself. To me, it was imperative I be the good wife—cooking,
cleaning, working, and helping my husband graduate from
school. I didn't begrudge my situation. Wasn't this what wives did?

Receiving only $75 a month "laundry allowance" from the
UTEP athletic department, I worked full time over the rest of the
summer and part-time during the school year to pay our bills. El
Paso Natural Gas Company (EPNG) had an arrangement with the
athletic department where it would hire spouses of athletes. The
NCAA prohibited athletes working during the school year, so I
went to work in EPNG's personnel department.

My Miss El Paso year seemed decades past—performing the
Love Story medley perfectly in front of thousands of spectators
while wearing the pink dress, sneaking downstairs to eat sugary
cake, giggling as my roommates quietly imitated the East Texas
contestant's protest, and laughing with Guy and Rex at the ex-
pense of the Juárez Strip's "Miss Texas."

Still, my employment at EPNG was a novelty. The company
soon used my likeness on the "Safety-Liner," a national brochure,
in which I wore a hardhat and red, white, and blue. I judged a
beauty pageant and performed other public relations tasks for
the company, while at home the marriage continued to fail.
When EPNG contracted Guyrex for its annual Sun Carnival float
for January 1973, I was the featured model on their Springtime
Fantasy float. This time I did not freeze.

One night after work in the fall of 1972, when Ace didn't arrive

to pick me up, I called several people to see if they could come collect me. With no luck and EPNG's office building locked for the evening, I walked fifteen city blocks in the dark through seedy downtown areas all the way to our North Oregon Street apartment. When I finally arrived late into the evening, my husband wasn't even home. He was out drinking with the boys and simply forgot about the obligation. Like two venomous heads on the same coin, my fury at being forgotten quickly overturned into hurt. His reluctant acceptance of new responsibilities turned into resentment. When they heard of my ordeal, my parents were alarmed but wisely did not interfere.

With the Oregon Street apartment vacated, the UTEP coaches next moved some of the players and their wives to new low-income housing, which I took as another failure in my married life. I had thought that government housing was reserved and subsidized for the very poor. I still have no idea how the accommodations were arranged, but UTEP athletics had an abundance of connections to address its players' needs.

Later in this apartment, his fingers gripping my throat, Ace told me how easy it would be to break my neck. He had been drinking, and though I wasn't afraid, I realized that no setting was going to remedy the mistake that we made in getting married. In the past, when I complained about a consequence of some poor decision I had made, Mother always told me, "You made your bed, now you lie in it." Disappointed and embarrassed with my lack of judgment, I would have to operate on this principle for our future to work. With no one to counsel me, this would be hard. Besides, I was too proud.

My parents next purchased a ten-foot-wide trailer for us to move into behind their house in the Upper Valley. I admit, I was relieved, despite the look of disgust on my mother's face. This

obviously had been Dad's idea. Soon we discovered that the trailer was full of bedbugs.

At least my successor was doing considerably better than I.

Instead of Barbara Barrington's home, Guy and Rex first moved Bebe Richeson, their newest Miss El Paso, to their basement apartment at the house on Montana Avenue for her Miss Texas pageant preparation. Living in an independent apartment owned or managed by Guyrex Associates or one of their sponsors would become the norm in future years.

In the few weeks between the 1972 Miss El Paso pageant and the Miss Texas-Miss America pageant, Guy and Rex worked to reconfigure Bebe's talent after learning there would be a concert pianist in the Miss Texas competition. Much like a Las Vegas puppet show, they developed an act building a large bird, like Sesame Street's Big Bird, out of rebar and pink ostrich feathers. During her talent preliminary, Bebe, dressed in black and strapped into a harness with a fire extinguisher in the back of the puppet, now called "Oogha," danced to the Janice Joplin song "Move Over." At the end of the song, as the puppet bent down to bow, Bebe squeezed the fire extinguisher to create smoke snorting out of the bird's big, black cone nose. Guyrex had choreographed every dance move, and Bebe had had to learn to dance.

The act was quite unusual and highly detailed, though, like me, Bebe Richeson didn't earn top ten semifinalist at the Miss Texas-Miss America 1972 pageant. Again, the judges awarded a special talent prize. B. Don Magness was determined to hold onto his two creative board members who continued to bring unique, well-prepared Miss El Paso contestants to the Fort Worth pageant. Still, Richard Guy and Rex Holt were flummoxed

over their contestant missing semifinalist recognition again.

A truth I would learn later was a Guyrex Girl is always a Guyrex Girl. Guy and Rex had no intention of letting me go. And this would be a good thing as they provided the only lifeline dangling within my reach.

Despite my matrimonial turmoil, Guy and Rex continued to include me in city activities during the next year, though my priorities had changed. My 1972 fall semester transcript had already revealed my lack of focus. In May 1973, Phyllis George and I were special guests again at the Miss El Paso pageant. So I could pick up Phyllis at the airport on time, I surprised myself when I walked out of a Spanish final, turning in a blank test. Remarkably, this time, my professor passed me in Spanish with a D.

At the 1973 pageant, the previous year's first runner-up performed "Orange Blossom Special" on her electric violin while hundreds stomped their feet, by far the best talent presentation I had yet to see at a Miss El Paso pageant. As a result, Terry Anne Meeuwsen Miss America 1973 crowned a new Miss El Paso Valerie Camargo, as Mae Beth Cormany Miss Texas 1972 looked on.

Several weeks later, at the Miss Texas-Miss America pageant, with their large, proud El Paso entourage in attendance at Fort Worth, Guyrex finally had a highly talented musician contestant win top ten honors with her toe-tapping act. Yet, Valerie did not place. Instead, Beaumont's Judy Mallett, another fiddler, took the title as Miss Haltom-Richland Area. A "repeat" contender, the previous year Mallett had participated as "Miss Big Thicket," placing in the top ten finalists.

As the months and years passed, Guyrex Associates showcased their El Paso Guyrex Girls together whenever they had an opportunity, just as they would group their Texas Aces later, their five consecutive Miss USAs. Fortunately, that included me. I bal-

anced my post–Miss El Paso life with the domestic mess I had
created. If Guy and Rex knew of my situation, they didn't show it.

AT STYLE SHOW—The Miss El Paso Scholar-
ship Guild held a fashion show and luncheon in
the El Paso Country Club. Honored guests were,
from left, Bebe Richeson Moreland, Miss El Paso
1972; Judy Mallett, reigning Miss Texas; Valerie
Camargo, Miss El Paso; Laurie Lea Schaefer,
Miss America 1972; and Janie Little, Miss El Paso
1971.

A Miss El Paso Scholarship Guild fashion show and luncheon
included current and past beauty queens. (*El Paso Times*, April
24, 1974, Authors Collection)

One afternoon in mid-November 1973, I returned home from a
veterinarian clinic with our Irish setter, Tara, a sweet dog that I'd
adopted from a Fort Bliss soldier before my family made the
move to the Upper Valley. She had escaped the yard while in heat,
and the ensuing "abortion" shot was an added, but necessary,

expense to our small budget. After walking through the door, and upon hearing the news, Ace clenched his fists. Even as the setter was greeting him, her large brown eyes looking upward for a pat, he punched her head violently, knocking the dog across the small living room. Tara yelped with fear and pain, cowering in a corner while my stomach heaved.

Then my rage erupted.

I screamed hysterically, my shrill cries bouncing within the trailer's narrow walls. But I could not shut off the voice that finally found itself, and I ordered my husband to leave as a tsunami of accusations, from the depth of my core, washed him out the door. I had turned into a victim, if not a shrew, and I didn't like it. I cradled the whimpering dog and then another thought hit me. I had dismissed the threats to my family members, but what if? What if we had children?

Early the next morning, I entered my parents' bedroom through their open door, and woke my father up. He was startled when he saw my pale face.

"What's wrong?" he asked, fumbling his words.

I hesitated, unsure how to begin. Then my words vomited in a torrent. "Daddy, I have to get out of this marriage," I gushed. I told him what had happened.

He sat up quickly, exclaiming, "Goddamn, it's about time! Your mother and I have been waiting!" He paused, just for a moment. "I'll call Weldon."

Mother's early prophecy, that I would become just like my divorced aunt, was about to become true. I recall watching Mother slowly calculate the plan behind her clear, bright eyes, common sense battling her natural stubbornness. She stared at me quietly and then turned toward Daddy and nodded her head in agreement.

Chapter Twenty-Seven

Fresh Starts

I stepped into the halls of the old El Paso County Courthouse on Tuesday, November 20, 1973, two days before Thanksgiving. I had only been in the building one time before—to get a marriage license. Now, a year and a half later, I was back to undo my mistake. I searched for County Judge Weldon S. Copeland, Sr.'s courtroom and connecting office. Judge Copeland was my dad's client and a good friend to the family.

When I finally found the small anteroom and announced my arrival for my scheduled appointment with the judge, a secretary disappeared for a moment. Returning to open another door, she smiled, "Judge Copeland is back and can see you now."

When I walked into the office, the judge had just shed his robe, hanging it on a hall tree of sorts. He turned to me and grinned.

"Miss El Paso! How are you? Okay, your dad told me why you're here. Let's talk about it! I hear you've been fussin' and fightin' . . ."

His words hung in the air. I knew that our problems were far

worse than his description, but I could only answer a soft "Yessir."

The judge pulled out an old oak chair for me to sit while he busied himself with a manila folder lying on a scarred table, likely as old as the 1923 courthouse. Then he sat as well, taking a wet piece of gum out of his mouth and sticking it on the table's battered surface to the side of the folder. He turned to me with a smile, but my eyes lingered on the gum.

I hadn't uttered anything but the one "Yessir," though I had been rehearsing what I would say. Now it appeared that Judge Copeland wasn't going to ask the reason for my divorce petition.

Stunned—and relieved, I waited.

"Okay, let's see here. What property do you own?" he asked, flipping to another document.

Well, obviously, we didn't own much. What does a twenty-one-year-old own aside from a stereo and clothing? My parents had arranged the mobile home, and the Rheys had given me furniture from their business. Aside from these things, I had the Buick, held in Dad's name, and Ace drove a brand-new, orange-and-white Chevrolet—UTEP's colors, of course. "We have a new car and a trailer."

"Do you want the car?"

I thought of the loan attached to the new Chevy. Ace would have to get a job if I didn't take it. "No, sir."

"What about the mobile home?" Judge Copeland queried.

I thought about my mother. "Yessir, I should keep it."

"Well, is there anything else of value we should consider?" he probed.

"I want my dog."

No more than thirty minutes later, I walked down the steps in front of the courthouse, dazed. Was this all there was to ending

a marriage? The marital contract that I had taken so solemnly was besmirched in its simple termination.

Now we both had a fresh start. Neither of us had been mature enough for marriage, but this realization and the absolution of blame would take years for me to fathom and accept. Mother would have been correct, if she had only told me that I wasn't ready for marriage. It was my turn for an El Paso start-over.

About two months later, I drove my Buick up a winding ski-run road to New Mexico's Sierra Blanca Ski Resort. With me were four of my sorority sisters. Tri Delta's acceptance of a twenty-one-year-old divorcée was unusual, and I was grateful. I planned to step back into my classwork and finish my English degree. Though I was certain that any opportunity to remarry had been dashed with the stigma that divorce carried, there was nothing I could do about it. But I could repair my grades. Besides, the last thing I wanted was to be attached to another male. After burying myself away from the public—and especially Guy and Rex—for two months, I had decided to take ski lessons.

Despite all my years living in El Paso, I never thought about driving the two-and-a-half-hour trip to the ski slopes of Ruidoso, New Mexico. Watching bears at the local trash dump had been our main entertainment there, not skiing. Besides, the sport cost money. Even if I could rent skis, boots, and poles, there was the lift ticket and ski clothing to purchase. Still, with a job at EPNG and no debt, no beauty pageants, and no events, the risk of trying something different was alluring. With my friends, I headed to Sierra Blanca.

The Mescalero Apache Indian Reservation sits in the Lincoln National Forest, a lush, piney landscape that the government

figured was worthless land when it moved the hapless Native Americans from another reservation fresh with gold discoveries. The Mescaleros' luck changed when, with an entrepreneurial spirit, they began renting ski resort facilities atop their sacred peak, the highest mountain in the forest. Called Sierra Blanca because of its once perpetual snowy cap, the near 12,000-foot peak can be wickedly icy during spring skiing. On its lower slopes, tribal members, owning what is now called Ski Apache, hold little patience for novice-skiers' antics. The tribe operates every ski lift on the snowy mountain and serves every patron at the lodge.

An older Oldsmobile Eighty-Eight slugged behind the Buick as we wound up the steep mountain. I paid no attention to the car, my eyes glued on the drop-off to my left. By the time we arrived on top, hundreds of vehicles already filled parking spots in the muddy slurry behind the ski lodge and bunny-slope areas. To one side, children sledded downhill to their waiting parents, while others, sans poles, on short skis, shadowed a ski instructor as he made squiggly trails in soft snow. Ski lifts had just opened, and we hurried to get our lift passes and ski school reservations. The Oldsmobile parked next to us.

My ski lessons had been horrific, and the instructor wore his patience thin behind a ski visor. I could not get up once I fell, my upper body strength waning in the high altitude. When I was up, I briefly felt the joy of snowplowing, the tips of my rental skis turned inward, before falling when someone came too close or the slope increased. Yes, I was afraid of falling, unless I planned the fall. When it was time to try a T-bar lift, I fell out of fear. A Mescalero operating the lift, a frown above his black sunglasses, ran to me and quickly hoisted my suspenders up and tossed me back in line out of the way of other skiers.

By the time we returned to the car to eat our lunches, I was exhausted. The occupants of the other vehicle, Texas Tech boys, arrived as well, grabbing an ice chest from the trunk of the Oldsmobile. My friends introduced themselves while I rudely sat inside the Buick eating my lunch, ignoring the good-looking guy who was just offered a piece of my fried chicken. I guess I was damaged. I cringed at loud male voices and detested male compliments. I decided I wouldn't date again for years. But I peeked at him anyway.

Exactly one month later, I was careening down a ski run aptly named "Deep Freeze"—not as an experienced skier or even a novice whose ski lessons had taken. Because they hadn't. I was a terrible skier. Deep Freeze was one of eleven runs on the mountain at this time, a "blue" run, meaning appropriate for intermediate skiers. I don't know why I chose this trail, except I obviously had a higher opinion of my athletic ability. On either side of me, "black run" skiers whizzed by from Apache Basin sitting up above, below crystalline blue skies.

The sun had warmed the snow the day before, and night froze the glittery slush by morning. The trail was packed hard. I tried to traverse my way down with no luck. My skis' edges had little use on the icy track in my mind, and basic snowplowing didn't work. There would be another accident, maybe a broken arm or leg if other skiers didn't get out of my way.

My arms windmilled at my sides; the ski poles useless in my flailing hands. A human propeller with a fur cap, I bowled past other skiers before my brain could determine my trajectory and send directions to my lips. Frantically yelling out "Right—no— your left, *my* right!" had little effect.

In a magazine interview with Guy and Rex, the boys affirmed that if their contestant were overweight, she was put on a diet. If

she were out of shape, she was given exercises to do on the road. And if there was a physical flaw that couldn't be corrected, they would camouflage it. I had not been overweight (in my view), nor had I been out of shape. Excluding the small bosom resulting from my diet, I possessed no physical flaw that they should correct. But I was accident-prone, and there was no denying it.

The first mishap occurred long before I met the boys, when I was thirteen years old, not too far away from the Sierra Blanca Peak. The first hole of the Cloudcroft, New Mexico, golf course claimed that horror, a popular winter sled run until someone was fatally injured. I crushed my left ankle, the same ankle that I had injured riding Banner through the fence. Then there had been the car wreck. I would break my left ankle two more times, get hit by a car, and have a horse fall on me. I was an accident waiting to happen and, at this moment, out of control on yet another blurred surface with no way to stop the increasing momentum.

At the bottom of the run, a piney-green tree line appeared, populated with people clad in colorful winterwear, mostly skiers. Other spectators in goggles, their visors reflecting sunlight, watched expert skiers zip downhill to join a gondola line now split in two by an out-of-control blonde wearing a silly brown hat and a scarlet ski jacket. I aimed for one tall pine, hoping for minimal damage, and prepared to grab its lower branches.

My arms felt as if they came out of their sockets when I finally stopped, sprawling underneath the tree. Ignoring a few critical remarks and ridicule from the people whom I narrowly missed, I felt my toes. I had survived! Though my skis had come off, I was too exhausted to try to stand. Then a black-gloved hand reached toward me. I looked up to see another mirrored visor below a head of long, curly, light-brown hair. Smile lines exploded around the goggles on tan skin.

"Are you alright?" said a soft voice. It was the handsome guy who had parked his car next to mine exactly a month earlier. He had a name: Gary. What can I say? This had been my destiny.

Three months later, I invited Gary to attend the Miss El Paso pageant with me. Guy and Rex had made a new halter gown, an expensive Kelly-green silk threaded with silver and gold. It was my first gown with an official Guyrex label. The pink dress and other Guyrex gowns had been tucked away safely in a front closet at my parents' house.

After I introduced Gary to Guy, Guy turned to me and smiled. "He has such big arms! He's handsome!" My date's face turned crimson, unfamiliar with the unabashed flamboyance. He was dressed in a plaid suit in a room of tuxedoed men, and I'm certain he felt like a rooster amid a flock of peacocks. Gary's ice-blue eyes looked at me with alarm. I laughed with Guy.

Phyllis George emceed instead of Serrano, changing back-and-forth into different Guyrex gowns and providing lively banter as she entertained the audience. Valerie Camargo performed her "Orange Blossom Special" again for the audience and walked the runway for the last time. Then Aundie Evers, a tall, blonde singer from Texas Tech University, took the new Miss El Paso crown, and Richard Guy and Rex Holt had another makeover to plot.

As in the past, my guest and I were seated with other dignitaries, including Miss Americas Laurie Lea Schaefer and Phyllis George, and, of course, B. Don Magness. Before the ball began, I introduced Phyllis to Gary.

Grinning, she leaned into my ear and whispered, "Are you happy now?" Evidently, Guy and Rex had understood my pain during the last year after all.

Indeed, I was. A kiss had sealed the deal in Ruidoso, New Mexico.

The orchestra started and Phyllis, from across the table, asked Gary to dance, leaving B. Don with me. Yes, I danced with him. The theme of Magic Moments carried the pageant setting, and my venture into Guyrex's fairy tale world was evidently not over. I paid little attention to the actual contest or former grievances. I was in love.

Unknown to the guests assigned to our table, this would be the last time for amicable relationships among the Northeast Texans and the Western El Pasoans.

Chapter Twenty-Eight

Something's Rotten in Fort Worth

On July 13, 1974, Shirley Jean Cothran, a flute player and Miss Haltom-Richland Area, won the Miss Texas-Miss America pageant, the fifth Miss Texas in a row from Dallas, Fort Worth, or nearby towns. Before she even had time to get used to her crown, Guy and Rex claimed foul. They thought they had it all figured out. Something was rotten in Fort Worth.

Other local pageants chimed in that it appeared that Miss Texas-Miss America pageant officials were handpicking their winners, rotating girls in a spiral of area pageants to the top. Worse, one parent claimed that before Miss Texas judges' ballots were even cast for final results, parents of the girls who would be named Miss Texas 1974 and first place runner-up were called aside.

A look at the past five Miss Texases revealed a pattern of using Fort Worth-Dallas area local pageants as "farm clubs." Phyllis George, as Miss Dallas, won Miss Texas in 1970. The year before,

she placed second as Miss Denton. Janice Bain, Miss White Settlement, won Miss Texas in 1971 and in 1970 won third place as Miss Denton. After Janice, Mae Beth Cormany, Miss Hurst Euless Bedford won Miss Texas, placing first as Miss Fort Worth in 1971 and a top ten finalist in 1970. Judy Mallett who won the Texas crown in 1973 as Miss Haltom-Richland Area was a finalist as Miss Big Thicket in 1972. Confusing?

Guy and Rex revealed that a "high Miss Texas official offered to help the point total to insure the 'right girl' was selected in El Paso." They asked, "If he can do that at a local pageant, why in hell can't he do that here (in Fort Worth)?" I thought back to the recent Miss El Paso pageant and Magness's oversight. Had Guy and Rex known of Magness's involvement then?

Soon newspaper headlines across the state cried, "Rigged for Repeats," "Say Miss Texas Is Rigged," and "Pageant Critics Press for Probe." B. Don Magness briefly said he would take a lie detector test but changed his mind, stating on July 20 in the *Dallas Morning News*, "The pageant feels it would be ridiculous." One paper reported that Magness had taken such a test in 1969 for similar accusations.

A recorded press conference shows reporters questioning Magness about Shirley Cothran's musical ability. Magness admits hiring Cothran as a babysitter before the Texas pageant, allowing her to sunbathe at his home swimming pool, but denies that Cothran only knew one piece on the flute. He does the Texas sidestep effectively—again.

UPI shockingly reported that the press organization had correctly predicted the top three winners in a dispatch published *two days before* the contest occurred by following the historical pattern for Miss Texas winners and placeholders. Guy and Rex claimed impropriety as early as the 1973 pageant, Guy remarking,

"We played their game this year to find out exactly what went on . . . Miss Texas for 1975 and 1976 have [already] been decided."

Guy and Rex contacted all the Miss Texas-Miss America locals for support in their claims against B. Don Magness, and twenty of the fifty-seven participants responded positively. Guyrex alleged that the winners were selected two years in advance, judges returned on a rotating basis to ensure the winners, and the Miss Texas 1974 was chosen and met with the judges prior to the final competition on July 13, just as other top ten finalists' parents had reported.

After Guyrex Associates protested nationally, Miss America's directors determined to take no action and let Texas stakeholders handle their own problems. Miss Texas-Miss America pageant officials and former beauty queens from the Fort Worth area claimed it was Guyrex's sour grapes, and nothing more.

Though I wasn't paying much attention to Aundie Evers's newspaper-worthy "bad" experience at the 1974 Miss Texas pageant, the publicity stirred up the memory of B. Don Magness, fake concern on his face, apologizing to us for a deliberate effort to get another girl into the top ten, a move that demoted me to eleventh place. Guy and Rex had been certain of my success on the final day of my Miss Texas pageant—until the judges moved a girl from the alleged "farm club" up. I was the rookie. It hadn't been my turn, if ever, as a western contestant. As for Magness, his shenanigans would catch up to him later, leading to the largest scandal in Miss Texas-Miss America pageant history at the time.

It was time for Guyrex's fresh start, their western do-over. After watching San Antonio's Miss Texas USA pageant limp through

the past three years, Richard Guy and Rex Holt successfully bid for its control. The result would be astonishing, beginning with Miss El Paso Aundie Evers winning the Miss Texas USA title in El Paso in March 1975 and then fourth runner-up to Miss USA on May 17, 1975, in Niagara, New York.

Just like for my trip to Fort Worth and the Miss Texas-Miss America pageant, Guy and Rex planned their inaugural participation in the Miss USA Universe pageant boldly. Incorporating the state's geographical individuality in a way that Miss Texas-Miss America pageant officials never understood, the men highlighted Texas's cultural and historical attributes. While presenting the mayor of Niagara Falls with a cowboy hat and a pair of Tony Lama boots, Aundie Evers bedazzled the USA pageant directors in her feathered and fringed chaps, glittery gauntlets, cowboy hat, and a bolo tied between her breasts, bare midriff exposed.

A dynasty had begun, and with it, a Western flavor to the Miss Texas USA pageant. More importantly, Guy and Rex were well on their way to becoming known internationally as the "Kings of Beauty."

After I met Gary, I tried to move back into my old bedroom. When Mother saw me packing, she angrily argued that I needed to remain where I was. I was deeply hurt, but Daddy overruled her. For reasons I cannot fathom, my presence still threatened my mother. Perhaps I wore my sympathy for my father on my sleeve. Perhaps I showed disgust for my mother's choices. In retrospect, I just didn't know enough about life to understand her pain.

In between rare moments of sunny disposition, Mother withdrew deeply, her perceptions clouded with tranquilizers and

evening drinks. Outbursts spilled over moments of false harmony when it appeared Daddy had another girlfriend.

Still, like an emery board rubbing against sandpaper, Daddy tried to smooth my mother's feelings on their anniversary. Mother had thrown away her wedding ring, worn thin from thirty years of marriage, so my father asked me to go shopping for a new, gold band. I recall he wasn't too selective but quick to purchase a ring that I picked out. For her part, Mother agonized days over searching for a gold pocket watch for Dad—one with a hunting scene. Later I sadly watched them exchange their gifts. Dad's lack of enthusiasm and Mother's hopeful expression.

In 1976, I married Gary, the person with whom I would spend my life, after meeting him on that ski slope in New Mexico. I worked to get a teaching certificate while he finished school with a civil engineering degree. Yes, I married a "crazy" engineer. Sliding down Apache Bowl from the Sierra Blanca Peak on my bottom—alternately falling and snowplowing—had given us plenty of time to initially assess each other, four hours on a ten-minute run.

My parents didn't seem too enthusiastic about the marriage, even though Gary and I waited two years. I honestly hadn't expected them to help with a second wedding, as I still carried the damaged-divorcée label in my heart. With no bells and whistles, I made my gown, and together, Gary and I paid for the small wedding.

Leaving El Paso to live near Lubbock and Texas Tech was not only the beginning of my severance from my parents but the beginning of my understanding of my parents' issues. Still, I continued to hold Mother accountable for my father's actions and blamed my father for my new waking nightmares of my husband cheating on me.

By this time, Guy and Rex had taken the Miss Texas USA pageant to a zenith. After Aundie Evers, Miss El Paso and Miss Texas winner Candace Gray placed in the top twelve at the USA pageant. The next year, 1978, Houstonian Kim Tomes, another Miss Texas titleholder, won the Miss USA Universe pageant. She also won the best state costume, dressed in a strapless one-piece sequined body suit, with Western woolies attached to its bell-bottomed legs. Boots, hat, gauntlets, bandanna, and an illusion of a holster completed the outfit. Guy and Rex had been at their best, and the term *Guyrex Girl* became a common identifier for their beauty queens.

Rubbing B. Don Magness's face in their success, Guy bragged, "Miss America is the girl who lives next door. Miss USA is the girl you *wished* lived next door."

But the boys hadn't forgotten me.

In 1977, my husband and I returned to El Paso to live. Not long after, Guy and Rex made contact. They needed a judge for the 1978 Miss El Paso pageant. On March 25 (along with Michael Gregory, who played Rick Webber on *General Hospital*; June Wylie, Catalina Swimsuits publicity director; Harold Carroll, Miss Del Rio pageant director; and Ted Haworth, art director of *The Getaway*), I sat in the dark with lit candles, trying to calculate the new Miss El Paso.

Our final tally would become another high watermark for the boys.

Thirty minutes before 7:02 p.m., the official time for the pageant to begin, a car plowed into a power station in East El Paso. Suddenly swept into darkness, including at the El Paso International Airport, travelers stepped into a blackened ter-

minal and electronic parking gates froze shut. Still, the Miss El Paso pageant regulars arrived in the night, no doubt expecting an unusual show.

Hector Serrano, who was back to emcee the *Roman Holiday-*themed pageant, had his work cut out for him, and hotel food services doled out extra liquor to keep the audience satisfied. Candle-lit tables provided weak light in the large ballroom, and at least one woman complained about spending a fortune on a gown that no one would see. In the 500-person audience, Jay J. Armes, decked out in a sequined black-and-silver tuxedo, glowed in the darkness like an incandescent compass. By 8:30 p.m., the lights were back on, and a lusty cheer accompanied Bellinda Myrick's performance.

The judges and I sat at a small round table in a hotel room trying to complete the last tally of the finalists' scores. One candidate unfailingly beat out all the other contestants in swimsuit, personality, and poise. She was 5'6" tall, weighed only 122 pounds, and already had a 19½-inch waist. She was also Black.

Guy and Rex hovered around our table. Fairness was imperative, especially after having experienced the Miss Texas-Miss America debacle. Guy watched us calculate without interrupting. When we told him the breakdown, he looked stunned.

Guy once emphatically stated that ages twenty-two, twenty-three, and twenty-four were the most desirable in a beauty contestant since "that age is more mature and [a girl] can handle herself better." He added, "This isn't a Miss Teenage contest after all!"

The winner was also only seventeen years old.

"Are you sure?" he asked, looking at each of us, pacing around our table with a cigarette in hand. The next contestant, a blonde, was close, only one and a half points behind, but we were certain. Fran Ford, who would be announced Miss El Paso in a

matter of moments, was ready-made. I wondered if Guy was concerned that the first ever Black Guyrex-Miss El Paso was about to be crowned or if it was Fran's perfection that stumped him.

"She's already perfect, Guy," I recall saying. "You won't have to do anything to her." But that was not what Guy wanted to hear. With little to no flaws, how would they famously sculpt her into a Guyrex Girl?

Momentarily lost to Guy was the fact that history had just been made. Fran Ford could have competed in the city's Miss Black El Paso contest (a local for the Miss Black America pageant begun in 1968), but she had chosen the Guyrex pageant. Even the area's media recognized Fran's potential, and in the coming days, newspaper stories focused on her intelligence, sense of humor, and experiences as a Black woman.

Rex, with typical dry humor, quipped in reference to the electrical problem with the pageant, "Well, black out, black in!" He grinned. His observation, unfortunately repeated later, was not lost on newspaper reporters.

In retrospect, Fran's win must have taken enormous publicity away from the Miss Black El Paso pageant winner, and she continued to be popular with reporters. Fran, not just a beauty queen, became a power player with Guyrex Associates. More than an asset, Fran would later become endeared to the boys and vice versa. Unlike me, she was compliant. Like mine, her parents trusted Guy and Rex implicitly.

Two years later, Guy and Rex again asked me to judge, this time for the 1980 preliminary Miss El Paso pageant. Two months after that, the Miss El Paso pageant would be a celebration of ten years, and all the former beauty queens were asked to appear for the anniversary. In return for our presence, Guyrex would outfit

us in differently designed gowns of the same fabric. They knew that I had recently given birth to a son.

Though I had sworn I would never enroll in an exercise course again, I went back to the gym. I worried that because I was the oldest and a new mother, I would be scrutinized the most. When I arrived at the Texas Avenue warehouse to get fitted, Guy and Rex had already predetermined that they would design a "fat dress" for me. I surprised them with my slim figure. But I was stuck with a toga design for the special pageant, the least favorite of my Guyrex creations.

An *El Paso Times* feature highlighted all the former Miss El Pasos. I was candid with the reporter about my fights with Guy and Rex, my weight, the 900-calorie diet, and my rebelliousness. Clearly, I had been Guy and Rex's "oldest child." They had learned on me while I grew up.

I received my ticket to the 10th Anniversary of the Miss El Paso pageant: Ticket No. 1; same time and place—Hilton Inn at 7:02 p.m. April 5, 1980; the theme, Celebration. When we waited below the runway that evening, wearing our peach-colored Guyrex creations, Hector Serrano began to introduce each of us by the theme used when we had first been chosen.

Serrano announced, "El Paso, You're Looking Good!" and I walked onstage. After ten years, he proclaimed that I was still "lookin' good." I felt beautiful and bold, too, unlike the insecure eighteen-year-old whose skin blotched in shame in 1971.

My parents were not there. But Gary was, sitting near Guy and Rex. Handsomely standing below the dais, dressed in their tuxedos, cigarettes in hand, they grinned up at me.

～⊚～

I quietly walked through the cool foyer of my parents' Upper Valley home and stepped into the living room. The portrait's face over the fireplace followed me as if expecting to witness a new tragedy.

My parents and I had established a truce despite the rotation of puzzle pieces—accusations, jealousies, moments of bliss and misery. We were a family whose moving parts seemed to have begun reversing. I felt more like the parent now, after grasping my parents' weaknesses and poor choices. Yet, some calculated actions felt downright unforgiveable.

I glanced at my mother's Elna sewing machine, sitting on the dining room table next to her, with piles of emerald-green satin fabric draped alongside. I thought Mother had begun making quilts, and my interest instantly piqued. But I was wrong.

The pink dress was sprawled over Mother's lap, spilling onto the lemon-yellow carpet in a cinematic infusion of color. Head bent down, her right hand held small scissors, and she was meticulously snipping off the pink, silk roses—in slow motion—from the dress's bodice.

Stunned into silence, I watched in disbelief as another rose fell softly to the carpet, scattering into a beautiful flower garden at her feet.

Like a thief whose hand is caught in a cookie jar, she looked up in surprise, a defensive scowl instantly unfurling across her face. Her blue-green eyes dared me to defy what she was doing, a sacrilege she and I both knew.

"Oh, Janey, don't be so selfish! You can always replace them later. I need the roses for a dress I'm making."

Seconds passed as Mother waited for my argument.

The back of my head began to ache, and my ears buzzed above the room's sudden silence. I looked beyond her at the

green folds of satin on the table, their colors starting to fade into a monochrome gray.

Instead of arguing, I turned, ignoring the portrait's unhappy eyes, and walked toward the front door, numb with sorrow.

The images of tumbling, pink roses seared my heart.

Chapter Twenty-Nine

Terminus

s the jet began its descent into El Paso, Texas, my heart began pounding. The desert landscape, at thirty thousand feet below, slowly revealed familiar, looming figures—dark mountains with fairy lights dancing at their toes. Then I-10 appeared, its busyness sparking reds and whites in the early evening twilight, as the roadway snaked through downtown, dividing the sister cities of El Paso and Juárez. Both cities had grown. To the south, on a hill of the Sierra de Juárez Mountains, well above a confusion of new adobe and stucco buildings, I could scarcely discern faint words, *La Biblio es La Verdad* (The Bible is the Truth). On the American side, an enormous star on the slope of Franklin Mountain twinkled its greeting for my arrival. Home.

I disembarked into a less-than-crowded passenger waiting area, its elevator music concerto accompanying a soft muffle of masked adult voices and children's high-pitched squeals. I judged that I could have been in any airport in the country with the COVID virus in its rear mirror, and the scene would have been similar. My ears strained to hear something different—a familiar

tune—but the same bland music escorted me on my ride down an escalator. Gone was Marty Robbins's melodic narrative, the drama that had set the stage for the West Texas town of El Paso and its visitors during the 1960s and early 1970s.

Moments later, when I slid into the front seat of a waiting car, I instinctively glanced across the parking lot toward the lights where the old Airport Hilton Inn had once occupied and where the early Miss El Paso pageants had been held. Beyond, the omnipresent and darkening Franklin Mountain waited to signal my starting point.

The purpose of my visit was to reacquaint myself with El Paso after living elsewhere for over thirty years. I hadn't had contact with Richard Guy or Rex Holt after 1980 despite my family's continued business relationship. I can't say why, except perhaps I believed I would face their scrutiny concerning my physical appearance, that my waist was no longer 21 inches or even 24 inches. As for Guy and Rex, I expect I had been a blip in the past, a learning experience from almost fifty years ago that they, too, had wanted to forget.

I had followed the men's successes, often feeling like an un-invited voyeur, my own loupe scrutinizing interviews that brought the queen-makers to the public's eye, including within the *Los Angeles Times*, *People Magazine*, and the *New York Times*. After taking over the Texas USA pageant in 1975, Guy and Rex ran six Miss California USA pageants, sixteen Miss Texas USA pageants, and twenty-nine Miss El Paso USA pageants. In a 1987 interview with the *LA Times*, Guy bragged, "We're the best now," and Rex added, "We've created history." The men had just sent three Miss Texas titleholders in a row to win Miss USA (1985–1987). The paper did not disagree with their self-assessment, dubbing them the "Kings in the Land of Beauty Queens." And, all this had taken

place in El Paso, "a border city that is a long drive from anywhere," as the *LA Times* reporter wrote.

The Kings' national pageant exposure was especially sweet. Their first in-your-face laugh came when Kim Tomes went on to win Miss USA in 1977, a short three years after the boys split from Texas's Miss America pageant organization and six years after B. Don Magness's deal with Guy and Rex at our Miss Texas pageant. I often wondered what Magness would have thought, but he had died in 2008, after his own notoriety blemished his life's work. Scandal had followed him.

After a 1990 *Life Magazine* article showed him colorfully posing in a bubble bath while gnawing on his trademark cigar, Magness finally had to resign from the Miss Texas-Miss America pageant franchise. An investigation began into whether he made lewd remarks to Miss Texas contestants, as quoted in the *Life* article. Magness insisted that his "Come on in, sluts!" had been a joke. Even in his final weeks as an employee of the city of Fort Worth, Magness was tainted by a sexual-harassment inquiry that the city eventually had to settle.

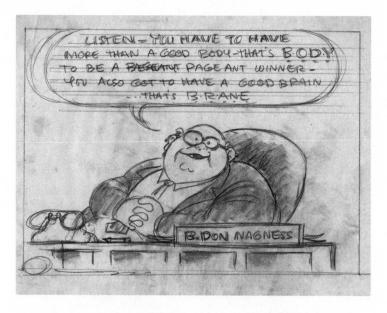

Miss Texas-Miss America Executive Director B. Don Magness
found himself in hot water multiple times, from accusations of
rigged pageants to his public disrespect for contestants.
(Courtesy of Etta Hulme Papers, Special Collections, the
University of Texas at Arlington Libraries)

Instead, it was Richard Guy and Rex Holt who moved on to
create pageant history, and profoundly so, bringing the West to
Texas pageantry. The televised 1988 Miss Texas USA San Antonio
pageant begins with a black-and-white Western reel. A horse
whinnies, and a cowboy steps down, his boots' spurs jingling. The
cowboy walks through batwing doors into a saloon to a poker table,
and viewers briefly see a handsome, pensive face under the hat.

Four hands of cards are dealt. The cowboy flips over a queen
of hearts that quickly melds into an ace and the face of 1985 Miss
USA Miss Texas winner Laura Martinez Herring. The next card

flips over into an ace as well, with 1986 Miss USA Miss Texas Christy Fichtner's likeness, and then a third ace with 1987 Miss USA Miss Texas Michelle Royer's face. The fourth card, when flipped, displays a question mark as a narrator asks, "Who will be the new Miss Texas?" After Courtney Gibbs won the title, she went on to win the Miss USA pageant, too, the national pageant televised from El Paso!

It was bold advertising, if not a direct taunt to other states' queens. When Miss Texas Gretchen Polhemus won the 1989 Miss USA title in Mobile, Alabama, Guy quipped, "My girls are not queens. My girls are aces." A new Guyrex brand had emerged. Rex, who enjoyed high stakes gambling in Las Vegas, would have called their success a *royal flush*. Now five successive Miss USAs, former Miss Texases, would become known as the *Texas Aces* (four aces and a wild card). All women either placed at a Miss Universe pageant or were in the top ten finalists. Guyrex dressed them all as cowgirls at the international pageant.

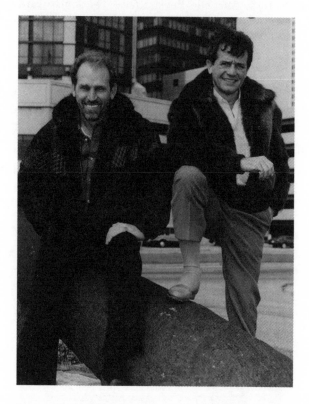

A press photo of "groomers" Rex Holt and Richard Guy in Mobile, Alabama, for their final Miss USA pageant appearance in 1989. There Gretchen Polhemus, Miss Texas 1989, won the fifth consecutive Miss USA title. (Photo by David Neville Ranns for the *Houston Post*)

Guyrex Associates created pageant history, bringing
America's West to the world stage. Shown here, Gretchen
Polhemus, 2nd runner-up to Miss Universe, representing
the United States in cowgirl dress.
(Photo by George Rose, Hulton Archive via Getty Images)

An *El Paso Inc.* reporter wrote in 2011 that the "Guyrex formula
probably kept beauty pageants, which have become increasingly
problematic since the late 1960s, thriving for years beyond their
expected cultural demise in the midst of feminism and the push

for gender equity." I could have told him that Guy and Rex's formula had always been about showmanship and illusion.

Still, disaster followed Richard Guy and Rex Holt along their journey. Three years after our 1980 Miss El Paso ten-year reunion pageant, Rex was arrested for "harboring illegal aliens" in an attic space above their El Banditos Restaurant atop a Dillard's department store. Despite Sib Abraham's best efforts, Rex Holt became a felon, receiving five years' probation, two hundred hours of community service, and a four thousand dollar fine, just as their pageant history was unfolding. An article in the *El Paso Times* on August 27, 1983, reported that the presiding judge incredibly remarked, "Artists are reputed to be—rightly or wrongly—naïve about some things." Hence, the light sentence.

And, just when it seemed the men were on top of the pageant world in 1990, a new managing company took over Miss USA Inc., firing Guyrex Associates from the Miss California USA pageant, despite the men's five-year contract with the Miss USA Inc. franchise.

At the time, newspapers reported that Guy and Rex claimed "conspiracy" when they filed a multi-million anti-trust lawsuit against Madison Square Garden Television Productions. Other injunctions and lesser lawsuits followed as pageant winners and pageant owners became entwined. Many blamed the split on the Miss Texas USA and Miss California USA pageants' phenomenal successes. Guyrex Associates had won five USA contests in a row with Miss Texas, when no other state had won more than two Miss USA pageants in succession (Virginia in 1969–1970 and Illinois in 1973–1974). Some believed Guyrex Associates upstaged the Miss USA Pageant and the new Miss USA managers didn't like it. Others claimed foul. How could the Miss Texas USA pageant win so many national titles?

Afterward, in 1991, Guy and Rex reemerged as GuyRex

Productions Company and registered their trademark *GuyRex Girl* on Tuesday, May 5, 1992. They intended to begin a new pageant organization, the GuyRex-Miss Texas pageant, a Miss World affiliation. Still, other losses followed—longtime relationships with friends and business associates and a Mulholland Drive mansion and other California real estate holdings, though the original El Paso property had remained in their hands.

Because of social media and online news, I knew that others had departed. During the 2020 summer, the world was shocked to learn of Phyllis George's passing at the age of seventy from a disease that the public had no idea she endured. Previously, she had broken the glass ceiling for women sportscasters when she took a job at CBS Sports as co-host of *NFL Today*. Later Phyllis became the First Lady of Kentucky.

Tom Bush had memorialized himself as an actor, including playing Deputy Sturgess on the *Bret Maverick* television series.

Various members of El Paso's Lebanese and Syrian American related families, who played supporting roles in Guy and Rex's successes and in my ascension to the Miss Texas pageants and womanhood, scattered into local history, just as their ancestors' diaspora had spread into Mexico and then El Paso.

Lee Chagra was murdered in 1978, the victim of a senseless robbery. Lee's wife, Joanne, died of cancer. Not long afterward, his brother Jimmy, the House of Carpets sponsor, went to federal prison, though acquitted for masterminding the murder of San Antonio Federal Judge James H. Wood, Sr., in 1979. Charles Harrelson, actor Woody Harrelson's father, was convicted for pulling the trigger.

The city retained some of its other colorful characters, including Jay J. Armes, though he and his wife finally sold their famous North Loop residence and its contents.

Just as Guy and I had struggled to balance my rebellious nature against his tendency to wear his feelings on his sleeve, Guy began to distance himself from some of the very people who had helped deliver his successes. Friends and business supporters dropped by the wayside over the years, I noticed, including some of the original Miss El Paso sponsors. On the other hand, Guy and Rex retained some unusually loyal relationships, including former pageant queens, who remained steadfast until the end.

Guy and Rex had finally passed, too, not as "the boys," but as "the Kings of Beauty Pageants." Rex Holt died in California in 2015 after a lengthy struggle with emphysema, and a grieving Richard Guy died in San Antonio late 2019. Their last GuyRex Girl had seen to Guy's final wishes upon his private passing.

The men are buried next to each other at El Paso's Mt. Carmel Cemetery. With no individual names, the plaque is labeled *GUYREX* because the shared name, as one person close to them said, "will outlive Richard Guy and Rex Holt." The bronze plaque also reads "God is good. Trust in God," and "LLL" for *live a life of love*, Guy's favorite mantra. Two letters—*OZ*—also etch the plaque. Was it a reference to Heaven? Or Guy and Rex's ideal world, a place over the rainbow where dreams come true?

Marty Robbins had a new single called "El Paso City" that hit the charts in 1976. Its lyrics return Robbins to El Paso where he contemplates his original "West Texas Town of El Paso" narrative with an introspective lens.

El Paso City, by the Rio Grande
I try not to let you cross my mind
But still I find there's such a mystery

In the song that I don't understand . . .
Can it be that man can disappear
From life and live another time
And does the mystery deepen 'cause you think
That you yourself lived in that other time.

Somewhere in my deepest thoughts
Familiar scenes and memories unfold
These wild and unexplained emotions
That I've had so long but I have never told

Like every time I fly up through the heavens
And I see you there below.
I get the feeling sometime
In another world I lived in El Paso.

Like Robbins, I needed to revisit my story. In my mind, there
was much to reconcile, something I should have done years ago.

Chapter Thirty

Reckonings

I intended to drive past the former Guyrex Associates' head-quarters where the men began their beauty queen dynasty and captured El Pasoans' imaginations in 1971. I almost passed their first residence and former Miss El Paso office since like many of the milestones from my past, the large house had changed. The giveaway was situated on one side of the building: a large metal *Guyrex* sign hanging haphazardly on its side. There was no driveway where once a motorhome sat, its sides painted with "El Paso, You're Looking Good!" Where a grassy green lawn and shrubs had been, mottled-gray concrete pavers filled the entire front to the street curb.

I knew that by 1975, Guyrex Associates moved their business next door on Montana Avenue, a busy street corner. I read they had a wall of pennies to the left of the stairs and dozens of photos of their Guyrex Girls in their office and on a wall that rose directly above the stairs. Had any of my photos hung there?

The house, stuccoed and painted a nondescript brown, bore thin bars covering all the windows. Still, Guy and Rex's distinctive

mark remained. Two bronzed greyhound statues, their frozen puppies climbing the steps below them, flanked each side of the portico, canine sentinels to large metallic entry doors. Above the doors, two crosses framed a bronze "Guyrex" script nameplate, and below that, again the word *OZ*. Guy and Rex, who had endeavored to purchase the *Wizard of Oz* ruby-red slippers, had created a world of fantasy within these doors, pulling the strings for all those who came across their paths. Friends, business associates, theater patrons, and Guyrex Girls, all experienced some aspect of their fairy tale lives. But there was another sign—"Luke 2:14." The Bible verse reads, "Glory to God in the highest, and on earth peace, good will toward men." Before they passed, Guy and, perhaps, Rex, too, came to a reckoning.

And so had I.

Festering wounds, like old photographs, eventually lose their fiery color, turn yellow, and then fade. Like most healings, my relationship with my mother eventually softened and hard memories of our wars had become fuzzy and uncertain. And while my sons have been spared some of those qualities that one maternal generation can transfer to another, I realize that I, too, most likely committed small injuries to those closest to me with the same characteristic all-knowing, persistent interference belonging to my mother. Generational sin.

After my parents' ailing marriage endured tortuous death throes during the 1980s, they eventually divorced, Daddy moving on to marry his most recent lover. At the news, Mother quipped, "At least I won't have to take care of an old man when *I* am old!" Indeed, she had not. With her small divorce settlement, she moved to the Texas Hill Country in the 1990s to be close to her

grandchildren and me, a daughter she counted on to take care of her in later years. I would be lying to say that her proximity did not cause some emotional duress. But time heals. Profoundly.

I no longer have dreams of my husband leaving me for another paramour. Nor do I fault myself for not joining a gym, though I have yo-yo dieted for years, my vision of a healthy self-image a recurring challenge. I have begrudgingly begun to accept my grandmotherly plumpness.

I don't mourn fractured and lost relationships, the divorce debris that my parents left in their wake. And most importantly, I finally accept my mother for who she was and why she made the choices she did.

This acceptance came almost fifty years later when she was dying. Like my father, my mother eventually had lung cancer, my parents paying a price for years of smoking. Unlike my father's, my mother's cancer was quick and deadly.

It was while driving my mother to myriad doctors' appointments in 2018 that she finally had direct, honest conversations with me. The years of suffering through my father's infidelities, financial problems, the moves, and taking care of us kids bubbled up at different times.

Once, I asked my mother a simple question. "Mom—why didn't you just leave Dad?"

She raised her eyebrows and looked at me like I should have known the answer to a first-grade math question. She finally answered, "Because, Janey, if I had, how would I have taken care of you and your brother? Despite all his failings, your dad was a good father."

I continued to listen quietly and occasionally asked more questions, especially about the years I was associated with Guyrex and the events that scarred my youth up until then. Later,

she gave me files with legal documents, letters, and other family papers that she had retained to support her decisions in both remaining and leaving my father. I hated to touch those files, but eventually my curiosity bested me.

On these trips, Mother typically sat slumped in the passenger seat, her 5'7" height reduced to 5', another byproduct of her smoking. She would gaze out the car window like a wizened child, pointing to landmarks that she had pointed out many times before, usually making some sort of verdict about what she saw.

On one of our last rides, we had been discussing something innocuous when she slowly turned to me, looked me in the eye, and said, "Janey, I never should have cut the roses off your pink dress." Then just as quickly as she had said the words, she looked forward, her keen blue-green eyes catching movement. She pointed out a red bird, the cardinal flying past our windshield.

My eleven-year-old granddaughter was in the "pink room," a guest room she named due to the gown that hung on a dress form within. I had been able to replace the silk roses, transforming the pink dress's mangy appearance to its original grand form.

"Nana, can I try on the pink dress? Please?" she begged.

I looked down into her hazel eyes, carefully unpinned the dress from the form—the gown had been too small to zip up on the form's narrowest setting—and piled the pink layers over her head. She put her small hands over the roses covering her chest and then to the rosy mounds, loosely sliding off her shoulders, at the same time beaming at the swath of skirts spread out on the floor. Then I began to zip up the dress.

At the waist, the zipper froze. I tried again, but there was no impediment blocking the zipper. My granddaughter's girlish

waist was simply larger than my waist had been in 1971. Un-
daunted, we removed the Miss America crown from the lavender
velvet pillow on which it had rested for almost fifty years. I gently
placed it on my granddaughter's head; I smiled in my certainty
that she would never be judged by the sum of her measurements.

Together we looked into a window-framed mirror, also
adorned with painted pink rosebuds. I waved away the imaginary
bluebirds hovering over us, and brushed back her long,
blondish-brown hair.

"Lacey Jane," I whispered in her ear. "You're looking good."

(Author's Collection)

Acknowledgments

Digging into one's memory after decades can be daunting. Hilda Harrell's twelve-foot-long scroll filled with Miss Texas pageant events and my reactions to them had been stored away for the moment I would finally initiate this narrative. Still, I often needed help in recalling my story, despite digging into volumes of clippings, photos, scrapbooks, programs, letters, and interviews. Together, the memorabilia easily formed a skeleton for framing the years and events of which I was associated with Richard Guy and Rex Holt. But the story's tissue—the part that tingles with excitement and flinches from pain—needed help with fleshing out.

I am indebted to my oldest friends—Nancy Brunsteter Díaz, Kristina Paledes, and Ceci Brunner Pierce—for their perceptions of my recollections as well as for clarifying cloudy memories. My mother had been involved in their lives, too. Most importantly, without Karen Thomas Williams' remarkable memory, some of the events in the memoir would be faulty or missing entirely.

Washington Post editor and author Amy Argetsinger's curiosity and passion regarding the Miss America pageant's organizational history, and its various state and local pageants, was essential. In Argetsinger's retrospective *There She Was: The Secret History of Miss America* (2021), a discussion of the Miss Texas pageant and B. Don Magness gave me the courage—no, empowerment—to

explore my own story; a story that I discovered is surprisingly not unique among beauty queens.

Early beta readers Debbie Font and Karen Thomas Williams read several versions of the manuscript and offered advice. Representing different generations of women, editor Rachel Santino, plus my former students Marla Jensen and Jessica Godwin Seifert, also shared their impressions in the draft's final days. I thank them profusely, too.

My friend Micki Fuhrman, musician-author, along with her husband, attorney W. Michael Milom [Entertainment & Sports and Intellectual Property], helped me navigate acquiring music permissions. I'm beholden to them for their professional aid.

Gorgeous Gretchen Polhemus Jensen, Miss USA 1989, last of the five Texas Aces and second runner-up to Miss Universe, shared my joy of telling the early Guyrex (GuyRex) story, validating the men's significance in national pageant history. Her image in Western garb at the Miss Universe pageant says it all. Fran Ford Miss El Paso 1978 and Bebe Richeson Miss El Paso 1972 also shared input. These strong Texas women deserve my gratitude.

Charles Rankin, former editor-in-chief from the University of Oklahoma Press, thought he was finished with me when he retired to write his own scholarly nonfiction. I am especially appreciative of his staying the course with my tale—early editing and advice—despite my deviation from writing western biography. I would like to have seen his face when he first read my descriptions of taping contestants' bosoms and a Mexican prostitute dubbed Miss El Paso.

My editors Brooke Warner and Lauren Wise of She Writes Press saw potential in the early memoir and delivered its final publication process. This was a novel experience for me, having written only for a university press in the past. I appreciate their

calm responses when my emotional ties to the narrative over-whelmed common sense. Their team's contribution to the man-uscript and cover concept has been invaluable. Thank you.

Finally, I am most grateful to my husband, Gary, who provided editorial advice (when asked) and emotional support (when needed) as together we smoothed the scars and celebrated the victories of my past. Without him, I never would have begun this narrative journey.

About the Author

National award–winning author Jane Little Botkin melds personal narratives of American families often with compelling stories of western women. A member of Western Writers of America since 2017, Jane judges entries for the WWA's prestigious Spur Award, reviews new releases, and writes articles for various magazines. Her books have won numerous awards, including two Spur Awards, two Caroline Bancroft History Prizes, and the Barbara Sudler Award; she has also been a finalist for the Women Writing the West's Willa Literary Award and Sarton Book Award. She is currently working on *The Breath of a Buffalo*, a biography of Mary Ann (Molly) Goodnight. Jane blissfully escapes into her literary world in the remote White Mountain Wilderness near Nogal, New Mexico.

Looking for your next great read?

We can help!

Visit www.shewritespress.com/next-read
or scan the QR code below for a list
of our recommended titles.

She Writes Press is an award-winning
independent publishing company founded to
serve women writers everywhere.